How to look
at a painting

D1430337

How to look at a painting

Françoise Barbe-Gall

F

FRANCES LINCOLN LIMITED

PUBLISHERS

Introduction

.
.
.
.
.
.
.
.
.

Learning how to look at a painting assumes first and foremost a willingness quite literally to believe our own eyes. The image that we see is a result of the artist's choices and decisions, the moves they made and did not make, when faced with the blank canvas. To give that canvas our attention is to give ourselves an opportunity to discover what it adds to the visible space around us.

But a painting can be intimidating: whether it is famous or not, a canvas possesses an aura that may attract or disconcert us by making us feel that our initial impression, however powerful, can always be extended and deepened. In short, that there is something that continues to elude us.

Whatever its subject, every work of art gives concrete expression to a whole series of perceptions and memories that are ultimately brought together. Its impact is both immediate and complex. The work may be new to us, but it never stands alone.

It is easy to understand the delight of the historian penetrating the hidden mysteries of a work and on the basis of his or her patient observations tracing the lines of aesthetic influence that constitute its history. But from the standpoint of the art lover categories and styles can merely add to the difficulty, as can theories and a specialist vocabulary.

And yet even the least well-informed observer can take in the general atmosphere of a painting. What we observe should never be underestimated. Our reaction may appear naïve, even to ourselves, but it is always a valid response. The way we first react to an image, falling in love with it or rejecting it out of hand, depends to a large degree on the way that image defines reality: we are struck first of all by the extent to which it resembles nature, by the way in which the world is idealized or transformed in a manner that surprises us or by the unsettling blurring of

familiar landmarks. These factors have an immediate impact and strike home more quickly than any other information. We may not be able to explain what we can see, but we are able to talk more or less clearly about what attracts or repels us.

How to Look at a Painting is arranged in such a way as to reflect this direct relationship with the images that it examines, and to discuss and consider the sort of effect that all observers can experience when looking at a painting. Of course reactions vary from person to person. But there are certain constants too, and these serve as the basis of our working hypothesis. Not everyone will agree with the way I've grouped the works together, or what I say about them. By taking a simple approach, and avoiding accepted terminology, I hope to at least open some avenues worth exploring. Certain works could easily be relocated to other chapters, just as over the years the same works will be perceived differently by the same observer.

Questions of history and style and of iconography and composition are not neglected, of course. Far from it. But instead of being imposed on each work at the outset, they are dealt with in the sections that follow on from each text. These sections provide further information, clarify certain questions and suggest other lines of enquiry. What matters is the ability to approach each work directly, just as we might go and meet an individual without knowing his or her history in advance.

The only aim of this book is to unlock the door to a painting by encouraging the observer to appreciate the power and relevance of our own perception.

Contents

chapter 1 > page 8

Observing
a simple reality

...

•

Discovering the essence
of a character
Raphael, *Balthazar Castiglione*
12

••

Confronting the truth of emotions
Caravaggio, *The Death of the Virgin*
20

•••

Guessing what remains unsaid
Bettera, *Still Life with
Two Lutes, a Virginal and Books
on a Table Covered by
a Carpet*
28

••••

Feeling a sense
of déjà vu
Constable,
Helmingham Dell
34

•••••

Believing you are at the cinema
Hopper, *Nighthawks*
40

••••••

Recognizing the substance
of the world
Tàpies, *Seven Chairs*
48

chapter 2 > page 54

Contemplating
the sublime

...

•

Taking part at an important event
Van der Weyden,
The Descent from the Cross
58

••

Flirting with the idea of perfection
Botticelli, *Primavera*
66

•••

Feeling time stand still
Vermeer, *Girl with a Pearl Earring*
74

••••

Accepting that we cannot
see everything
Velazquez, *The Rokeby Venus*
82

•••••

A moment's grace
Renoir, *The Moulin de la Galette*
90

••••••

Witnessing the birth of light
Soulages, *Painting*
98

chapter 3 > page 104

Analysing
distortions to the
visible world

...

•

Imagining the point of eternity
Giotto, *Saint Francis Receiving
the Stigmata*
108

••

Discerning the troubles of history
Parmigianino, *The Madonna with
the Long Neck* 116

•••

Sensing a metamorphosis
Ingres, *Mademoiselle Rivière*
124

••••

Glimpsing primitive nature
Rousseau, *Child with Doll*
132

•••••

Adapting to circumstances
Picasso, *The Aubade*
138

••••••

Abandoning the evidence
Dali, *Persistence of Memory*
144

chapter 4 > page 152

Taking account of what
appears confusing

..

•

Making allowances for mystery
Anonymous Provençal artist,
The Boulbon Altarpiece
156

••

Taking time to be wrong
Bruegel, *The Bearing of
the Cross*
164

•••

Appreciating a way of thinking
Watteau, *Embarkation
for Cythera*
172

••••

Measuring the difficulty of seeing
Cézanne, *In the Park at
Château Noir*
180

•••••

Welcoming a new freedom
Kandinsky, *With the Black Arch*
188

••••••

Feeling our way to reality
Braque, *Woman with a Guitar*
194

chapter 5 > page 202

Getting over the shock
of our first impression

..

•

Considering the function of
a painting
Grünewald, *The Crucifixion*
206

••

Seizing the grandeur of a ritual
Rembrandt, *The Flayed Ox*
214

•••

Passing through the mirror
Goya, *Las Viejas* or *Time*
220

••••

Understanding the logic of a vision
Gauguin, *Vision of the Sermon
(Jacob Wrestling with the Angel)*
230

•••••

Seeing life unravel
Munch, *The Scream*
238

••••••

Gaining access to the opposite
side of things
Bacon, *Study of George Dyer
in a Mirror*
246

chapter 6 > page 254

Abandoning
ourselves to the
gentleness of a painting

..

•

Abandoning our fear of shadows
Da Vinci, *The Virgin and Child
with Saint Anne*
258

••

Seeing history in the making
Poussin, *Rinaldo and Armida*
266

•••

Forgetting the weight of the world
Murillo, *Saint Thomas of
Villanueva Distributing Alms*
274

••••

Enjoying a lasting peace
Chardin, *Three Apples, Two
Chestnuts, Bowl and Silver
Goblet*, or *The Silver Goblet*
282

•••••

Welcoming the ephemeral
Monet, *Water Lilies*
290

••••••

Learning to wait
Rothko, *The Ochre*
298

Observing a simple reality

A painting that reproduces the real world always has something satisfying about it. Looking at the image, we are able to say what we can see and have the agreeable feeling that the painting confirms our own conclusions about the world. Even more significantly, it seems to sanction those conclusions by giving them a sense of permanence. We allow ourselves to be drawn into the picture because we are confident that we shall be able to find our way out of it again: the landmarks are clear, and the rules have been respected. It is as if we are entering a well-kept house where we shall have no difficulty recovering an object that we left there the previous day. No untoward event undermines our sense of certainty.

And yet the image is all the more deceptive precisely because it respects the world of appearances, for the observer is now defenceless. Such a work inspires no disquiet. Feeling that we are in good company, we tend to linger, admiring the artist's infallible technique and noticing what that technique involves in terms of time and virtuosity. All of this gives us pleasure, but it does not excite our curiosity. And yet a painting that calms us by using familiar objects and a language that we ourselves can speak does not reveal its true purpose in this way. We can easily identify the sitter in a portrait or recognize a landscape or some other object in a painting while still failing to see the painting's significance.

That is why, contrary to received opinion, older paintings are no more accessible than contemporary ones. Nor is figurative art simpler than abstract art. At most they have a different potential for seducing the observer, depending on the individual concerned. Whatever its vocabulary, a painting increases the number of ways in which we can gain access to reality. The artist may describe reality with clinical precision using a trompe l'œil technique or he may retain only the raw material, but he still pursues the same objective, which is to encourage us to see something in ways that differ from what we think we know.

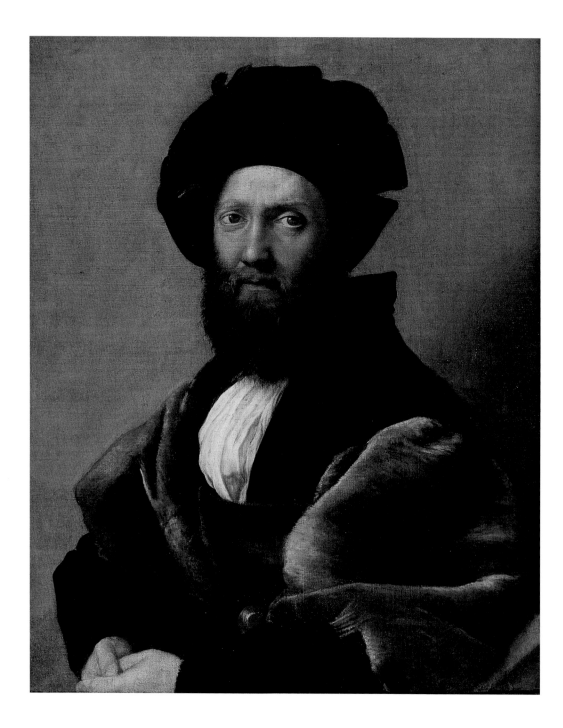

Discovering the essence of a character

Raphael (Raffaello Sanzio) (1483-1520)
Balthazar Castiglione, 1514-15
Oil on canvas, 82 x 67 cm (32½ x 26½ in)
Musée du Louvre, Paris

This man sits before us with calm assurance. His portrait might even escape our attention, so much does it appear to merge with the world around it. He strikes us as familiar and yet we have never met Balthazar Castiglione. Raphael presents him to us discreetly, in half-shades. Or perhaps it would be more exact to say that he presents us to him, for his unflinching gaze leaves us in no doubt that it is he who is watching us and taking his time as he does so.

Balthazar Castiglione was a friend of Raphael and Urbino's ambassador in Rome, but there is nothing about his portrait – a model of reserve – to suggest his status or his power. He sits before a uniform background, dressed in grey and black, the white of his shirt forming a nucleus of light at its centre. The sobriety of the overall impression is such that we might almost be put off by such a monochromatic image. But it is enough to look a little more closely and examine the portrait in greater detail to make out a subtle luminosity, slight reflections and textural nuances of which we had previously not been aware. We notice that the black of the doublet is all the more striking when set beside the white of the shirt and that it appears to be even deeper in colour beside the grey of the fur, its severity tempered by the smoothness of the velvet. We can imagine the softness of the fabric on his brow. The folds in the shirt over his breast suggest a knotted bundle of energy that causes the centre

of the painting to vibrate. Such energy is all the more striking and intense in contrast with the soft opulence of the fur.

By eliminating variety of colour, Raphael has created a portrait that is anything but austere. Rather, he has reduced his palette to a series of contrasts in order to highlight the opposing forces of black and white, which he does with the lightest of brushstrokes. Based on a multiplicity of intermediary shades, the painting becomes an apotheosis of grey. And in this way Raphael celebrates the diplomat Balthazar Castiglione: conscious of the need to mediate between extreme positions, the diplomat is skilled at listening to differing points of view and of weighing up each of them without neglecting the substance of the other. He takes account of everything, assessing the light and the shade and preventing contradiction and conflict. Who better to know the value of grey and the infinite wisdom of its associations in a world in which colours vie with one another for their splendour?

It would have been easy for Raphael to bring out the brilliant sheen of the silk and suggest the rustle of the satin by means of flattering lighting. But Balthazar Castiglione is not interested in creating a stir. However expensive, velvet and fur have a remarkable ability to absorb the light, which is hidden away in the thickness of the sitter's apparel like a well-kept secret. A tiny feather nestles by the side of his beret. A few glints of light hover above the grey of the sleeves, suggesting the merest of murmurs dying away. They will soon be completely inaudible. The calm of the image is contagious. In the proximity of the ambassador, the world grows much less agitated, and restraint is revealed as an expression of human grandeur.

There is something about the sitter, whose shoulders are turned slightly to his left, that suggests that other business could call him away at any moment but that for the moment he is content to remain here, seated, available for other, more trivial concerns. His hands are clasped, revealing no particular emotion. Raphael could have dispensed with them entirely, as portraits of the time often did, depicting only the sitter's head and shoulders. This portrait however belongs to a different category, one that is more modern and that depicts half-length figures, taking account of the expressive qualities of the hands. It is significant, however, that the artist depicts them only in part, cut off by the lower extremity of the painting. In this way he puts us on our guard: something is still missing. Next to nothing, or almost, but enough to persuade us that the ambassador is not telling us everything that he knows, everything that he is working on. He combines clarity and allusion. We know only what he consents to tell us, nothing more.

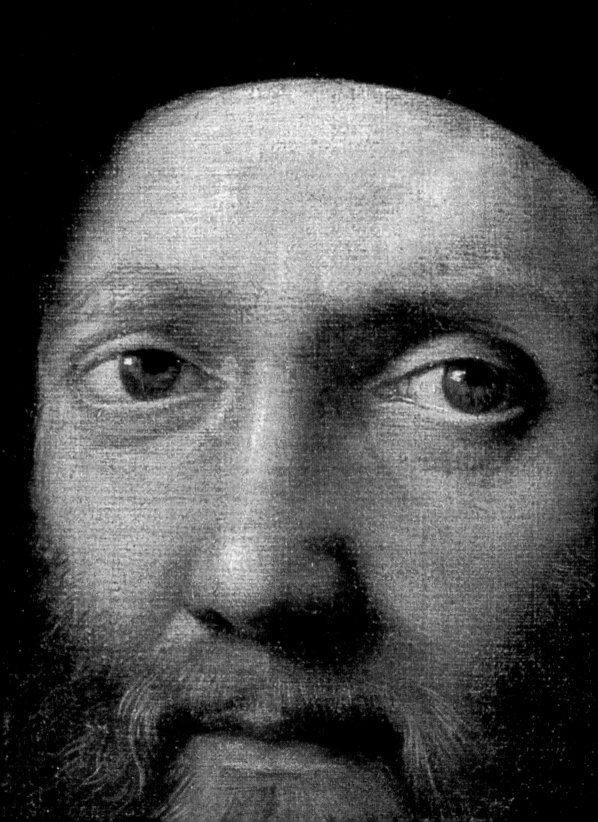

As the minutes pass, the portrait seems to change beneath our gaze, as if its expression were changing. This is not true, of course, it is simply that we are seeing it more clearly. Whereas it initially gave us the impression that it portrayed an evident, unquestioning and almost humdrum reality, the image now starts to appear supremely calculated and knowing. Just like Balthazar Castiglione himself. Observing his portrait is like getting to know the man himself and gradually gaining an understanding of this apparently unassuming individual who never raises his voice, a man who had one of the most sophisticated minds of his day. This could soon become intimidating, but the ambassador – in spite of the keenness of his steel-blue eyes – sets store by putting us at our ease. His eyes are neither raised nor lowered, but place us on the sitter's own level. From the outset he turns us into his interlocutor. The space that the painting occupies is that of a dialogue that we ourselves have been invited to attend, and the man who watched us arrive is our host. He was waiting politely for us to acknowledge him.

We may form a fairly accurate idea of the conversation that would ensue if we were to take a look at his famous work, *The Book of the Courtier*, which unfolds over a series of evenings at the Palazzo Urbino, one of the principal centres of Italian Renaissance culture: here a number of distinguished individuals, men of the cloth, poets and military figures discuss their views on beauty and love and on their loyalty towards the princes of the realm, assembling in a spirit of friendship and exploring with consummate ease the loftiest regions of the mind, while paying homage to the pleasures of the world. The perfect balance that is achieved in this portrait of Balthazar Castiglione is part of an overall triangular design that shows not only how we are rooted in the earth but also how we aspire to a higher dimension. As such, it conveys the very essence of the words of these discussions, words that are filled with that particular sense of refinement that we call civility.

Balthazar Castiglione (1478–1529)

•

Balthazar (or Baldassare) Castiglione was an Italian diplomat who was thirty-seven at the time of this portrait. He was born into the illustrious Lombard family at Casatico, near Mantua, and educated at the court of Ludovico II Gonzaga, Duke of Milan. An accomplished humanist, he was well versed not only in the art of warfare but also in Latin and Greek and, finally, in literature and philosophy. In 1500 he entered the service of Francesco Gonzaga, the Marquis of Mantua. From 1504 to 1516 he served the dukes of Urbino, Guidobaldo da Montefeltro and Francesco Maria della Rovere, before returning to Mantua, where he remained until 1524. On being widowed in 1520, he took minor orders, ending his brilliant career as papal nuncio at the court of Charles V of Spain. He died in Toledo shortly before being appointed a cardinal.

Urbino was the birthplace of Raphael, and it was here that the two men became friendly. They met again in Rome, when Castiglione became the ambassador of Urbino in 1513. It was around this time that the portrait was painted. Raphael was in Rome, decorating the Vatican Palace, a task that occupied him from 1508 until his death in 1520.

The construction of the portrait

•

In fifteenth-century Italy, most sitters were painted in profile, following the example of classical medallions. Only gradually did the three-quarter profile initiated by Flemish artists assert itself and allow painters to exploit the psychological dimension of the eyes. The present portrait dates from the early sixteenth century, a period dominated by the emblematic figure of the *Mona Lisa* begun by Leonardo da Vinci in 1503. One of the crucial elements of this famous painting is to be found in the representation of the hands, which suggest interiority and the virtuality of action. Whereas Leonardo uses his portrait of the *Mona Lisa* to celebrate the ideal serenity of humankind in its transitory relationship with Creation, Raphael privileges the existence of a specific individual committed to the present day within a given society. The half-hidden hands are a subtle device to reflect a particular relationship with the world. A black band that Raphael painted round the four edges of the portrait indicates that he always intended to frame it in this way.

The Book of the Courtier (Il libro del cortegiano)

•

Published in Italian in 1528, Castiglione's book is an essential reference tool for anyone wanting to understand the Renaissance. The term *cortegiano* is used in its original sense meaning a 'gentleman at court' in contrast to a boor lacking all education. It was the bedside book of both Charles V and François I and set out to define the courtier who would be truly worthy of that name. Adopting a conversational tone that avoids any hint of pedantry, it describes the moral, intellectual and physical qualities that the courtier should display, qualities that should be guided by a superior sense of moderation. Raphael's portrait reflects Castiglione's principles, including his precept that 'a man ought always to be a little more backward than his rank warrants' (ii.19), while also encouraging the courtier 'to avoid affectation to the uttermost as if it were a very sharp and dangerous rock; and, to use possibly a new word, to practise in everything a certain nonchalance [*sprezzatura*] that shall conceal design and show that what is done and said is done without effort and almost without thought' (i.26).

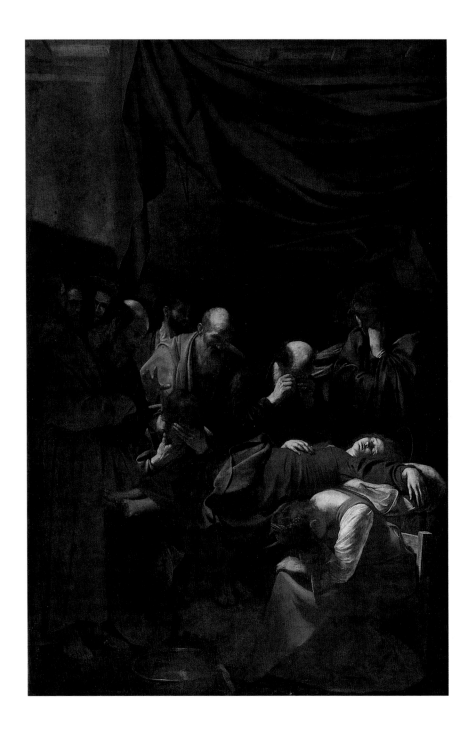

●●

Confronting the truth of emotions

Caravaggio, born Michelangelo Merisi (1571–1610)
The Death of the Virgin, 1605–6
Oil on canvas, 369 x 245 cm (145¼ x 96½ in)
Musée du Louvre, Paris

.
.
.
.
.
.
.
.

People gather around the body. Within the confines of the room, they must be feeling hot. There is so much red in the painting. Their voluminous cloaks fall heavily and a little light strikes their heads from above. Their faces are less important than their bodies: the way in which they stand says more than the features on their faces, no doubt because grief robs them of their identity. Who they all are, including the woman laid out before them, changes nothing. Their names can wait. The observer recognizes the scene even before knowing when and where it took place or who is being mourned. The scene would be the same anywhere, no matter who the person was. Moreover, these people are not concerned about being seen and do not care what we think about what they are wearing. They clench their fists to their eyes, bowed low by their anguish. They are simply there, barely moving. There is nothing more for them to do. Caravaggio has not depicted the intensity of the final moment of life and the overwhelming grief that follows – he has painted what comes afterwards: the consternation, the emptiness, the crushing futility of any gestures before the rituals associated with death begin and life slowly resumes for the living. Some of the figures at the back are still talking, suggesting one last remaining vestige of anger. Each buries themselves in their grief in their own particular way. We can hear them silently sobbing.

A young woman is seated close to us, weeping, her face buried in her hands. And yet her anguish, however real, is not what first strikes the observer, it is rather the brightness of her neck and of her auburn hair and the brilliance of her amber dress. In the midst of all this grief, her beauty has something incongruous about it. It seems out of place. Our eyes linger over her and find some comfort. We allow ourselves to forget, but not for long. The copper bowl recalls banal reality. It bars our passage: we might almost have stumbled over it. The time for contemplation is over. The body needs to be laid out. The young woman at the front will know what to do.

These people mourn their dead like any others. And although the title of the painting leaves us in no doubt, we have to look closely to see the halo, a thin gold line floating behind the head of the woman laid out before us. The Bible says nothing about the death of the Virgin Mary, but legend has it that the apostles were miraculously transported into her presence. It is they whom we see here, barefoot and weary. One of them, on the right, rests his head on his hand in an attitude of meditation and melancholy. It is Saint John, who according to tradition took care of Mary after Jesus' death. The dark drapery that cloaks him underlines his resolution. Partially hidden by the black clothes that attest to his mourning, he remains the most alert, the most upright, set apart from the others who are standing around him.

The line that divides up the wall in the background reflects the weight of the shadow falling upon them. As so often in his paintings, Caravaggio uses the background to convey a sense of the interrelationships and tensions either between the figures themselves or within their own minds. In some ways it could be described as an abstract realization of these tensions, reduced to the geometry of light and shade and reflecting the drama as it unfolds before us.

Her features furrowed with old age, the Virgin Mary lies on a table. Her dress has ridden up a little, revealing her ankles. A blanket has been hastily thrown over her. The observer is reminded of the scene of an accident rather than a peaceful death. It is as if the mourners have had to improvise and make arrangements for the body, which could not be left on the ground. The scene rings true – too true, in fact, for the members of the clergy who in 1607 were horrified to see the painting: what had become of the astonishment of the apostles, the kindliness of the annunciatory angel and the Virgin's murmured prayer before she dies? Where are the clouds that should carry the apostles to the Virgin and bear the Virgin to heaven? Caravaggio should have interpreted this moment as something transitional and joyous, not as an end in itself. But he shows us none of this. Nor does he depict Christ, who is traditionally seen holding something in his arms that appears to be a child but which is in fact his mother's soul, which will soon be welcomed into the kingdom of heaven.

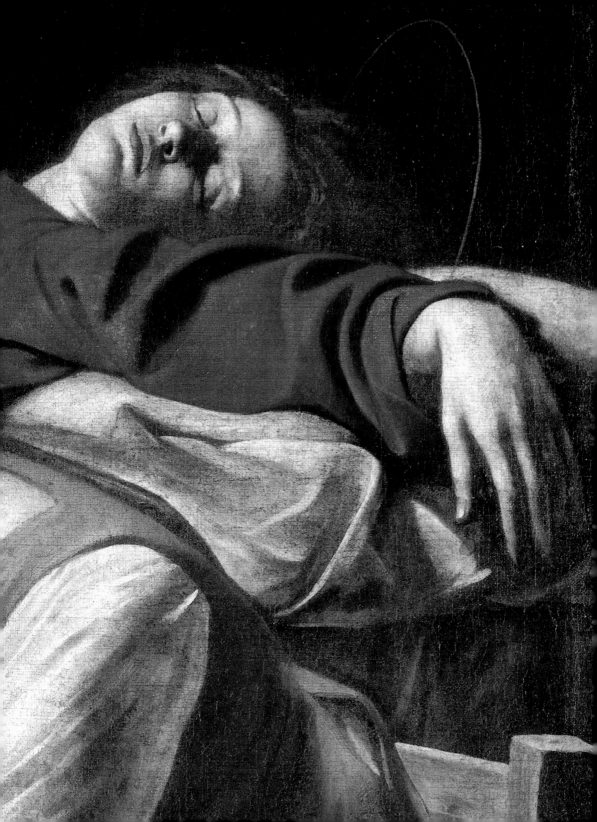

The image of the Virgin Mary is not just surprising but also disturbing and almost sacrilegious. Her eternal youth and chastity were part of God's grand design. But nothing in this painting suggests the least vestige of godlike glory. Nor is there anything in the Virgin's lifeless features to indicate the joys that lie in store.

Even so, there is no lack of decorum: the large red curtain that dominates the scene introduces a curious note of theatricality that seems odd in the context of the reality depicted all around it. This had been a traditional accessory in paintings over the centuries, used to elevate the scene revealed to a higher reality, even if that reality was no more than the obligatory prestige associated with a ceremonial portrait. Behind the theatrical prop, however, there is also a memory of the Veil in the Temple, which shielded the Holy of Holies from the eyes of the profane.

The staging of this scene may nowadays instil a little unease – it implies an artifice that renders the reality suspect. The observer, who had sympathized with the figures in the painting, begins to think that it may simply be a mere show after all.

But if we take a step back and look again, it is at this point that everything falls into place. The face of the Virgin, caught by the light, is the only face that we can see completely, the others all marked in their various ways by the shadow that tells us that they are still a part of this earth. Then there is the dress that falls down over the edge of the table beneath the sumptuous curtain. The contrast between the poor cast-off dress and the magnificent drapery above it symbolizes destitution and grandeur, death and transfiguration. The curtain – a trivial theatrical prop – is suddenly seen to play a much more significant role as Caravaggio establishes a magisterial parallel between it and the body of the Virgin.

The artist has dispensed with all the established rules, the reality of the emotions felt by the figures carrying him into a world far beyond that of empty conventions. If Caravaggio sets up a dialogue between earth and heaven, it is on his own terms. And if the fabric of the vast curtain mirrors that of the dress, it is because it holds out the promise of an afterlife. The drapery represents nothing in itself, it is merely an indicator of the possibility of transcendence. The Virgin and her cheap and crumpled dress bear the crude stamp of reality, but the curtain transfigures them. This period also witnessed the birth of opera, with its entirely new combination of music and theatre. The present painting in turn becomes a theatrical space resonating with a deeper meaning. The curtain rises, song-like, towards heaven, signifying a life that is greater than the present one, a life as free, as powerful and as pure as any aria. This is perhaps not yet the final act of the drama.

The death of the Virgin

●

Traditional representations of the death of the Virgin are based on an account that may date back to the fourth century AD, the *Transitus Mariae*. As with many of the themes associated with the history of Christianity, the different versions of the tale were compiled by Jacobus de Voragine (c. 1225/30–98) in his *Golden Legend*. The story begins with an angel visiting the Virgin Mary, then aged seventy-two, and announcing her imminent death. She asks the angel 'that my sons and brothers the apostles be gathered unto me, that I may see them with the eyes of the flesh before I die, and may be buried by them, and may give back my spirit to God in their presence'. Shortly afterwards, writes Jacobus de Voragine in his account of the Assumption of the Blessed Virgin Mary, 'All the apostles were plucked up by clouds from the places wherein they were preaching, and put down before Mary's door.' Caravaggio sidestepped the miraculous aspect of the legend, which goes on to explain how John was the first to arrive and how he warns the other apostles: 'See to it, brethren, that when she dies, no one weeps for her, lest seeing it the people be troubled, and say: "Behold, these men preach the resurrection, yet they themselves fear death!"'

Catholic doctrine

●

The need to idealize the figure of Mary the Mother of God was bound up with a fundamental point of Catholic teaching: according to the doctrine of the Immaculate Conception, the Virgin Mary was from the outset exempt from the original sin that taints the rest of humanity. Although this was not established as an article of Catholic faith until 1854, a belief in the Immaculate Conception had given rise to lively controversy from the Middle Ages onwards. The Assumption of the Blessed Virgin Mary is the logical consequence of this belief: following her death or, to be more accurate, following the sleep of death, Mary's body and soul are borne to Paradise by angels. Artists had depicted this subject from the Middle Ages onwards, even though in this case the dogma was not accepted as such until 1950.

The woman's limp and worn-out body that Caravaggio depicted caused a scandal because it implicitly contradicted these two ideas. The rejection of the painting by the Church was based, therefore, on theological considerations and was not an aesthetic decision prompted by an image felt to be indecent or lacking in nobility.

The beginnings of opera

●

The earliest operas were written by Jacopo Peri (1561–1633) and were performed in Florence between 1597 and 1600, but it was not until Claudio Monteverdi (1567–1643) appeared on the scene that the new genre left any real impression. Two performances of *Orfeo* were given at the ducal court in Mantua in February and March 1607. By a remarkable coincidence, it was only a few days later that the duke himself, Vincenzo I Gonzaga, one of the greatest art collectors of his age, acquired the painting by Caravaggio that had created such a stir in Rome.

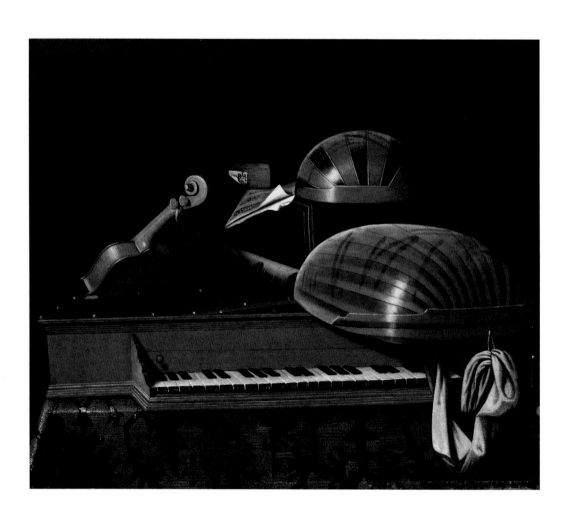

Guessing what remains unsaid

Bartolomeo Bettera (1639-87)
Still Life with Two Lutes,
a Virginal and Books on a Table Covered by a Carpet
Oil on canvas, 70 x 82.5 cm (27½ x 32½ in)
The Israel Museum, Jerusalem

.
.
.
.
.
.

A number of musical instruments have been left in disarray on a table. The image is an austere one, its simplicity appearing to make no demands of the viewer, and unless we feel a particular interest in early music, we may perhaps be content to glance swiftly at these objects, none of which is in itself surprising, and then continue on our way. As is often the case with still lifes, the title is descriptive and precise, almost disappointing in its dryness. It does not explain the painting, nor does it invest it with any poetic meaning or suggest any sense of historic greatness. It simply states a fact. It gives the impression that everything is included in this list, like a set of ingredients for an unknown recipe with which one has no idea what to do.

Our interest in the painting grows only when we forget its title and take an interest in the things that it does not mention such as the brightness of the white light on the backs of the lutes, the deep red of the carpet and the large pink ribbon used by the musician to support the instrument when he played it.
This kind of reality is of a wholly different kind as it depends entirely on the goodwill of the artist. In order to paint a satisfactory representation of a lute, he had to give it this form and these proportions, but nothing forces him to arrange it as he has done here, so that the light brushes across the wood. This is also true of the way the ribbon falls and of the dog-eared piece of paper projecting from the

pages of the book to the rear of the painting. Still lifes with musical instruments were a local tradition in Bergamo, where they were turned out by the dozen. Although it is sometimes difficult to identify the artist, every painting has a unique atmosphere that stems from the choice of details that it includes.

The willingness to submit to nature is fundamental to any work where we expect a portrait-like degree of resemblance, and yet it has its limitations. While the objects in the painting bear some physical relation to the real world, the relations that are established between them assume a meaning that is unique to the painting in question: there is little chance that the artist will have composed this image simply because 'that is how things are'. He has clearly given them specific roles to play.

Here we are, then, in a space that bears no relation to ordinary life. The empty blackness of the background removes the image from any context and isolates the instruments from the real world by placing them together on this table, which acts as a kind of stage. The oriental rug that covers the table is enough to provide the décor. It evokes no specific place, merely the luxury of an elegant dwelling, suggesting warmth and the thickness of the wool beneath the hand. Each object is like an actor. In the guise of its voice and text, it has a shape and colour, it occupies a certain position and is made up of a particular material. In this painting, the artist adds to his arsenal by showing musical instruments, each of which suggests a particular sound.

The image conveys a whole range of sensations. The curvature of the lutes engages in a dialogue with the straight lines of the virginal, the gentle curves of the former complementing the acute angles of the latter. The colours clash or complement one another. What we see here are gentle and subtle pinks, deep and warm reds. The ribs are made from alternate strips of wood, their colours more highly contrasting in the lute at the rear of the painting. In each case they echo the keyboard of the virginal, the neat black of the keys expands to encompass the large-scale motifs on the carpet. The violin is more discreet and slightly set back, suggesting a more discerning character as delicate as its scrolls and ever ready to be eclipsed.

The large lute in front of us assumes the leading role. Scarcely less important is the virginal on which the overall composition is based. Without it, it seems that the image would have no foundation. Certainly the virginal and lute dominate the painting, and it is around this couple that the plot revolves: their encounter produces the concert. The score is not far away, placed, as it is, on the large black box that also supports the smaller of the two lutes. A thick volume – perhaps a Bible – prevents it from sliding off or blowing away. Between its pages a scrap of paper has been placed, acting as a bookmark: either the reader broke off at this point or wanted to mark a chosen passage.

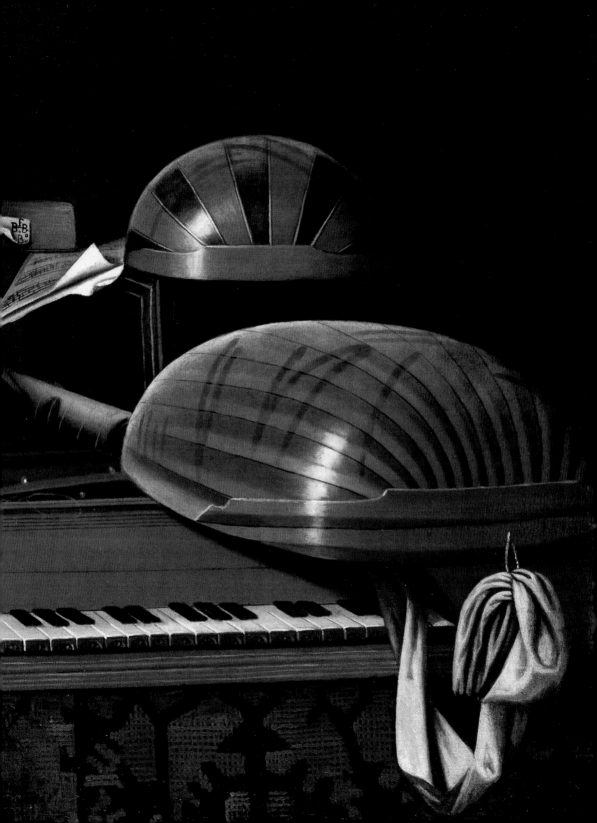

Only the position of the book and the score at the centre of the image indicate their importance: even when placed at the back, partially obscured by the shadows, they dominate the others by virtue of the information that they contain. It is up to them to establish a sense of harmony and to teach us the principles of art.

The pile of objects is gradually transformed into a group of characters who in turn allow us a glimpse of other figures, this time of flesh and bone. Musicians have been here, at least one of whom was probably a woman, playing the virginal. They have abandoned their instruments. Has the concert just taken place? Or did they leave sooner? Was it some minor drama or merely indifference that took them away? Their nonchalance, perhaps even their haste, may be guessed from the precarious positions of these valuable instruments. They were planning to return and felt it unnecessary to worry about them any further. But then they failed to reappear. Time has passed, and dust has started to settle.

Thanks to his expert technique, the artist has tricked us so effectively that in the museum or gallery we might almost be misled into thinking that the painting has not been properly dusted. But this is simply an illusion, a trompe l'œil effect. The lesson is clear and familiar from countless still lifes from the seventeenth century: to trust in appearances, which are always deceptive, is as futile as it is blameworthy. If the observer is so lacking in judgment as to be taken in by such tricks, then the snares of the world will surely drag us down into unfathomable abysses. It is time to devote ourselves to the celestial truths.

The melody has fallen silent. The painting speaks only of absence and of truths that we can only ever grasp very fleetingly.

We are not alone in indulging in this daydream. Someone else passed this way only recently, brushing their fingertips over the arched backs of the lutes and leaving a trace in the dust. No doubt that person is still close at hand. Perhaps one of the musicians, or simply a passer-by like ourselves, absent-mindedly drawing these lines in the dust.

The musical instruments

Bartolomeo Bettera was a pupil of one of the masters of the still life, Evaristo Baschenis (1617-77), and like Baschenis he worked near the instrument makers of Cremona. Their paintings take as their starting point the aesthetic beauty of the instruments and their different uses in order to suggest miniature scenes in the theatre. The lute is depicted with particular frequency because its music, often melancholic and grave, was felt to be dangerously seductive. The virginal was a kind of harpsichord and was essentially a woman's instrument, light and easy to transport. The violin was to prove immensely successful, but in the seventeenth century it had only recently gained its patent of nobility, having for a long time enjoyed a poor reputation as a popular, folk-like instrument.

The trompe l'œil

Trompe l'œil paintings are found in classical antiquity, notably in the decorative arts. In Book Thirty-Five of his *Natural History*, Pliny the Elder (AD 23-79) tells how Zeuxis painted a still life depicting a bunch of grapes that were so realistic that birds flew down to peck at them. But Zeuxis had to admit defeat at the hands of his rival, Parrhasius, who had invited him to draw back the curtain concealing a picture of his own, while failing to notice that the curtain was itself painted. Since then, the trompe l'œil was regarded as evidence of an artist's technical skill, but it also provided the basis of a moral reflection on credulity and its consequences. From this point of view, it plays an important role in the repertory of images found in seventeenth-century still lifes.

Oriental carpets

Oriental carpets are represented in western art from the fourteenth century, initially in religious subjects, then in portraits and still lifes. Imported from the Orient through Genoa and Venice, they were predominantly bright red in colour and for the most part originated in Pergamon in eastern Turkey. They were felt to be too valuable to be placed on the floor and so they were used as table covers. While attesting to a flourishing trade with Turkey, they also added an abstract dimension to the image by virtue of their repeating geometric designs.

Dust

Perhaps even more than the musical instruments, dust is the fundamental element in this image, so great is its power of evocation. Its symbolism is bound up with the fate of mankind and derives from the Book of Genesis: 'And the Lord God formed man of the dust of the ground' (2:7). After man has been guilty of original sin, God curses the serpent that tempted Eve: 'Upon thy belly shalt thou go, and dust shalt thou eat all the days of thy life' (3:14). God then turns to Adam before sending him forth from the garden of Eden: 'In the sweat of thy face shalt thou eat bread, till thou return unto the ground; for out of it wast thou taken: for dust thou art, and unto dust shalt thou return' (3:19).

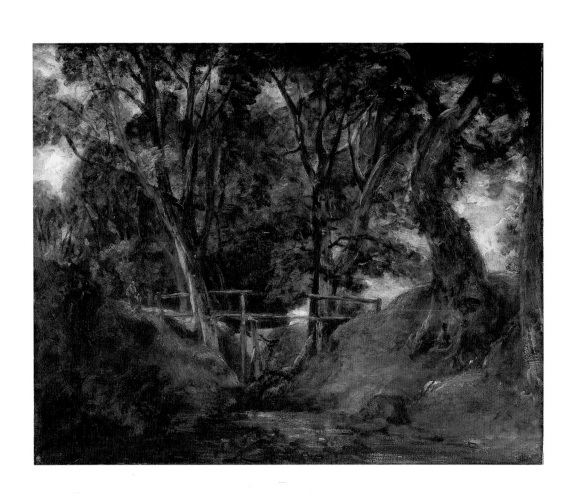

Feeling a
sense of déjà-vu

John Constable (1776–1837)
Helmingham Dell, c. 1823
Oil on canvas, 103 x 129 cm (40½ x 50¾ in)
Musée du Louvre, Paris

The walk holds no surprises. We have passed this way so often that all the details of the place are familiar and we no longer pay them much attention. It is scarcely a landscape at all. But we do not think in these terms. We need to stop, to look around us and take a step back in order to realize that this corner of the countryside is indeed worth painting. The moment is perfect in its simplicity. Nothing disturbs the natural order of things. If something were to happen, it would be too far away for us to hear about it. For the moment, the only problem that we can envisage is that rail on the little bridge. Perhaps it should be repaired before someone falls over the side, even though it has been like this for some considerable time. The children who live hereabouts have got used to it. Nothing untoward has happened here. It is rare that anything happens here at all.

Constable's painting is grounded in the absence of any event. If it unsettles today's viewer, perhaps it is because it allows us to discover that we can enter the world of the image even though we do not need to. There is nothing here to analyse or to understand. The image conceals no sense of threat, not even the slightest enigma. Nor should we expect a sudden revelation. The visitor has only to explore the world of nature by trusting the artist who takes them here, to this part of the world that he knows so well.

The visitor feels at ease here. The stream does not look very deep, and the only danger would be of getting our boots wet. The colours of the leaves are well matched, and the vast tree trunks have seen many a generation of visitors pass this way.

The artist remains a discreet host, underlining various aspects of the scene without ever lapsing into vapidity. His practised eye makes out the contours of a woman wearing a skirt, he notes the thin branches floating in the water and observes that these ancient trees did not suffer unduly during the recent storm.

There is nothing more to be seen. It is a great luxury that the artist permits himself, describing a relatively banal place with no anecdotal accessory to turn it into something picturesque. It is simply the place where our daily lives unfold. Constable takes us off the beaten track to a place where he himself likes walking. What makes it so special is that it breathes the spirit of a new tranquillity that deliberately ignores the rest of the world and all its turmoil. One might assume that the subjectivity of such a choice reflects the artist's aims and that Constable will present us with a narrative or risk some confidence. But what he shows us is what any other observer could have seen, a point that each of us can verify. He sticks as closely as possible to outward reality and does not transform it in any way. Therein lies his boldness.

For Constable, the landscape's ability to affect our emotions counts for more than the quest for an unusual point of view. He treats the subject in a manner so direct that he seems to be on the most intimate terms with nature. He works in the area around him, with no wish to prove or demonstrate anything other than the fact that he has been brought here because of the way in which all that he sees around him has been passed down peacefully from one generation to the next. It is possible that he also feels a slight sense of pride, but his principal sentiment is the very particular feeling of being safe that we all feel whenever we discover a place that we have known from our earliest childhood. The feeling of balance and comfort is so powerful that it is communicated to the observer from the outset, so much so that we may even feel a slight sense of boredom. Even when we see it for the first time, it may seem over-familiar.

The feeling of déjà vu is one of the main features of Constable's paintings. As such, his work is at odds with a whole tradition of images, sacred or profane, that had been used for centuries to unsettle the viewer, transporting us to other spiritual worlds, telling stories that are miraculous or terrifying, or depicting the changing aspects of power. Constable's paintings are not didactic. On the contrary, they record the neutrality of the everyday and bring an unprecedented value to the natural habitat of a life that is lacking in history.

We can all recognize ourselves in these landscapes. The exact details of the place are unimportant. The smell of the moist earth and the crackling of the dry wood beneath our feet are everywhere the same. We have a vague sense that we do not need to worry about the nearest village or the road that we shall have to find if we are to return home before nightfall. Sufficiently overgrown to be charming and sufficiently civilized to offset the fear of meeting something untoward, the painting agrees to carry us along without asking any more questions. Before Constable, these little things that everyone feels a connection to and these pathways that are lacking in mystery had found no place in painting.

Constable brings a whole new repertory into play, the repertory of the insignificant. The refreshing novelty of his painting at the beginning of the nineteenth century is no doubt more difficult to appreciate today, when whole generations of artists, including the Impressionists, have so closely followed his lead, to say nothing of postcards and holiday snapshots. It seems that at some point in our lives we have all spent a weekend in Constable country and that he has been our guide on the banks of these very same streams. His countryside has become a part of our memories and we have assimilated it to such an extent that we tend to ignore the role that has been played by aesthetic choice.

The artist's intimacy with nature also brings with it a physical closeness to things, a closeness that can be seen in the way the image has been framed, narrowing the focus of interest: when compared with the vast historic compositions of the past, this painting favours detail. In the past a mere handful of trees and a stream would not have been sufficient to establish the subject matter of a landscape, whereas here they constitute its essential motif. The image is content to explore a modest territory that reflects the realities of our walk. It is no longer a question of the painting covering as vast a space as possible. There is no point in looking so far. We shall never go there. No longer concerned about his or her itinerary, the viewer gradually understands that nothing obliges us to admire it. We even find that we are free to think of other things.

The landscape has been relieved of its ambitions and utopian visions. It has become habitable by placing us in the exact context that is ours, a context of which we have the full measure and that suits us to perfection.

Constable's Suffolk

Constable was born in the Suffolk village of East Bergholt and spent his entire life painting the villages and landscapes where he grew up. In 1821 he wrote to one of his friends, John Fisher: 'Still I should paint my own places best; painting is with me but another word for feeling, and I associated "my careless boyhood" with all that lies on the banks of the Stour; those scenes made me a painter, and I am grateful.' Constable's brother was employed as a steward by the Tollemache family, who owned the local estates. It was during a visit to the Helmingham Rectory that Constable painted several versions of this landscape, which depicts a dell or combe at Helmingham. The large oak with the curved trunk that can be seen on the right of the picture still stands in Helmingham Park, which is open to the public.

The canvas in the Louvre takes up a motif that Constable was to use in two other paintings, one of which dates from 1826 and is now in the John G. Johnson Collection in Philadelphia, while the other was painted in 1830 and is in the William Rockhill Nelson Gallery of Art in Kansas City. Here the little bridge has been repaired.

A new type of painting

Constable's landscapes ignore all sense of narrative pretext and in this way reflect an important stage in the development of a subject whose roots can be traced back to the seventeenth century, most notably to the work of Claude and Rubens, but also to such Dutch masters as Ruysdael and Rembrandt. Abandoning the field of religious and literary iconography, Constable follows the route opened up a century earlier by Gainsborough, who, a native of Suffolk like Constable, had given the landscape an importance previously unknown in England. Gainsborough's landscapes were, in Constable's words, 'soothing, tender and affecting'. Both artists sought in their work to capture the truth of emotional states. But Constable added a further quality to this intimate style by taking account of the objective phenomena of nature, developing a passionate interest in geology and studying the sky and clouds and the properties of the spectrum of colours that make up the rainbow. In this way early nineteenth-century landscape painting established a synthesis between general principles and an awareness of the particular, between the 'scientific' observation of nature and an uncompromising subjectivity.

The meditations of a landscape painter

Between 1833 and 1836 Constable gave a series of lectures in London and Worcester in which he expressed his views on painting in general and on landscape painting in particular. He noted, for example, that 'Painting is a science and should be pursued as an inquiry into the laws of nature. Why, then, may not a landscape be considered as a branch of natural philosophy, of which pictures are but experiments?' In 1836 we find him devoting a lengthy disquisition to the fate of an oak tree that he had drawn at an earlier date and that he personifies as a 'young lady': 'It is scarcely too much to say that she died of a broken heart. [...] I saw, to my grief, that a wretched board had been nailed to her side, on which was written in large letters: "All vagrants and beggars will be dealt with according to law." The tree seemed to have felt the disgrace, for even then some of the top branches had withered.'

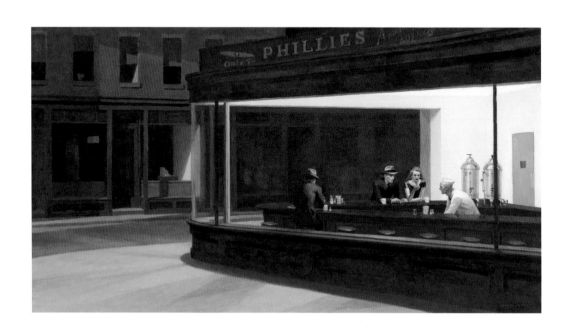

Believing you are at the cinema

Edward Hopper (1882–1967)
Nighthawks, 1942
Oil on canvas, 84.1 x 152.4 cm (33 x 60 in)
The Art Institute, Friends of American Art Collection 1942-51, Chicago

.

.

.

.

.

.

.

What time is it? This is not really a question, merely something we say out of habit, a sort of involuntary reflex. One thing is certain: it is late. Too late for a lot of things. The streets are deserted. The night seems unending. The neon light from the bar hurts our eyes. Soon, we shall have turned the corner of the street, and after that there will be nothing. Only emptiness again. We could go in. Sit down for a moment, have a coffee. It must be cool inside the bar: in the apartment block opposite, all the windows are open. It is one of those nights when staying up seems like the only option.

The front of the bar extends beyond the edge of the painting. Steps ring out on the pavement with unnatural loudness. This town is so clean that it looks like a film set – a street in a ghost town like one built in a Hollywood studio.

And yet it is real, this Greenwich Avenue in New York. And 'Phillies', too, is real. Hopper would often call in here as he lived close by. He has painted only the principal structure, a shell of reality, but has added just enough realistic detail to make us believe in the image. We do harbour doubts and wonder vaguely if the painting really depicts this quarter of Manhattan or, rather, some pasteboard reconstruction. The painter only borrows a handful of objects from everyday life and only if they are associated with the figures. They could be props that the actors need to flesh out their parts: a cash

register in the shop opposite, the bar stools, some cups and glasses, and a cigarette. Nothing very complicated. Points of reference to establish the characters' roles and justify the setting.

As we walk past, we may well imagine ourselves in a film, a black and white film to which colour has been added. The dialogue is brief – just a few words exchanged without looking up. The man opposite us, resting his elbow on the bar, will sound like Humphrey Bogart. Beneath the heavy shadow of his hat, his eyes stare fixedly at something in front of him. The woman with the thick eye makeup is examining her nails. To what extent do they know each other? Perhaps they have only just met. Or perhaps not. The merest possibility of contact hovers between them. There is no need to speak. In any case, what would they say? The bartender throws in a word while looking for something beneath the counter. He has already seen all this and much else besides.

Everything about Hopper's painting is smooth and sleek, as if his paintbrush moves without ever encountering an obstacle. Everything is well ordered, including the silence and the sharp colours. The surface seems to be untextured and indifferent. Nothing is felt to change. The absence of anything random causes the viewer's gaze to wander, and we allow our eyes to run over the areas of colour. Hopper's characters take no interest in us or in the world outside, a point well illustrated by the man sitting at the bar with his back to us. Self-absorbed, he is happy to occupy a stool at the longer side of the bar, at a respectful distance from the other drinkers.

'Phillies' stays open all night, the glare from its windows lighting up the building opposite, attempting to invade the shop interior, projecting a triangle of light on the wall beyond one of the windows. And yet it remains aloof from all that it touches. In most early paintings, the moving light of nature or the brightness of lamps accompany our train of thought and suggest the passage of time, inviting us to look more closely and representing a challenge to the artist, who has to capture the glare and its nuances. Hopper, by contrast, succeeds in capturing the functional coldness of electric lighting, a coldness that reflects the elemental lines of the architecture. It is a type of lighting that is devoid of mental states, crushing in its constancy and perfectly controlled – a dentist's light that makes the complexion look pale.

The bar's interior décor plunges the street into a bath of green, contaminating the whole painting: the pavement, the shop and its empty windows and even the blinds that the inhabitants of the apartment block have left open because of the heat. The way in which the image has been framed and cropped prevents us from seeing higher than the first-floor windows and serves to

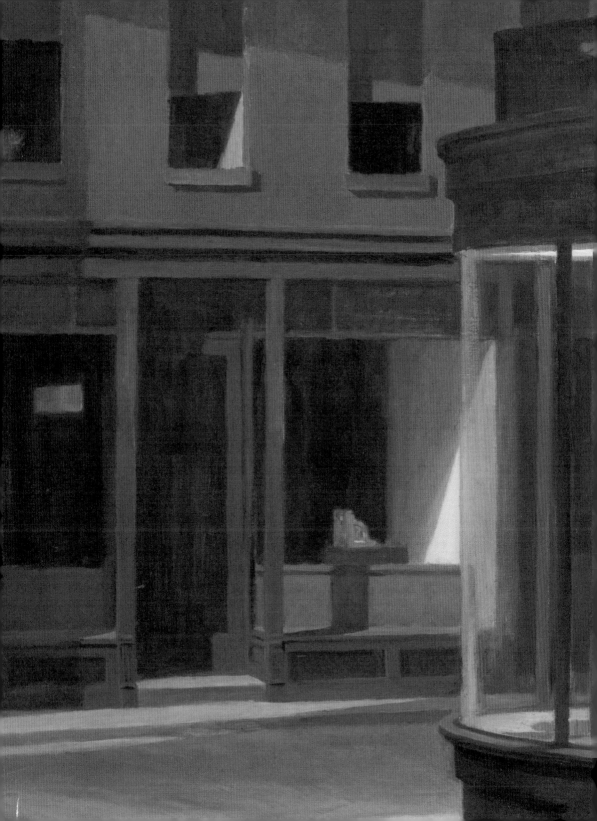

make the atmosphere seem even heavier. The sky is too far away, completely invisible. The wan image allows nothing to filter through, not even a breath of air.

We may have the illusion that if we remain in front of this painting – this building – for long enough, something will happen: a furtive apparition at one of the windows, the arrival of another passer-by, or movement inside the bar.

But no. The painting remains desperately flat, robbed of the least irregularity. Everything seems so simple, the roles all cast to perfection. And yet we shall never venture outside this world of appearances. Hopper's painting functions with the efficacy of a trap, creating a sense of expectation in the viewer, inviting us to imagine that because this void exists, something will come and fill it. He provides a scene and characters, but never a plot. It is as if he has arranged a meeting knowing he will not turn up for it. And it is in this that the value of the painting lies: as soon as we begin to think that the image is deceptive and duller than it seems, we understand exactly what it is that constitutes Hopper's art. His true subject, above and beyond anything purely descriptive, is the sense of disillusionment that seizes hold of the observer. We too enter into the silence that overwhelms the other people in this bar, in this harsh light that offers the only alternative to the darkness of the street. It endorses the isolation of the man walking the streets at night. There is nothing to be discovered at 'Phillies'. Or, if there is, it is at best another kind of emptiness.

What if we were to try to enter? But we must already have passed through the entrance, which is nowhere to be seen. In this slow-motion image, Hopper has succeeded in drawing us in too far. The painting has taken advantage of the tiredness we typically feel at night. We need to retrace our steps and find the door. Where can it be? It is not worth the effort. It is already too late. Perhaps another time.

A short story by Hemingway

●

It is said that Hopper's painting was inspired by a short story by Ernest Hemingway, *The Killers*, which was first published in 1927. It deals with two hired gunmen who have come to wait for their victim in a restaurant. But the man does not show up on this particular evening. The overall mood of the story is more important than the plot, establishing a climate of fatality and indifference within barely a dozen pages 'The door of Henry's lunch-room opened and two men came in. They sat down at the counter. [...] "I can't stand to think about him waiting in the room and knowing he's going to get it. It's too damned awful." "Well," said George, "you'd better not think about it."'

The outlines of all the male figures in the portrait are based on those of Hopper himself, even though it is impossible to speak of a self-portrait. Hopper's wife, Josephine Nivison, posed for the woman, as she did for many of his other canvases.

Hopper and the cinema

●

Hopper was a great fan of the cinema. 'When I don't feel in the mood for painting,' he once explained, 'I go to the movies for a week or more.' In many ways, Hopper's aesthetic reflects the world of Hollywood: the framing devices, the stark contrasts in the lighting, the perspectives suggesting a moving camera, the celluloid smoothness of the image and the geometric use of space. Even so, there is no evidence that any of Hopper's paintings refer directly to a specific film, whereas his own images often influenced the cinema, which found in them a kind of linear décor that could easily be exploited and a sense of emptiness useful for creating a feeling of dramatic tension. The most famous example is Hitchcock's *Psycho* of 1960, with its reconstruction of Hopper's *House by the Railroad* of 1925. More recently echoes of Hopper have been found in the work of David Lynch (*Blue Velvet*, *Twin Peaks* and *The Straight Story*) and Wim Wenders, who refers to *Nighthawks* in his film *The End of Violence*.

Hopper's realism

●

The directness of Hopper's approach to realism is part of a wider trend in the history of ideas that can be traced back to the very origins of American art. Painting in the United States sprang from the seventeenth-century Protestant tradition in the Netherlands and two centuries later still shared its love of the everyday and its desire to present a true and convincing portrait of society, hence its fondness for detail. A pragmatic vision, anxious to deal honestly with the visible world, took precedence over all speculative considerations in an art that was essentially secular. As a result, painting stuck as closely as possible to the truth as it was experienced, with no sense of drama or overt emotion. Taken to its extreme, such an attitude must necessarily culminate in trompe l'œil effects, which were indeed one of the options explored by American artists in the nineteenth century. By avoiding illusionism, Hopper practised a kind of realism at one remove, which meant that he was more than a simple illustrator. He describes without deceiving the observer and takes an inventory without playing with us: with him, reality is both omnipresent and inaccessible.

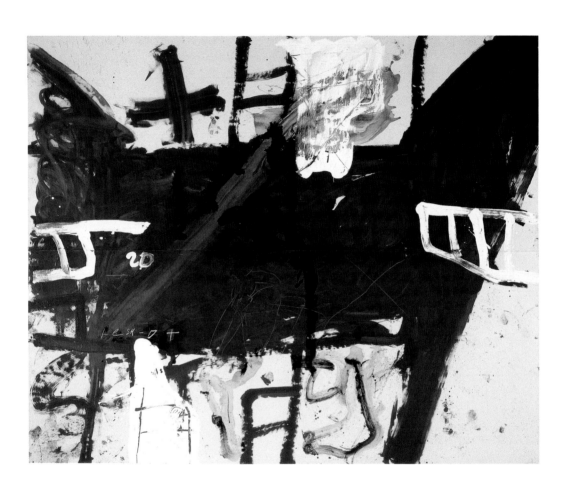

Recognizing the substance of the world

Antoni Tàpies (born 1923)
Seven Chairs, 1984
Mixed media, 307 x 376 cm (121 x 148 in)
La Colección de Arte de Telefónica, Madrid

.

.

.

.

.

Caused by soil or perhaps by dried mud, the brown stains stand out against a light ochre background, rudimentary shapes around the perimeter of a vast surface daubed with paint. A few thick lines have been traced in the calcified matter. What strikes us initially is that the painting does not resemble anything that we would normally consider: we can identify nothing that might constitute an image, at least one based on traditional criteria. Understandably disconcerted, we try to work out how this vast aggregate of raw material might constitute a work of art. What is the use of such an image if, in the absence of any identifiable meaning, we cannot even appreciate the practical skill that has gone into producing it?

It is generally accepted that an artist can make even the least attractive aspects of nature appear seductive. It is neither the dirt nor the loose threads on a pauper's rags that we enjoy in a classical painting but the credible way in which they have been depicted and the virtuosity of an art that makes the actual subject unimportant. Once they are reproduced, the dust and filth that are a matter of either indifference or annoyance in everyday life change their underlying nature – they become art. The problem is that Tàpies removes the comfortable distance that images generally establish. The balance that exists between an unpleasant reality and its aesthetic treatment is upset. It is as if a piece of matter – a fragment of a wall or a piece of land – has been extracted

from the world and barely modified. It is all an illusion, and Tàpies's work is not as different from tradition as we might initially think: for him, it is still a question of concealing his means. In the past, artists played down the physical reality of the painting and concentrated on the illusory objects that it represented. Here reality seems almost untouched, having evidently benefited from the artist's attention for only a short space of time: he has added a little – or a lot of – colour before passing to something else. The painting seems abandoned, and as viewers, we are close to thinking that we are in the same situation and that we too have been abandoned. Here we are, powerless and robbed of our role in the presence of an object so close to elemental reality that we are willing to concede its status as an image only with some reluctance.

The painting seems to retain almost nothing of all that lies around us. There seems little point in lingering in front of it. And yet – and this is the essential point – the painter himself lingered in front of it. He concentrated his energies, his intelligence and his entire education on creating this irregular surface and forming this uncertain space in which different shades of brown overlap with streaks of white liquid. The geometry of this large painting implies a stylistic assurance in stark contrast with the indeterminate nature of the areas of colour. An undeniable physical power bursts from the middle of the glutinous mass. We become aware of the fact that what we initially assumed to be the work of chance is articulated with clear intent. The brutal shapes that seem to stagger through the thick layer of paint finally reveal their importance: the wall had to be subdued, a tool – it matters little whether it was a piece of wood or the handle of a brush – had to be driven into the surface to produce these outlines, outlines whose finality is less critical than their presence.

Chairs. Ready and waiting. Upright, upside down, and seen both from the front and from the side. Rickety, but there. Wherever we may have come from, a moment's rest is still possible. We may break our journey. Seven chairs like seven days. The days of the world's Creation and the additional day of rest.

The painting tells us that an encounter with reality is inevitable and that the nature of this reality is beyond our comprehension or, at best, something that still has to be explored. This is a plain fact, heavy with implications, but as self-evident as the earth on which we stand and as incontrovertible as the walls that shelter us and shut us in, and as welcoming as an empty chair.

Tàpies' work is a product of the aftermath of the Second World War. He opened up to painting a world of great immediacy, a new field to be tilled: the soil of Catalonia, which crumbles and settles in all his paintings as if we were walking over it. He waters it with his paint. He writes disconnected numbers

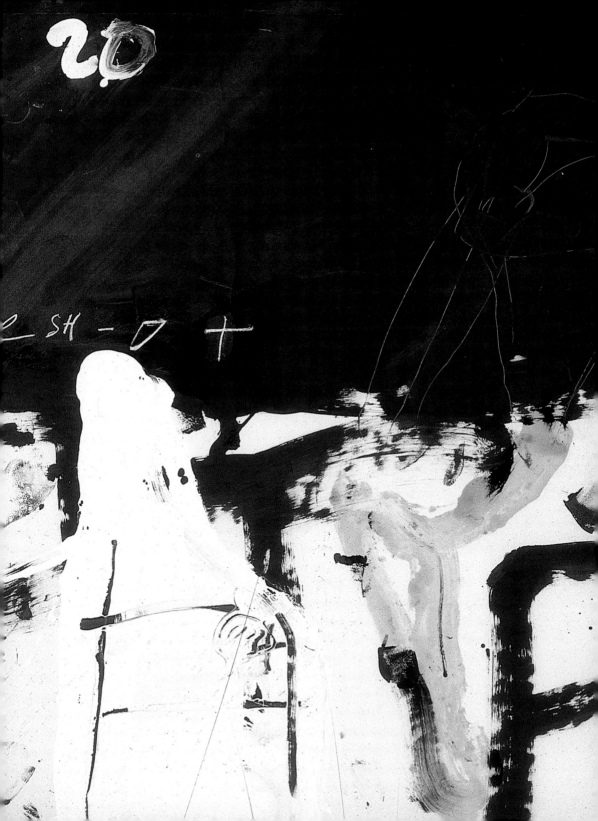

on it, the last remaining vestiges of mathematical calculations whose original data have been lost or whose laws have yet to be discovered. At the top of the painting, a large brown cross stands at an angle on a bed of sand. The Christian symbol of victory over death plays a multiplicity of roles in the work of a painter who keeps adding to its meanings: a sacred sign, but first and foremost the letter T for Tàpies, also for the name of his wife, Teresa. The cross combines the universal with the specific. It signs the painting as if it were a document, the solemn mark of a person who has not mastered the art of writing. The signature of an illiterate individual, a sovereign symbol of human dignity and assent, the authorization of our existence and our faith. Here the truth of the couple takes the form of a unique and solitary sign. Tàpies affixes a cross, rather than drawing or painting one and in this way he situates the image beyond the confines of history.

Tàpies turns us into explorers. We are the first to see these crude marks as if we were sweeping our hand across the mould that prevents us from reading some ancient inscription. A stele, a plan, a lost project, the sketches for a building. A room where we can sit and talk. The floor was beaten earth, the chairs neatly set along the four walls. The painting has something monumental about it. It tells a story whose characters have vanished.

The artists of the prehistoric period worked with no more materials than these. They prepared burnt ochre, combined black and white, applied the pigments with their hands, and traced the outlines of vast herds of animals. Between them, in the shadow of their caves, a decision was taken: to conjure up the shapes of what they feared or what they desired, to invent a space that would give their world what was missing, a link between the limitless world outside and sensations that did not yet have a name – to create images.

Tàpies' work stirs our memories of this original quality of painting, when we could conceive of nothing but its nutritive function as our link with a world without knowledge.

It would be enough for the cross to tilt a little further and it would be completely transformed, becoming a plus sign and signalling multiplication. The day will come, in an hour from now or perhaps in the course of the coming centuries, when the world will juggle with figures that are still invisible and perform endless calculations. We shall then work out the meaning of infinity. The four arms of the cross open up the world in every direction. We are ready to start. It is the dawn of time.

Here we are on the day after. What should we do about all these scraps if not lament the dead? Those who spoke, seated, elsewhere. What shall we do with this clay apart from build with it? We could allow ourselves to sink into the mud. Or dry a little of it and build walls, houses and towns. And then build new lives.

The wall

●

It turns out that in Catalan tàpies means 'wall'. 'It is a curious destiny that is inscribed in my name,' wrote Tàpies in his memoirs, first published in 1981. 'The image of the wall can contain countless suggestions. Separation, claustrophobia; wailing walls, prison walls; witnesses to the passage of time; surfaces that are clean, smooth, calm, airy, or tormented, ageing and decrepit.' By assuming the appearance of part of a wall, the painting also claims the wall's power of evocation. If it can initially seem devoid of meaning and indifferent to every human dimension, it quickly asserts its identity as a space immersed in the real world and as a repository of history. The artist produces a petrified version of the violence and emotions of the past. As a clean slate waiting for inscriptions that are not unlike graffiti, both the canvas and the wall recall the subversive calling of art: writing, anonymous and rebellious, shatters fossilized ideologies just as it breaks down the rules of syntax, declaring that in every work there is an inherent resistance to oppression in all its conceivable forms.

The theme of the chair

●

Tàpies often depicts chairs in his work. They may be interpreted as everyday objects while at the same time linked to pensive reflection. The theme appears at its most striking in *Cloud and Chair*, the sculpture that adorns the façade of the Fondacion Antoni Tàpies in Barcelona. Made of aluminium tubes and stainless steel, it dates from 1990 and creates an eloquent transition between the reality of the building and the infinity of space: the silhouette of a chair placed on the intricate handwriting of the cloud stands out against the sky.

The poverty of materials

●

By evoking an untreated wall, the physical aspect of the painting allows us to connect the activity of the artist with that of the first humans producing images on the walls of their caves. As far as we know, the cave paintings of prehistory were not ornamental in character but probably played a role in religious ceremonies or magic practices, in which regard they were a vital part of the life of the community. The artist measures his commitment against the yardstick of this quintessential demand, unsullied by any sense of compromise. His painting may then be seen as a space encapsulating the primordial relationship between mankind and the world around us, a space in which everything can be said by means of ochre, earth and dust. This desire to strip away all the non-essentials is additionally justified by Tàpies' interest in Far Eastern philosophy and, in particular, Zen. The way in which the painting explores the void thus encourages meditation.

Contemplating the sublime

Certain works have the power to root us to the spot. We are compelled to stop without knowing why. It is not always in front of a painting that seems attractive at first sight. At this point our aesthetic opinion is of no importance. From the outset we feel quite simply that the work is stronger than we are. It commands our respect and sometimes induces an emotion so powerful as to be disconcerting.

When the painting in question is famous, then our approach is complicated by the prestige which for historical reasons is associated with it. Its notoriety both attracts us and at the same time clouds our vision to the extent that in the end we are no longer certain if we are responding to the work itself or to its reputation. It becomes difficult to distinguish between what we can see and what we expected to see.

The feeling that we are approaching an absolute survives these questions because it creates certainties and draws its strength from the notion of durability. The painting that is capable of suggesting this sense of the absolute becomes imprinted on our memory. It takes its place among all the other paintings that we should like to see again, as if to assure ourselves of their truth, even though we have a vague fear that we shall be disappointed: perhaps what we saw was a passing illusion, the result of a whim or of circumstances beyond our control.

But the works themselves resist this impulse. They convey more ideas and sensations than we can ever conceive of, and we suspect that we shall never fully understand them. It is not that they confront us with a confused image or with ostentatious complexity. Quite the opposite, in fact. Their clarity places them beyond our ordinary visual experience. They attest to a wondrous harmony or, rather, to that rare coherence that life offers only occasionally in moments of dazzling insight.

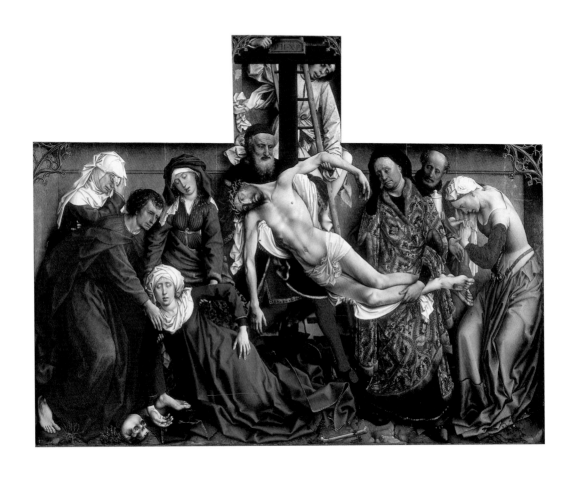

Taking part in an important event

Rogier Van der Weyden (c. 1400-64)
The Descent from the Cross, c. 1435
Oil on wood, 220 x 262 cm (86½ x 103 in)
Museo Nacional del Prado, Madrid

·
·
·
·
·
·
·
·

A majestic ballet unfolds before the dumbstruck viewer. The work demands our respect. It is as much a living picture, a theatrical event, as a painting. The presence of the figures is too intense for us to draw any closer. Indeed, it would never occur to us to do so: there is an invisible line that stands in our way.

Christ's body is being taken down from the Cross. The Virgin Mary collapses close to Saint John, who rushes over to support her. Further away, Mary Magdalene is wringing her hands. There are other people here, too, helping, looking on or incapable of seeing through their tears. The artist has given these eloquent bodies a weight similar to that of the sculptures that filled the churches of this period. In the abstract niche where he has placed them, the air circulates between the different protagonists as though they are carved from wood. Their heavy robes fall in folds that break and fall open on the ground. The solidity of the volumes permits a profusion of details whose luxury can only be guessed at: the transparency of a veil or the exquisite elegance of the embroidery. Nothing can make these figures stagger – neither the piling up of the fabrics nor the knowing disarray of the draperies. Against the gilt surface that obstructs our view of the panel, a number of key colours produce a sense of rhythm that is altogether irresistible. The figures' suffering takes root.

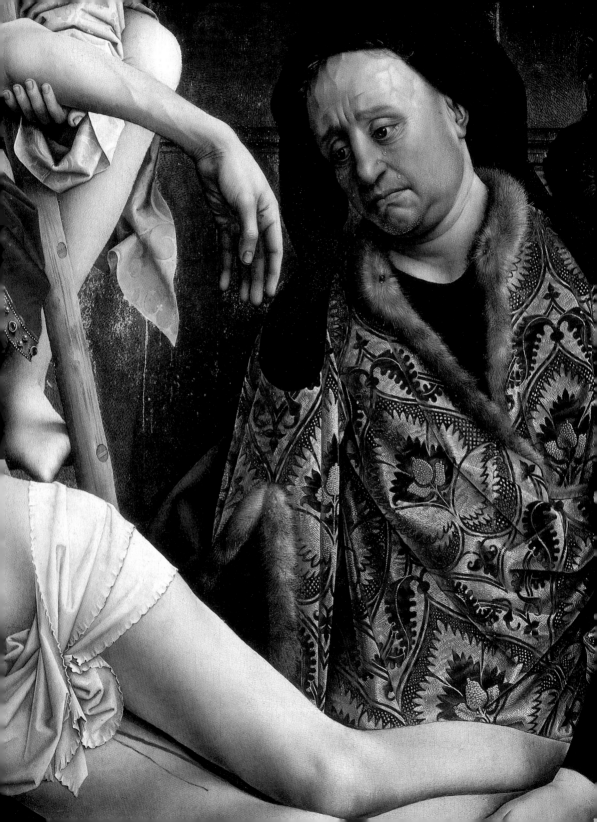

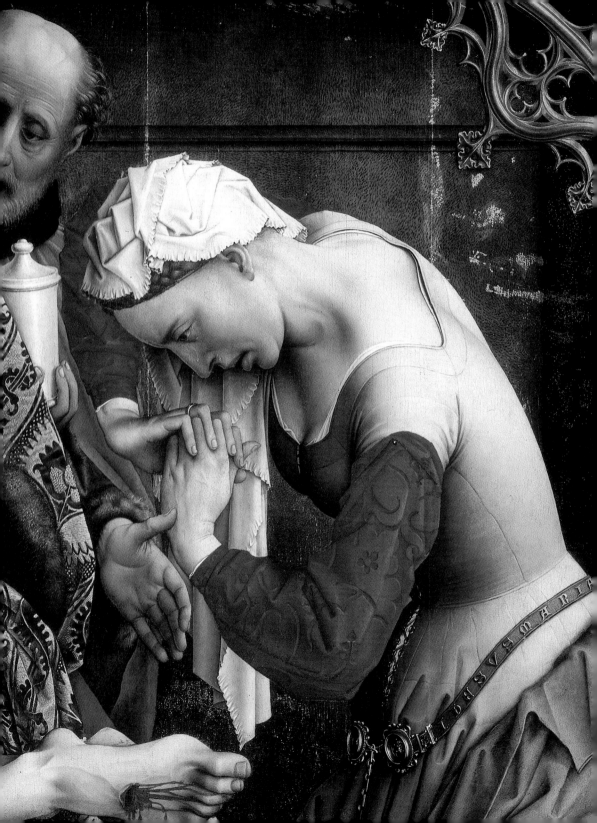

The absence of movement conveys the horror of all that these people are feeling. Their positions are absurd, untenable. We imagine that so much accumulated anguish must produce a veritable explosion, as if too much energy were contained within a confined space. But nothing happens. Everything is turned to stone. History unfolds but does not advance. The body of Christ remains suspended between the Cross and the ground where He is to be laid out. The Virgin Mary faints, but she does not fall to the ground. Saint John cannot raise her up again. The convulsed body of Mary Magdalene is frozen in time. There is no remission.

Although sculpture is surely an influence on these figures, their motionlessness goes beyond a mere quotation and absorbs it. It is their misfortune that turns them to stone.

The artist takes verisimilitude to its furthest extreme. But at the same time he subjects these figures to an abstract construction that turns them into symbols of the Passion. The silhouette of the Virgin creates an arabesque similar to that of her son: the curve of her breast, the angle of her left arm and the way in which she extends it all reproduce the position of Christ's body. The death of her son affects her to such an extent that her own body is reconfigured. She is so pale that she looks to be grey, her son's sufferings having drained her of blood. Christ's flesh may perhaps still have a little of its warmth: in her heavenly mantle, which looks as if it has never been so blue, Mary is already ice-cold.

The figure of the Virgin is a true echo of Christ's body, prolonging and amplifying it. At the foot of the painting, the artist has made her the chosen receptacle of all suffering. The impact of the painting depends very much on this emotional wave that overwhelms all the figures, establishing a contrast between its own dynamic power and their terrible inertia. Like ripples in a pond, growing in size and moving away from their point of origin, the lines of composition suggest that this will reverberate beyond the confines of the painting.

Believers who came to pray before this altarpiece in the early fifteenth century were able to engage with it in this way. Times were changing. The Middles Ages were drawing to a close, and painting was no longer at pains merely to teach contemporaries what they should know about church history. It also expressed the emotions of people who resembled them, people who, like them, were made of flesh and blood and prey to human frailty.

The believer does not need to move any closer, for the sadness that overflows from the painting envelops us too. We recognize in it something of our own existence, albeit transfigured. Everything looks so real. And yet everything is very different. The fall of a dead body puts us in mind of the flight of a bird. The slightest gesture acquires meaning within the context of

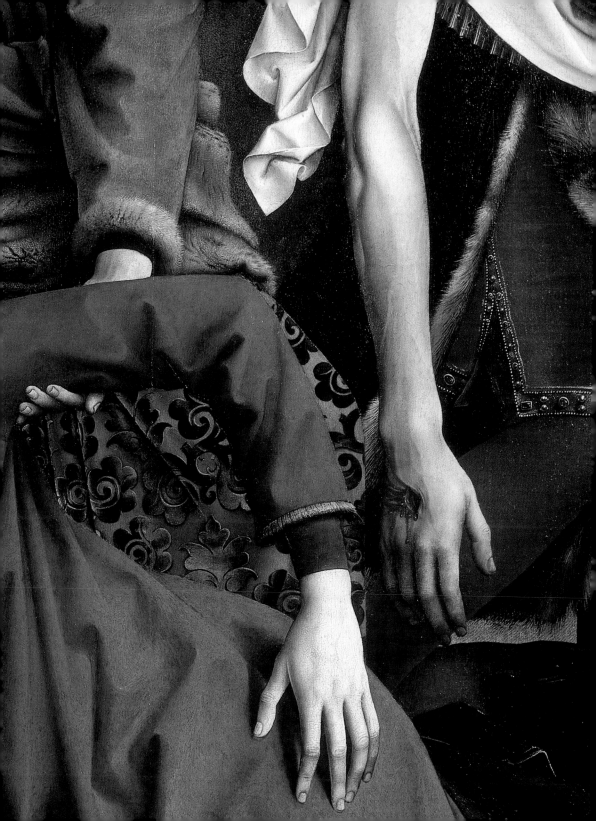

a staging that seems to prove that no detail, no tear is unworthy of our interest. In the artist's hand, those tears glitter on the mourners' cheeks, domesticating the light. Life does not lose its weight or its wretchedness but is radiant with splendour. Death is no longer a source of fear.

Saint John approaches the Virgin. The red of his cloak will warm her. Higher up the painting, the green of a dress springs up like living grass. It is one of the Holy Women who supports the Mother of God. Mary Magdalene, her body contorted with horror, endures every torment at once, passing from red to blue and from passion to abandonment. Her skirt combines everything, feelings and colours. Seated or standing, she turns purple from it all. A stone grey colour seizes her by the throat. Clasped before her face, her hands imprison her like chains. Her gesture encapsulates all the different forms of fear and anguish. Magnificent and insane, it expresses in a single wild-eyed attitude both distraction and meditation, the despair that briefly finds peace through prayer, and the pain that returns and twists the hands that were clasped together in grief.

No one, of course, stands like this. And yet the figure has an astonishing truthfulness about it. It would need the genius of a choreographer like Martha Graham to create anything remotely comparable: more than any individual here Mary Magdalene is a summation of all the torments that sap her strength. She counterpoints the submissive anguish that finds numb expression in the features of the Virgin Mary. The sinner stands alongside the Madonna.

Against the immediacy of the gold background, the grief-stricken figures of Mary Magdalene and the others rest like precious gemstones in a priceless casket. On the women's hair, the crystalline whiteness of their veils creates an air of freshness.

A secondary figure catches our eye. Or, rather, his cloak does. He must be Nicodemus, oddly dressed in brocade and fur. Behind him, his servant is carrying the myrrh and aloe needed to embalm the body: no one will reproach him for his wealth, any more than one would reproach the prosperous merchants who admired this painting in the early fifteenth century. Whether they are patrons of the arts or simple observers, they know better than anyone how to appreciate the value of a fabric and can only be pleased to take note of this token of Flemish elegance.

The cracked earth evokes the world of nature in which all of this occurred, but it does so only to make use of its symbols. It bears the archetypal signs of death and of the return of life in the form of a skull and some bones and leaves. They all assume the roles that they were allotted to play. All is well.

The Descent from the Cross

The four Gospels speak of the burial of Christ and the preeminent role that was played by Joseph of Arimathea, a wealthy member of the Sanhedrin – the highest court of justice in Jerusalem – and a secret follower of Christ. Having gone to Pontius Pilate to claim Christ's body, he wrapped it in a shroud and placed it in the tomb that he had prepared for himself. In accordance with tradition, Rogier van der Weyden represents him as a bearded old man, supporting Christ by the shoulders. Only the Gospel of Saint John mentions the presence of Nicodemus, who is generally depicted at Christ's feet. The very precise action of taking Christ down from the Cross on Good Friday is not mentioned in any of the Gospels, and so it was left to artists to introduce the various individuals who are not mentioned in the Gospels, namely, Mary the Mother of Jesus, Saint John and Mary Magdalene. Also visible here are an anonymous servant standing on a ladder behind the Cross, and, in green, a woman who may be Cleopas's wife, also called Mary. The way in which the scene is staged reflects the influence of the religious theatre that played such an important role throughout the fifteenth century.

Golgotha

The skull recalls the death of Adam who, according to medieval legend, was buried at Golgotha, which means 'a place of a skull' and which is also where Christ was crucified. The connection between original sin and redemption is thus symbolically made, all the more so in that the Cross was believed to have been hewn from the wood of the tree that grew over Adam's grave.

A guild commission

As well as the Church and private individuals, guilds – be they professional associations or religious brotherhoods – played an important role in commissioning works of art. Their main task was to organize funerals and Masses for the dead, a point well illustrated by the present altarpiece. It was painted at the request of the Louvain Guild of Archers. Ornaments in the form of crossbows in the corners of the painting indicate the precise nature of the guild. We may even wonder if the strangely bowed bodies of Christ and the Virgin Mary are not a sort of poetic reflection of the guild's activities.

The appeal to sensibility

The fifteenth century was notable for a new spirituality that has been called devotio moderna. It first arose in the Netherlands among the Brothers of the Common Life and stressed meditation, asceticism and the importance of the individual's contribution to the quest for salvation. As a result, emotional closeness to God plays an essential role in the Imitatio Christi (The Imitation of Christ), which was probably written by Thomas à Kempis (c. 1380–1471) and which began to circulate in Europe before 1424. Initially aimed at an audience of monks, it quickly came to be considered a key work in terms of the Christian life in general and for a long time remained the most widely read book after the Bible. Its spirit is best summed up by a sentence that occurs towards the beginning of the work: 'I would rather feel contrition than know how to define it.'

with blowing is communicated to a young nymph whom he catches and proceeds to impregnate. She attempts in vain to escape from the breath that seizes hold of her, as if she is terrified of this force of nature, but the leaves are already issuing from her mouth. She herself is only an intermediary figure, a body in which this encounter between the elements can find material expression. The drama grows less intense in the figure of advancing Spring, achieving its ideal in her. The wind that has fathered her has left the mark of his desire. The nymph, her mother, has bequeathed her eternal youth. The airy draperies that make up her billowing dress constitute a symphony of flowers: we have just attended the birth of the most enchanting of all the seasons.

Three more characters may be seen to the left of Venus. They are the three Graces, three sisters as similar to one another as the three figures to the right of the painting were different. Their harmonious movements are those of a dance, whereas in the brutality of the chase, the irrupting wind breaks through the edge of the image. They move with the rhythm of regular breathing as if, by twining their arms together, they also have the secret ability to extend the lives of all the others.

At the heart of the image, Venus does not merely preside over this loving reunion, she also ensures that there is a certain rightness to the scene by positioning opposing natures and conflicting rhythms to the left and right of the picture. In this way she guarantees the balance between opposing forces: to her left is nature, acting out of pure instinct, and to her right – the direction to which she inclines her head and holds out her hand – is the uninterrupted fluidity of time.

And yet the Graces are threatened. Their innocence will not last for ever. Crowning the painting above Venus is her son, a little Cupid with blindfolded eyes – Love is traditionally blind. He does not need to see clearly in order to aim his arrow. The Grace in the middle will be the best target: the absence of any ornament in her hair indicates that she is the most innocent of the three. And we may imagine history repeating itself: the excitement of the chase, the embrace, the flight and the new flowers. They know it too. Their dance reflects the law of eternal recurrence, their arms rise and fall, their eyes meet and move apart again, they are identical and yet always unique.

Another male figure has been added to the left of the painting, and calls into question the symmetry of the two groups. Quite simply, he prevents the scene from achieving a set perfection. The god Hermes stands there nonchalantly, left arm akimbo, playing the troublemaker. Thanks to him, the world is in a

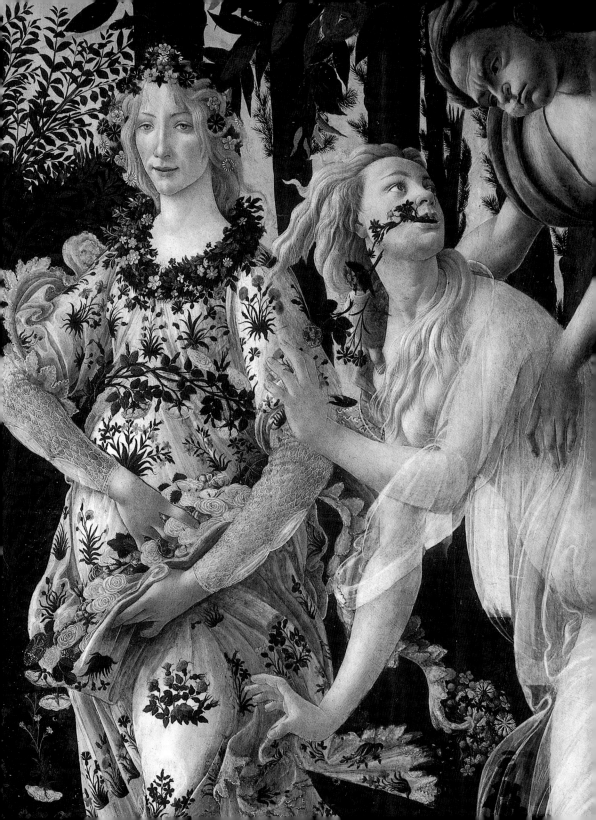

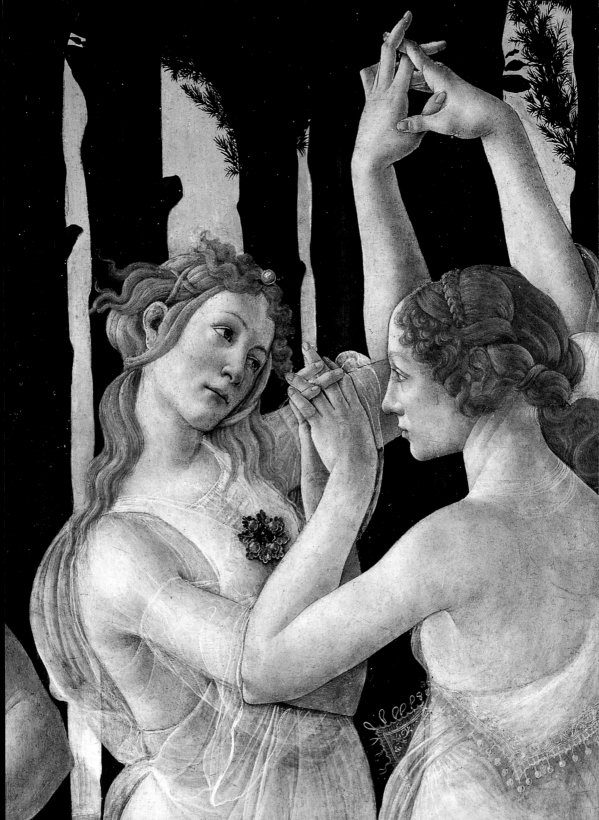

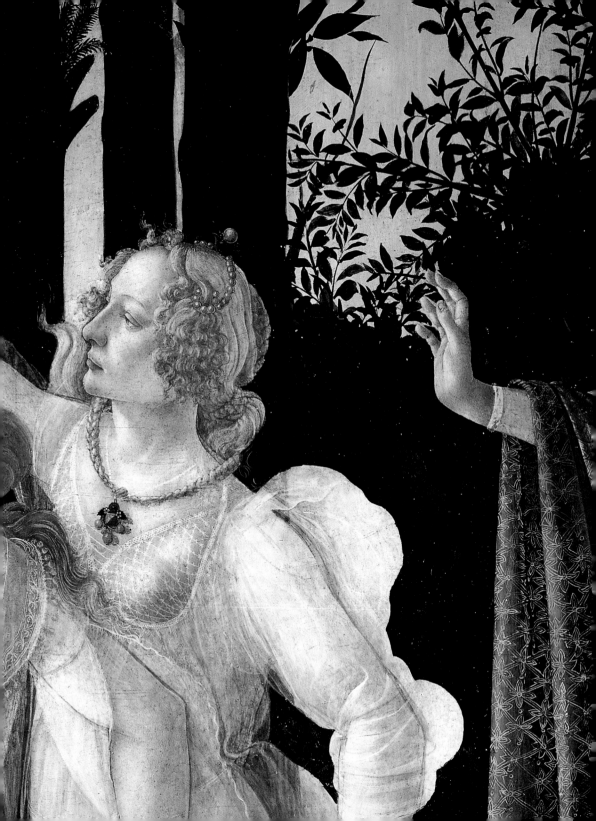

state of perpetual motion. He advances on all fronts, ensuring that everything changes hands and explores other avenues: he is the god of merchants and crossroads, but also the god of thieves. The god of translators, he communicates words and ideas, forging a link between languages and minds. In this way it is Hermes who ensures that knowledge is transmitted from person to person.

That is why, as a worthy messenger of the gods, he busies himself here chasing away the clouds that were forming a shield above him. Some of them linger, but they will shortly move from the frame and reveal a radiant world. But we ourselves shall not see it.

We can no more gain access to the heavens than we can see the perfect bodies of the Graces beneath their gossamer veils, because, no matter how much the gods may favour us, we see the world through a glass, darkly. All our knowledge is incomplete. The thin layers of paint are superimposed upon one another like clouds, allowing us merely to guess at the existence of the absolute beauty that is out there, close at hand, almost within our reach.

But the painting is more than the celebration of a springtime ritual, which is why the artificiality of nature, as depicted by Botticelli, is the very first thing that strikes us. It is not so much a landscape as a stage set in which the tiny scattered flowers recall the art of tapestry-work and the trees are regularly spaced, forming a portal of leaves behind Venus. On this clearly structured stage, the jubilation and exuberance depicted by the artist are first and foremost those of Botticelli's own age and of the artists and men of letters around him. After all, Hermes' hand movement suggests the way in which human intelligence seeks unceasingly to drive darkness and ignorance from the world. And the inhabitants of fifteenth-century Florence could indeed feel that the world was being reborn beneath their very feet. The rediscovery of classical art through the medium of the ancient Greek manuscripts that were then being translated allowed contemporary Florentines to penetrate the mysteries of a culture whose splendours they had hitherto failed to appreciate. It seemed as if the old winters that turned the sky to lead had finally grown weary and that it was possible to rediscover the warmth and voluptuousness of the human body by caressing well-proportioned classical sculptures and, that finally, order, moderation and balance had returned to reign over the reconciled senses and intellect. It was, quite simply, the Renaissance, an age of bliss and benediction.

A shadow of nostalgia haunts the painting and makes the faces more serious than first appeared to be the case. No matter where they come from, the gods cannot rid themselves of their hint of melancholy as exiles. Their world is not our own. But this is something that we have always known.

The world of the gods

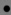

Although the subject of Botticelli's painting continues to be widely debated, there is no doubt that it is indebted in particular to the *Fasti* of Ovid (43 BC – AD 17 or 18), a poetical calendar describing the various Roman festivals and celebrating perpetual spring – the month of May – in Venus's orchard, which is here the Garden of the Hesperides. Botticelli depicts the golden apples dedicated to the goddess as well as the myrtle and orange trees, the forget-me-nots and cornflowers, the irises and periwinkles, the pinks and anemones. According to Ovid, Zephyrus, the god of the west wind, married Chloris, a Greek nymph named Flora in Latin, and gave her the power to rule over the world of flowers. The three Graces bring joy to the world of nature, their round dance a symbol of generosity and abundance. They are traditionally attended by Mercury–Hermes, who draws the spirit towards the world of transcendence and accompanies our souls on their journey into the afterlife. As the goddess of love and human knowledge, Venus–Aphrodite may represent the balance between carnal passion and spiritual restraint as well as the union of desire and marriage.

Botticelli's style

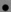

The Renaissance was notable for its interest in anatomy and in a truthful representation of the human body. Having benefited from their formal analysis of classical statues, the painters of the period sought to compete with nature. Painting in oils had grown more widespread in Italy from the second half of the fifteenth century and increased its potential yet further by creating subtle translucent effects and luminous nuances. The same was true of perspective, which produced the illusion of depth in painting. Botticelli was fully conversant with this technique – so much so, in fact, that he was known as 'the master of perspective'. And yet he seems to have felt little inclination to share his contemporaries' interest in three-dimensional objects on a flat surface. His linear, stylized approach to anatomy yields little to a true handling of volume, and the decorative organization of the surface takes precedence over any real sense of depth. In general he also preferred to paint with tempera made from eggs instead of oil.

Melancholy

No matter whether Botticelli's subjects are religious or mythological, most of the faces of his figures express a sort of distant dreaminess that comes close to melancholy. In adopting this approach, he represents a synthesis of the Christian and classical traditions, both of which are based on the idea that we have lost our original perfection – in the Bible, this perfection was paradise, whereas in classical antiquity it was the world of archetypes of neo-Platonic thought. The pensive seriousness of the figures reminds us that their bodies are merely temporary shells that allow ideas to become visible, prisons for souls that long for release. Only a few years after Botticelli painted *Primavera*, the Florentine spring effectively ended: the death of Lorenzo the Magnificent in 1492, the theocratic republic established by Savonarola and the latter's death at the stake in 1498 ushered in a new era marked by religious and political unrest.

as it is straightforward, stripped bare, as it were, of any ideas that might later weigh on our minds. We are relieved of the need to understand or to wrack our brains – as we would undoubtedly do elsewhere – about the painting's possible significance. The image interrupts our line of thought. It rewrites the laws of nature, as if time could slow down, enough for us seize hold of something that was otherwise likely to escape from our grasp for all time.

Vermeer's painting brings together everything that is normally at odds with itself. Those of us who are so often torn or reduced to impotent hesitation by conflicting courses of action are suddenly presented with an image of reality that contradicts everything we know. The black background, often used for religious works, here renders the image timeless. Cut off at the shoulders, the sitter withdraws from any active part in the world, which she then proceeds to ignore.

Even so, the image appears to move, and the young woman's facial features seem to be suspended in the light, enveloped in a brightness that somehow reveals none of their details. Their outlines remain vague, not because we cannot see them but because time has not yet left its mark on them. All that we register is their flawless regularity and their absence of care. The image is new, as if nothing has ever happened to it. The woman has no past. Here she is, resolutely set apart from everything, including the passage of time, hence her youthful vulnerability.

Her lips are half-open. She is speaking. Or perhaps we are being presumptuous. Nothing substantiates this suggestion. This could be her natural expression. We do not know if a phrase has just passed her lips, or if this is the customary balance of her face. Air starts to circulate in the painting – it is she who is breathing. Just a breath. And if we had to describe it in greater detail, we might say that it was pink in colour, like the full mouth and the very soft cheek. The image is warm.

Does the heavy pearl earring that the young woman is wearing imply a degree of flirtatiousness on her part? It is more than a symbolic accessory or a mere ornament to be shown off to others. It is important for precisely what it is: a natural form that is translucent and pure, representing the union of light and geometry. The painting unfolds around this pearl as if around a nucleus. Vermeer treats light as if he were an architect, with the pearl as his plumb line, while the folds in the turban resemble the flutings on a column.

Large areas of colour lend the image its sense of structure. Everywhere, the contact between brush and canvas, neither openly displayed nor deliberately concealed, reveals volumes of infinite subtlety, shaping their underlying structure. The young woman has been sculpted as much as she has been

The world of the gods
●

Although the subject of Botticelli's painting continues to be widely debated, there is no doubt that it is indebted in particular to the *Fasti* of Ovid (43 BC – AD 17 or 18), a poetical calendar describing the various Roman festivals and celebrating perpetual spring – the month of May – in Venus's orchard, which is here the Garden of the Hesperides. Botticelli depicts the golden apples dedicated to the goddess as well as the myrtle and orange trees, the forget-me-nots and cornflowers, the irises and periwinkles, the pinks and anemones. According to Ovid, Zephyrus, the god of the west wind, married Chloris, a Greek nymph named Flora in Latin, and gave her the power to rule over the world of flowers. The three Graces bring joy to the world of nature, their round dance a symbol of generosity and abundance. They are traditionally attended by Mercury–Hermes, who draws the spirit towards the world of transcendence and accompanies our souls on their journey into the afterlife. As the goddess of love and human knowledge, Venus–Aphrodite may represent the balance between carnal passion and spiritual restraint as well as the union of desire and marriage.

Botticelli's style
●

The Renaissance was notable for its interest in anatomy and in a truthful representation of the human body. Having benefited from their formal analysis of classical statues, the painters of the period sought to compete with nature. Painting in oils had grown more widespread in Italy from the second half of the fifteenth century and increased its potential yet further by creating subtle translucent effects and luminous nuances. The same was true of perspective, which produced the illusion of depth in painting. Botticelli was fully conversant with this technique – so much so, in fact, that he was known as 'the master of perspective'. And yet he seems to have felt little inclination to share his contemporaries' interest in three-dimensional objects on a flat surface. His linear, stylized approach to anatomy yields little to a true handling of volume, and the decorative organization of the surface takes precedence over any real sense of depth. In general he also preferred to paint with tempera made from eggs instead of oil.

Melancholy
●

No matter whether Botticelli's subjects are religious or mythological, most of the faces of his figures express a sort of distant dreaminess that comes close to melancholy. In adopting this approach, he represents a synthesis of the Christian and classical traditions, both of which are based on the idea that we have lost our original perfection – in the Bible, this perfection was paradise, whereas in classical antiquity it was the world of archetypes of neo-Platonic thought. The pensive seriousness of the figures reminds us that their bodies are merely temporary shells that allow ideas to become visible, prisons for souls that long for release. Only a few years after Botticelli painted *Primavera*, the Florentine spring effectively ended: the death of Lorenzo the Magnificent in 1492, the theocratic republic established by Savonarola and the latter's death at the stake in 1498 ushered in a new era marked by religious and political unrest.

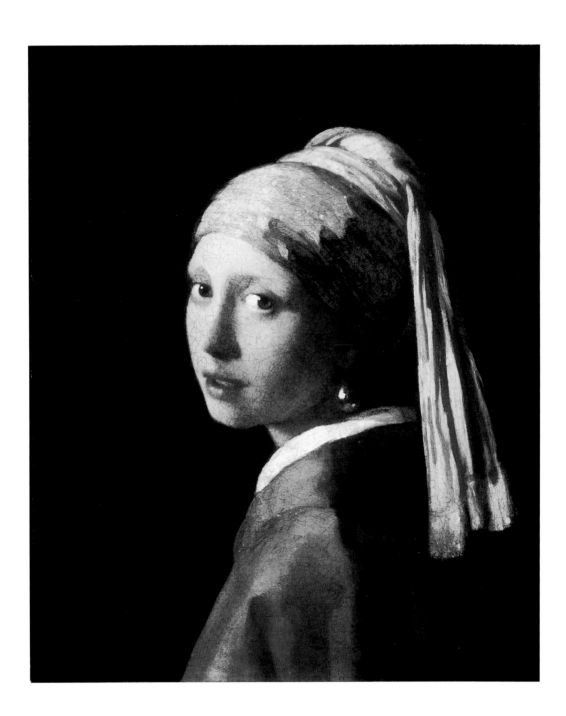

●●●

Feeling time stand still

Jan Vermeer (1632-75)
The Head of a Young Girl, or Girl with a Pearl Earring, c. 1660-65
Oil on canvas, 46.5 x 40 cm (18½ x 15¾ in)
Mauritshuis, The Hague

.

.

.

.

.

.

.

.

She turns towards us for only a second – just long enough for us to register her image. And just long enough for us to realize that this is a unique vision and that in a certain sense it was never intended for us at all. Much the same is true of the glance that this young woman grants us at the moment of turning away. We do not even know who she is. Later, of course, we may be able to imagine an entire novel and infer a whole life from this furtive apparition, but not just yet. At this moment the image produces a rare sensation: that of being overwhelmed.

In this way the question of the sitter's identity does not arise, her anonymity having something comforting about it: even a simple name would have set us thinking and forged a link with history or at least with one particular history. But we are not dealing here with a portrait, for Vermeer has painted a face that is complete in and of itself and free from any other association. Nothing matters, except what we can see in the here and now. Life outside this painting is momentarily forgotten.

If there is only a tenuous connection with reality, it is not because we have entered a world of dreams but because the image presents us with a sublimated version of reality that dispenses with daily experience. The encounter is unique, without any preliminaries or aftermath, as unexpected

as it is straightforward, stripped bare, as it were, of any ideas that might later weigh on our minds. We are relieved of the need to understand or to wrack our brains – as we would undoubtedly do elsewhere – about the painting's possible significance. The image interrupts our line of thought. It rewrites the laws of nature, as if time could slow down, enough for us seize hold of something that was otherwise likely to escape from our grasp for all time.

Vermeer's painting brings together everything that is normally at odds with itself. Those of us who are so often torn or reduced to impotent hesitation by conflicting courses of action are suddenly presented with an image of reality that contradicts everything we know. The black background, often used for religious works, here renders the image timeless. Cut off at the shoulders, the sitter withdraws from any active part in the world, which she then proceeds to ignore.

Even so, the image appears to move, and the young woman's facial features seem to be suspended in the light, enveloped in a brightness that somehow reveals none of their details. Their outlines remain vague, not because we cannot see them but because time has not yet left its mark on them. All that we register is their flawless regularity and their absence of care. The image is new, as if nothing has ever happened to it. The woman has no past. Here she is, resolutely set apart from everything, including the passage of time, hence her youthful vulnerability.

Her lips are half-open. She is speaking. Or perhaps we are being presumptuous. Nothing substantiates this suggestion. This could be her natural expression. We do not know if a phrase has just passed her lips, or if this is the customary balance of her face. Air starts to circulate in the painting – it is she who is breathing. Just a breath. And if we had to describe it in greater detail, we might say that it was pink in colour, like the full mouth and the very soft cheek. The image is warm.

Does the heavy pearl earring that the young woman is wearing imply a degree of flirtatiousness on her part? It is more than a symbolic accessory or a mere ornament to be shown off to others. It is important for precisely what it is: a natural form that is translucent and pure, representing the union of light and geometry. The painting unfolds around this pearl as if around a nucleus. Vermeer treats light as if he were an architect, with the pearl as his plumb line, while the folds in the turban resemble the flutings on a column.

Large areas of colour lend the image its sense of structure. Everywhere, the contact between brush and canvas, neither openly displayed nor deliberately concealed, reveals volumes of infinite subtlety, shaping their underlying structure. The young woman has been sculpted as much as she has been

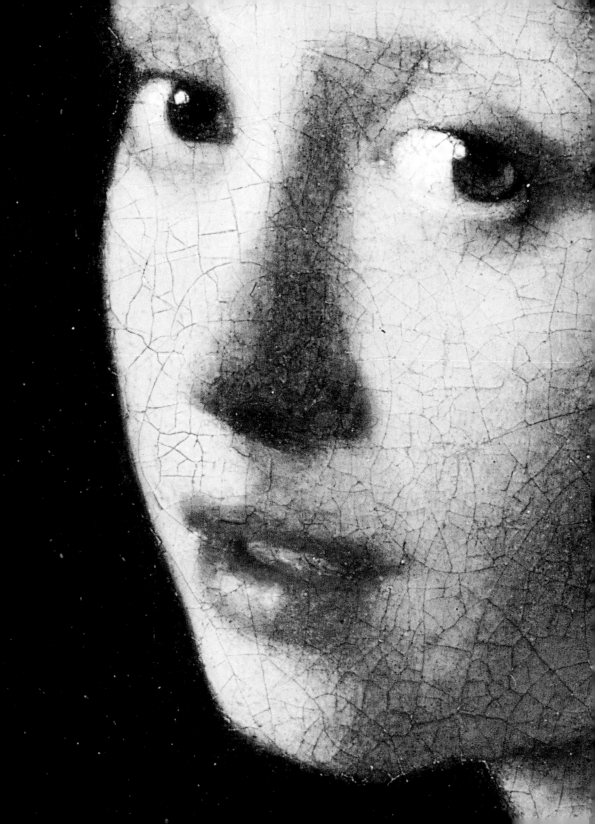

painted. Her face is a pearl. The fascination exerted by Vermeer's portrait also rests on the balance of the two principal tonalities, blue and yellow, which are found in most of the artist's paintings. These two colours are equally intense when it comes to conveying the light that makes the world visible. But they are opposites, having divided up between them the two worlds that were symbolically separated at the beginning of time: the separation of the light from the darkness described in Genesis may be said to mark the establishment of the opposing principles of black and white. But in the world of humankind – the world of the earth and the seasons, of the hours that pass and the time that changes – these absolutes assume more nuanced forms, the different colours fading into each other with imperceptible subtlety. Blue, a cold colour that suggests the endless space of the heavens, implies inaccessibility. By definition, it inhabits the world of the untouchable. We do not own what is blue, we contemplate it, knowing that it is both present and beyond our reach. It covers every shade from dawn to nightfall and finally sinks into blackness. For its part, yellow radiates the power of the sun, transmitting heat and brightness and the energy of a new beginning. Combined together, yellow and blue produce green, from which all the landscapes of the world are born.

The blue of the turban is dotted with tiny flecks of yellow, and minute droplets of blue fleck the yellow fabric like shards of ice. But the two colours never mix. Time has ceased to advance. The young woman is standing in a space that has been miraculously preserved and in which green has yet to be created. History is in a state of suspense. It is on the point of inventing itself.

.
.
.
.
.
.
.
.
.
.
.
.
.
.
.

The opposite of a portrait
●

Portrait painting presupposes a desire to
depict a particular person, whether that
person be famous or obscure, living or dead,
recognizable or not. What matters is the notion
of a verifiable identity, even if that identity has
been forgotten in the course of time. Even if a
model posed for this particular portrait, the
representation of the young woman depicted
here does not come under that heading. In the
Netherlands of the seventeenth century, it was
known as a tronie, a face or head depicted
wearing fantastical headgear, in this case a
turban of a kind altogether exceptional in this
period. The desire to generalize raises such an
image to the status of a symbol, yet the
viewer's desire to identify the sitter often
persuades us to invest the model with the
features of a particular individual. André
Malraux wanted to see in her the daughter of
the artist. More recently the American novelist
Tracy Chevalier has taken the painting as the
starting point for a whole story centred on
Vermeer's servant girl. Regardless of its
intrinsic charm, the interest of *Girl with a Pearl
Earring* lies in its magnificent ability to suggest
the essential meaning of the painting, which
abolishes all sense of individuality in favour of
a purely emblematic image.

The pearl as a symbol
●

Quite apart from its material value, the pearl
has a whole series of symbolic associations
that exist in many civilizations. It is a symbol of
perfect beauty, both physical and spiritual, and
also a token of virginity: its presence within the
oyster encourages us to reflect on the contrast
between a coarse and graceless exterior and
the pure and luminous interiority that nothing
can attain. According to legend, pearls are
born from the dew and the light in the depths
of the oceans, bringing them close to Venus,
the goddess of love and beauty who was
similarly born from the waves. Christ's words,
'Give not that which is holy unto the dogs,
neither cast ye your pearls before swine, lest
they trample them under their feet, and turn
again and rend you' (Matthew 7:6), also
encourage us to see in the pearl a symbol of
sacred knowledge too precious to be divulged
to spirits unworthy of it.

Blue and yellow
●

The harmonious relationship between blue and yellow that is so typical of Vermeer's art was also
noted by another Dutch artist whose inspiration was very different from that of his predecessor
but who made it his own favourite colour combination, too. Writing to Émile Bernard in July 1888,
Vincent van Gogh had the following to say about Vermeer: 'The palette of this remarkable painter
is blue, lemon yellow, pearl grey, black, white. It is true that in the few pictures he painted, one
can find the entire scale of colours; but the use of lemon yellow, pale blue and light grey together
is as characteristic of him as the harmony of black, white, grey and pink is of Velazquez. [...] Those
Dutch painters had hardly any imagination or fantasy, but an enormous amount of taste and a
feeling for composition.' This union of opposites that was typical of Vermeer may have given Van
Gogh a kind of reference point that brought with it the idea of harmony and ideal serenity.

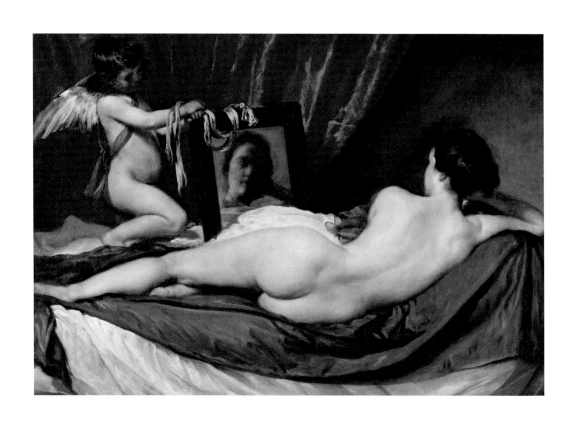

Accepting that we cannot see everything

Diego Velazquez (1599–1660)
The Rokeby Venus, c. 1647–51
Oil on canvas, 122 x 177 cm (48 x 70 in)
National Gallery, London

She knows that she is beautiful, that people are looking at her and that all of this goes without saying. The presence of a visitor standing behind her does not worry her. There is no suggestion that she is trembling. She is reclining there calmly, without posing. She could have made herself comfortable in some other way without any greater sense of calculation, but, in each case, the result would have been as perfect.

Faced with such natural behaviour, we realize that in painting, nudes often appear to be incapable of movement, even if the thought were to occur to them. Outside the painting for which they have been conceived, their body would be robbed of all credibility: its proportions, outlines and gestures exist only as a function of a specific pose assigned to it by the painter, whereas this particular woman would be at home anywhere, infinitely beautiful wherever she was. Above all, we feel that she is free to get up from this dark grey sheet with an air of nonchalance and perhaps even to stretch for a moment like a cat. Nothing is holding her here except her own private pleasure – she has stayed on in the painting. And yet she is also aware that she does not belong to it – at best she is making use of the possibility that it offers her. Neither this particular image of her nor any other would ever be lacking in grace.

More than any of her attributes, it is this nonchalance that tells us who she is: Venus, beauty incarnate, the goddess of love and its pleasures. Her miraculous birth from the waves and the foam has no doubt left an echo in the white of the sheet and the curve of her hips. The movement of the waves, the slightest breeze: her presence brings a whole landscape to life. A few loose strands of hair have broken free from the chignon that she has knotted in her haste.

At her feet, a cupid serves as a miniature page boy. The blue sash that he wears is the delicate chain that ties him to Beauty. He has laid aside his bow, and on this occasion his wings are sufficient to indicate his role. Without his arrows, he would not be able to act so cruelly. Venus allows him to play for her and hold her mirror. He is still a child. The large red curtain is as well suited to his sense of theatricality as it is to his mischievous outbursts. For today, the goddess will do without ornaments and accessories.

The artist is her ally in this game of independence. Velazquez has ignored the great painters of the past and the examples they might have set him. He has seen and admired them, studying them everywhere, including Italy and the royal collections in Madrid. Classical models have long been familiar to him. But the reality that he contemplates would cause any myth to pale into insignificance, for the body of his Venus ignores the rules of statuary and mocks all the marbles on earth, too happy is she to be alive to have any memory of the past.

The young woman has just turned twenty, or perhaps she is only eighteen – it matters little. Other young beauties people the history of painting, but they rarely allow us to forget that they come from a bygone age. They were admired in their own day, and here is their image, the image of a face or a body from the past. Velazquez' painting gives us the impression that we could in fact know this woman, that she exists in the here and now and that there is nothing left from her own century that could persuade her to return there.

The reverence that we owe to works from the past leaves her untouched: she is no less close to us for finding herself in so old a painting. Perhaps it is her unaffectedness that obliges her to turn away, to maintain a sense of distance that we ourselves could so easily forget while with her.

And so she turns her back on us. This is as well, for Spain did not trifle with decency at this time, and so deeply Catholic a country was suspicious of pagan frivolities. At court more than anywhere else, people feared for their safety and their salvation, especially in the presence of paintings and other such images. Velazquez knew that his painting would lose nothing if it appeared to take account of religious concerns. Quite the opposite, in fact. And so he

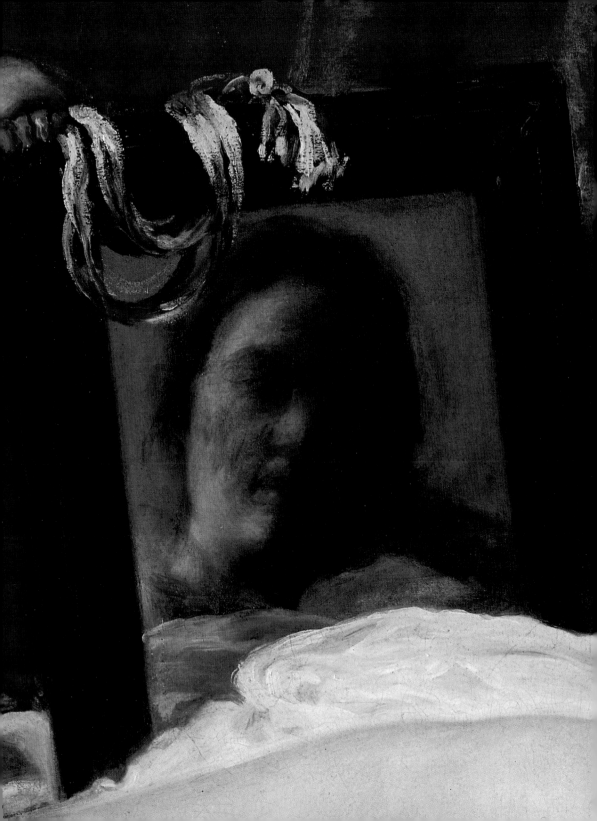

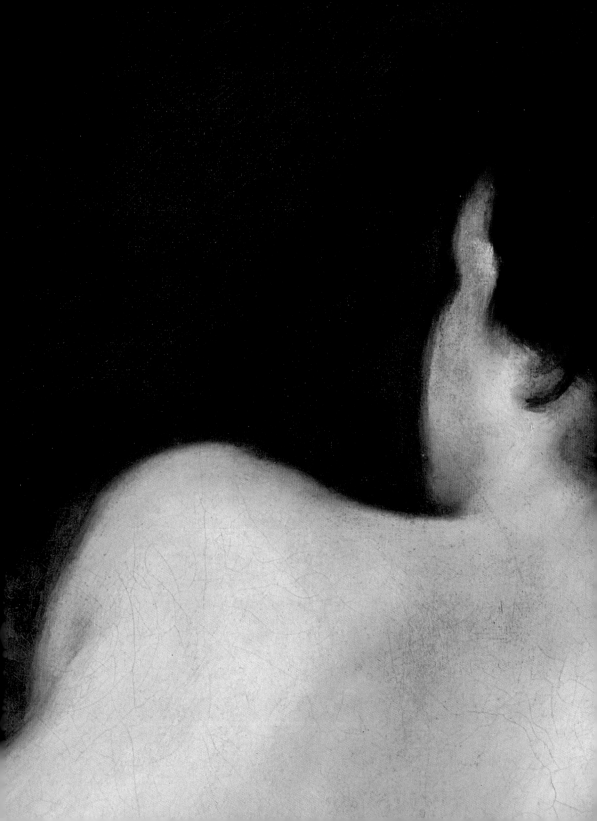

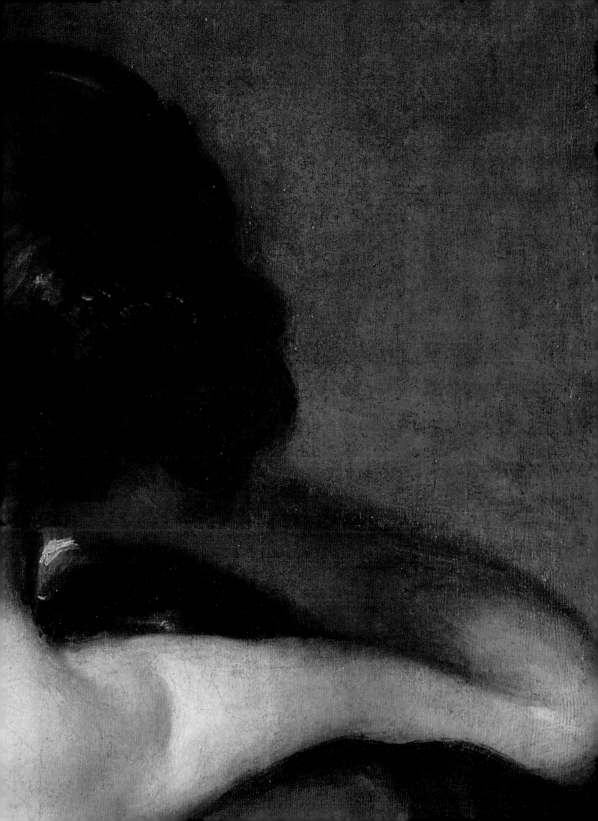

ensured that his Venus would be inoffensive both visually and morally. Why should she offend us? Because this unprecedented pose merely increases her seductiveness. We are at her mercy.

She can permit herself anything and everything, even blurring the reflection in the mirror in order to escape from her visitor's indiscretions. Cupid holds the mirror without worrying about its angle: logically, it should show the goddess's body, not her face. Velazquez is party to the deception, playing with the laws of perspective. He could have moved the mirror very slightly, and the reflection would have been more legitimate, but less subtle. The evident gap between reality and its reflection is necessary to show us that the arbitrary nature of the gods overrides the laws of optics.

This is also why, in spite of the fact that the mirror does not reveal very much, the goddess can observe us in it with greater attention. We can guess at her amused detachment, which is itself a kind of indulgence. Certainly, the gentleness of her features, diluted by the steel mirror, encourages us to believe as much, yet we see only the semblance of a face and we are reduced to well-meaning suppositions.

Beauty slips through our fingers at the moment we least expect it. We naïvely thought that we were about to discover her completely. But Velazquez is too wise to allow us to believe that this is desirable — he knows better than we do, he who has wooed her all his life. He has long known that her greatest power lies in the desire that she inspires and not in any assuaging of that desire. He leads us into her presence like some faithful servant, weighing up the liberties that she will allow him to take. He tells us that she is there, that she agrees to let us approach her and that she will keep us waiting as long as she likes. Now it is time to understand. No, we shall not see her any more. At least, not today.

Velazquez casts a spell on us at the same time that he dismisses us, leading us back to our lowly mortal condition with a supreme elegance as if it were the easiest thing in the world.

.

.

.

.

.

.

.

.

.

Vélasquez and his Italian model

The *Rokeby Venus* derives from several different types of composition familiar to Velazquez both from the Spanish royal collections and from his visits to Italy in 1629–30 and between 1649 and 1651. The present painting may well date from the last of these visits. The two most popular subjects – also found in the work of Titian – depict Venus reclining while facing the observer and Venus looking at herself in a mirror. The second of these is related in turn to the theme of the *toilette*. In varying the poses of his nudes, the great Venetian painter had created a series of mythological subjects in which Venus was depicted from behind. Velazquez' portrait combines these different traditions and adds a new one in the form of the contemporary depiction of his model, which owes nothing to the world of classical statuary. The nude represented a bold choice in a country as staunchly Catholic as seventeenth-century Spain. The privileged position at court of the man who commissioned the painting, Gaspar Méndez de Hero, seventh Marquis of Carpio, who was the son of the prime minister and great-nephew of the Duke of Olivares, may help to explain why this violation of the country's religious principles could have gone unpunished. Velazquez painted three other nudes, none of which appears to have survived.

The motif of the mirror

By entrusting a mirror to the little cupid in the painting, Velazquez is not content simply to accessorize Venus's beauty, he is also taking his place in a tradition that can be traced back to Jan van Eyck, whose *Arnolfini Portrait* of 1434, with its astonishingly realistic convex mirror, was part of the Spanish royal collections. The mirror is able to increase the size of the room depicted in the picture and reveal what would normally be hidden from view, with the result that from the fifteenth century it was a particularly prized motif in painting. Velazquez owed it to himself to rise to the challenge, which he did not only here but also a few years later in *Las Meninas* (1656), in which a small rectangular mirror placed at the back of this vast portrait of the royal family allows us to see the faces of Philip IV and Queen Maria Anna.

The status of the Spanish artist in Velazquez' day

Until Velazquez arrived on the scene, Spanish artists were treated as mere artisans, carrying out commissions much as a carpenter would do. But in the fifteenth century, this medieval attitude was rejected by the Florentine humanists, who argued that the artist was also an intellectual: according to Leonardo da Vinci, 'La pittura è cosa mentale' (Painting is a matter of the mind). One hundred and fifty years later Velazquez was the first painter in Spain to match practical knowledge with culture of the highest level. As a court painter who enjoyed the patronage of Philip IV, whose portrait he painted repeatedly throughout the monarch's reign, he was the recipient of innumerable honours: appointed palace marshal in 1656, he became a Knight of the Order of Santiago in 1659, a title that no previous artist had held. Above and beyond all questions of social ambition, it was also the official recognition of his position that was at stake here: with Velazquez, painting had finally gained respectability in Spain.

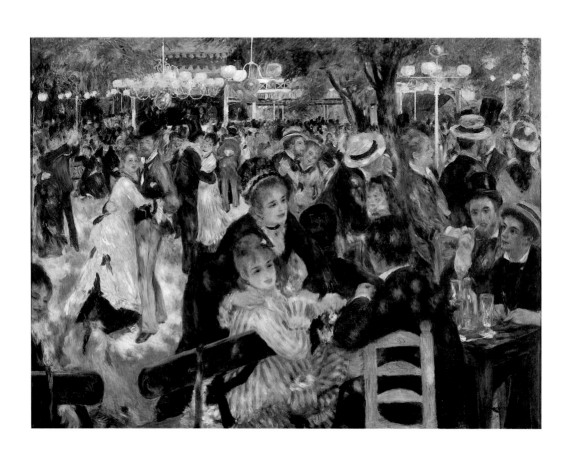

A moment's grace

Pierre-Auguste Renoir (1841–1919)
The Moulin de la Galette, 1876
Oil on canvas, 131 x 175 cm (51½ x 69 in)
Musée d'Orsay, Paris

The open-air café is crowded – there are so many people here they can barely move without bumping into each other. But they all remain good-humoured. The picture is welcoming, open to all. A seat will be found for any new arrivals. The existing visitors will make room for us by moving up a little. We shall be offered a glass of wine and be casually encouraged to sit down and join in the gossip or dance. No one here is taking themselves seriously. They have come to enjoy a beautiful summer's day, and it is clear that it will be a success from start to finish.

At the Moulin de la Galette people can dance without putting on airs. As soon as the women find a partner to their liking, they allow themselves to be carried away by the rhythm of the music. The steps are not always in time, and the dancers adapt the rules in whatever ways they like. The women nestle up to their partners, or else the menfolk lean forward a little too eagerly. Their hats dance in turn. Now is the time to fall in love.

The artist creates a rhythm from the dance. He causes the colour to vibrate on the dress of the dancer in pink. Powerful gestures accompany the dancers' movements. As for the young women engaged in conversation and calmly seated on a bench, the painter keeps his enthusiasm in check, discreetly focusing on the murmur of their voices. Here the painting might almost pass for a pastel. Perhaps there is the slightest hint of face powder – if such a thing were permitted to respectable ladies like these.

Renoir's characters need scarcely move in fact. Their range of gestures and attitudes can be reduced to very little: with Renoir, it is the painting that dances, and the light draws even the most indolent couples into its joyous atmosphere.

We are lucky, for the weather today is quite glorious. The trees conceal the sky, but we imagine that it is cloudless. All is well, if perhaps a little hot. In spite of the trees that shade the garden, the painting bursts with light, a light that is free to explore every corner of the image. Renoir is playing hide and seek with the sun, his brush tracking it down and trying to grasp it while delighting in its inability to catch it.

For Renoir, the light is revelatory: it transforms banal reality – not only its appearance but also its very nature. To the young women in the foreground it gives the colour of fine porcelain, increasing the moiré effect of their Sunday dresses. Here they are, swishing those dresses, as refined as any eighteenth-century marquise. When it strikes the head of the little girl sitting in the corner, it turns her hair into a cloud of gold. The fleeting reflections that are scattered over the ground cause it to gleam beneath the dancers' feet and undoubtedly increase the dizziness of the dancers. Before the spinning spots on the dark-coloured jackets, we forget even the memory of black: there is no point in keeping it on our palette as it would only dull the general mood. The light settles on the straw hats and boaters and breaks up the scene. The carafes of wine and the glasses that have been placed on the table likewise sparkle like precious gems.

A moment of wistful reverie, an appreciative glance at a pretty redhead, a political discussion: those who are not dancing are not bored for a moment. We may guess that these romantic attachments may drift apart at the end of the evening with no ill feelings and that others will follow. Some blow a kiss on their companion's ear, while others continue to talk. The image turns out to be less restless that it had seemed. Beneath the tireless play of the sun, it is ultimately the motionless figures who outnumber the others. Drawn by the colourful thrill of the canvas, we discover figures who are calm. To a certain extent, this reflects the artist's approach in general: beneath their apparent turbulence, they conceal a whole world of contemplation.

The crowd is thus arranged along a certain number of lines, the green bench having been placed at an oblique angle, while the verticals are the trees on which the brightest straw boater is superimposed as if by accident. A kind of horizon is provided by the crowd of people disappearing into the distance and underscored by the perpendicular lines in the background.

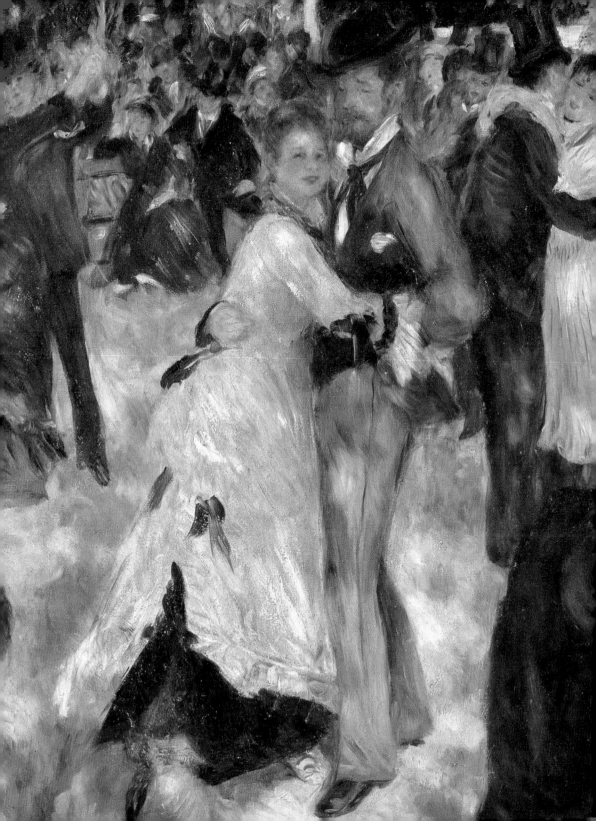

For all that this image gives the impression of having been painted on the spur of the moment, there is nothing at all spontaneous about it. Renoir chose models and made them pose for him repeatedly, while taking great care to ensure that everything was in the right place. In spite of this, the painting's powerful appeal is not based on the presence of precise individuals. Renoir adopts a more general approach, raising his characters to the level of everyman and appropriating them for his own particular ends. The people he paints become Renoirs.

The scene is one of a new kind of subject dear to the Impressionists: that of commonplace moments captured against the background of the increasingly rapid pace of contemporary life. Renoir is no more interested than his fellow Impressionists in narrative or in some literary theme or other. But whereas his colleagues all argued that the changing light added to the feeling that all things are transient, he believed, conversely, that it magnified all that it touched.

The works of the great masters whom Renoir admired in the Louvre are all in the same spirit. Although their subjects may have changed, he shared their desire to transcend reality and to invest humanity with an aura of myth. As a member of the avant-garde, he chose to paint people who resembled him, the people with whom he rubbed shoulders every day, and it mattered little that it was Montmartre that replaced Olympus and the Garden of Eden. Beneath the guise of a genre scene, he has produced a minor miracle in the form of a public holiday, a brilliant moment in a blessed world that persuades us that our original innocence was never lost. The future no longer means anything. The present is all that matters.

The Moulin de la Galette

●

From the Middle Ages onwards, the summit of Montmartre has been home to numerous windmills. Used to grind corn, press grapes and crush various raw materials for use in local manufacturing, they also became a popular destination with Parisians out for a walk. In time it became the custom to come here every Sunday to dance and drink. The Moulin de la Galette was built in the early seventeenth century and still exists, having been turned into an open-air café in the middle of the nineteenth century. In 1876, Renoir set up his studio not far from here in the Rue Corot in order to make it easier for him to carry his canvas to the café's garden. It was a unique opportunity for him to attempt a modern subject in an ambitious format. Friends and amateur models were required to pose for him on several occasions.

Working in the open air

●

As a generation, the Impressionists typically worked out of doors. They were all distinctive individuals who subscribed to no particular theoretical programme. To a certain extent it was the public's lack of understanding for their work that bound them together as a group, even if some of them, including Monet and Sisley, frequented the same studio as Renoir at the Beaux-Arts – the French national art school. It is worth recalling that the term 'Impressionist' was originally a jibe directed at Monet for his painting *Impression: Sunrise*, which he exhibited in 1874 at an exhibition organized by the photographer Nadar. Other artists, including Constable, had already tried to paint outside their studios. What distinguishes the Impressionists is their passionate interest in the changing phenomenon of light. The sheer difficulty of seeing nature became an essential dimension of the image which, instead of simply describing a scene, conveyed a partial, approximate aspect of it. It was an approach that from now on was recognized as the sign of a truthful and authentic relationship with the world.

The Caillebotte Collection

●

First seen at the second Impressionist exhibition in 1877, *The Moulin de la Galette* was no better liked than any of the other canvases on display, and its large size made it difficult to sell. This was one of the reasons why the artist Gustave Caillebotte was persuaded to acquire it. Having private means at his disposal, he helped his colleagues by buying their work and built up a sizeable collection that he left to the state. Unfortunately most members of the general public regarded Impressionist art as a sham at this period. Far from demonstrating traditional techniques and exploring literary and historical subjects capable of capturing the imagination or causing their viewers to shed a sentimental tear, these paintings merely seemed to prove the artist's ignorance. Following Caillebotte's death in 1894, his legacy gave rise to embittered negotiations with the administration of the Beaux-Arts, which finally selected a number of works from those exhibited in 1897. In the event it decided to retain *The Moulin de la Galette* by Renoir, little suspecting that it would become the archetypal image of an entire era.

As viewers, we feel at once and in the most physical way that we are in the presence of something that is beyond us, and yet we are not crushed by that sensation. The monumental size of this polyptych aligns it with the world of architecture, with which it shares the same sense of stability and weight. It also encourages a journey along the length of the canvases, our guide being the long parallel streaks that run across the surface of the painting. Cut into the thick layer of paint, they increase its density by superimposing their trajectories upon it.

This painting seems to reproduce nothing, and yet its lines are familiar, for they could also be those parcels of cultivated land that can be seen from a distance, even from space. The artist has no need to imitate them. He rediscovers their accents and their inflections, merging for a moment with the emblematic figure of the ploughman. He writes in the fertile soil. His gesture acknowledges a secular heritage and is inevitable. The viewer understands that this is why they were never surprised: all that is here was already a part of our memory.

We no longer know if we are very close to the canvas or very far from the earth, unless it be sand or gravel or mud that we are looking at. But it is of little importance, for this painting does not claim to be a landscape. The studied slowness, the time that stretches out along the lines and the material into which we sink count for more because each of us recognizes in them something of our own position in with the world.

The vertical edges of the four canvases that make up the work play an important role in its overall composition, constituting as many breaks and interruptions as if these paintings, intimately bound to each other, were part of some polyphonic exercise. The result is an unpredictable visual rhythm that obliges us to abandon the route that we had initially taken on one of the canvases before setting off again on another one. Continuing on our chosen course is not enough, and on each occasion we have to start out again, without hesitation. From the outset, our momentum is at its maximum.

One might have thought that the sovereignty of black would assert its sway, resisting our gaze and refusing to open up an illusion of depth. Or, conversely, that it would plunge the visitor into an abyss. A glimpse of this gulf would be enough to suffer from dizziness, in which case the painting would have been indistinguishable from a shadowy hole. But things turn out very differently. The grooves stand out, glittering and preventing us from falling. The paint, which could have hollowed out a space or formed an impenetrable barrier, causes the wall to vibrate beneath it.

As our eyes glide over it, we notice more and more of the subtleties of the light. It is an apprenticeship full of sweetness and surprises. We follow its play on the surface as on the surface of waves. In places the black is so shiny that it seems to be wet. Reflections obscure it to the point of transforming it and turning it grey or white. Other sensations are awakened. Memories are roused. We lose sight of it: what has happened to the impenetrable screen that we thought we had in front of us? And what if it had been there only to be forgotten?

The work draws its strength from the tension between two poles, gradually allowing the observer to feel their power: unwavering density followed by transparency. The balance in Soulages' painting stems from our contemplation of two extreme forces that share equally in its conception. We cannot choose between them. The contradictions no longer hold, whether we were first struck by the blinding intensity of the black or by the fluidity of the light.

The spirit of logic and reason baulks at this: black, after all, is obscurity, darkness. It seems obvious that yellow, blue and white have more in common with light. This is true. And yet black is ultimately superior to all the other colours in that it can neither represent the light or evoke it. Because it is the opposite of light, manifesting its absence, we have to call for it, wait for it and welcome it. We have to tame it.

When the light arrives, it settles on the black, a light film, scarcely even a gleam, a sort of veil, opening out and starting to float. Here no hint of yellow speaks of the sun, no blue suggests the expanse of the sky. The white of the canvas has vanished beneath the black. The painting is compact, like stone. Here, where nothing resembles it and nothing can replace it, light can finally appear.

.

.

.

.

.

.

.

.

.

.

.

The link with architecture
●

Soulages was only twelve or so when he visited the Benedictine abbey of Sainte-Foy at Conques, frequently stressing on subsequent occasions the extent to which this encounter with medieval architecture overwhelmed him and played an important role in his later development as a painter. While never evoking architecture in any direct way, his work as an artist has much in common with its spirit: the balance between heavy blocks of stone and the measured diffusion of light in a sacred space are both paralleled in his paintings. The viewer, confronted by his work, may well share the sensations of the visitor to a Romanesque church, penetrating to the very heart of a mystery that gives material expression to his or her own need for meditation and feeling transported to a place inside us, protected from all intrusion and surrounded by silence. It was only right, therefore, that in 1987 Soulages was commissioned to produce 106 stained glass windows for the abbey church of Sainte-Foy at Conques, a commission that he completed in 1994.

The polyptych
●

A polyptych, from the Greek word *poluptukhos*, meaning 'with numerous folds', is made up of a series of panels that may be painted or sculpted and that sometimes occupy several levels. Such works were found increasingly in churches from the fourteenth century onwards. They reflect a system of hierarchical representation that reserves the central position for key figures in church history such as the Virgin and Child, Christ or a particular saint. The side panels are occupied by secondary characters in the story. Today's artists have revived this tradition, increasing the number of painted areas, without, however, attaching any specific value to them. The arrangement of the panels underscores the ability of painting to appropriate space, making it as much of a place as it is an object. It also results in the essentially fragmented nature of every image. Logically, the works of every artist may be regarded as a gigantic and unending polyptych whose individual panels are condemned by their human dimension to remain scattered. Through its associations as much as through the impact of its size, the very form of the polyptych tends to locate a work within a sacred perspective, no matter what its subject matter may be.

Monochromaticity
●

Monochrome painting first appeared in 1918 with *White on White* by Kasimir Malevich (1878–1935), soon becoming a genre in its own right and enjoying particular interest after 1960. It is impossible to place all its variants under a single heading for it is merely one means of expression among many, an element in the artist's vocabulary that assumes a meaning only as a function of the artist's journey and the choices that he or she makes. Even in non-abstract art it can be found in numerous works, including those of Picasso's 'blue' and 'rose' periods. It is first found in Soulages' work in 1979. His entirely black paintings are a demonstration of the jubilant freedom acquired by the artist, who since then has created a truly classical body of work.

Analysing distortions to the visible world

A painting shows us nothing to which we cannot give a name, be it living creatures, landscapes or everyday places. But it can also fly in the face of our experience and show us a world that ignores the laws of nature. All that we hold to be true no longer operates: the rules of anatomy and equilibrium, the relations between people and things, the functions that objects should customarily fulfil – everything has changed. Proportions are improbable, the logic confused. We have read the text a thousand times, but suddenly the syntax and punctuation to which we had grown accustomed are no longer there to guide us.

Common sense takes over: you have to pull something here, push it there, stick back the missing pieces, redraw it along more accurate lines and restore a sense of order to this distorted world. Our gaze grows keener as it identifies what is wrong. It concentrates on the discrepancies and the distortions, ending up by concluding that nothing corresponds to the directions for use that are currently in operation, that the details cannot be squared with the whole and that each plausible element is inevitably contradicted by something else.

This distortion of appearances may move us to pity or annoy us depending on whether we see it as the result of a clumsy experiment or as a gratuitous attempt to provoke us. It may even amuse us, because the licence taken by the artist makes up for our own inability to change a certain reality. He must be using it in this way as if it were a dream that legitimizes every transformation.

In fact the artist uses outward reality as his point of departure, raw material that has to be shaped and worked in order for its meaning to be revealed. What we see as a distortion is generally the result of this process, which accentuates certain aspects, while suppressing others, with the aim of making this reality more explicit and easier to read.

of Christ, so remote from our own reality, may be painted slightly smaller without causing any offence. He occupies a space inaccessible to anyone other than the saint.

The remaining space does not allow Giotto to paint a more comfortably proportioned landscape. None the less, he had to situate the scene somewhere in time and space. And although fourteenth-century artists were not interested in documentary accuracy, the art of the period was required to provide a historical setting and remind observers of the context in which events may have occurred. Francis was particularly fond of nature and divined the thinking of God and the reality of Creation in its most humble manifestations, speaking to the animals and celebrating the beauty of the elements in hymn. It is impossible to recall this episode in his life without taking account of this fact, and so Giotto chose a few trees and a section of hillside. It matters little whether or not it appears to be convincing. No one will be misled, for it is the artist's intention that counts: the result is a truth of sorts.

The artist uses generic objects that seem to have come straight out of a toyshop: there are bushes and small flowers, miniature houses, a few animals and not much else, apart from some geometrical ornaments. He sticks to a global topography and retains only the pieces indispensable to his purpose. And he takes only new and dazzling objects. Taken together, they would form a unique summation of the saint's life, a résumé of his existence. The result is like a text from which all unnecessary extras have been removed. Tree. Chapel. Hill. It is a world without question marks, a world every bit as straightforward as on the first few days of the Creation. A world in capital letters.

At the edge of the image, the ground gives way abruptly. In this shorthand depiction of nature, Giotto is careful not to omit this precipice. In spite of all its appearances, the world of Saint Francis avoids the simplicity of the fairytale, and the painting's apparent ingenuousness does not aim to exorcise its inherent dangers: the Fall is still something that we should fear.

In this way the painting expresses a view of the world. Instead of revealing what we can see in it, the artist teaches us all that we need to know about it according to prevailing Christian values at the end of the thirteenth century. He indicates the priorities and persuades the viewer to feel a sense of security, like a hiker on a path which, however steep, has at least been marked out. The system of proportions that he uses reflects a spiritual hierarchy that bears no relation to the logic of any land surveyor.

The different episodes are arranged along chronological lines. At the foot of the altarpiece three moments from the saint's life complement the main

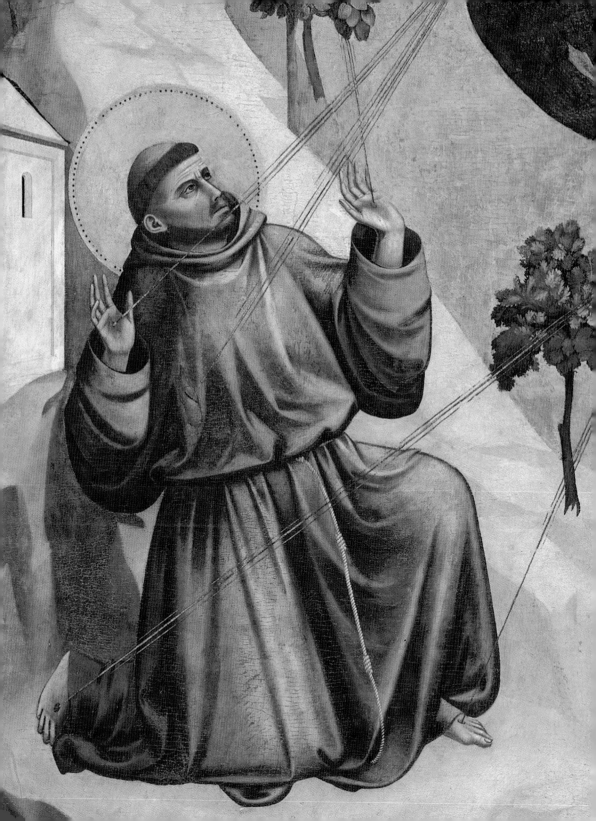

image, which shows him alone, facing God, whereas the others depict him in the midst of this world.

To the left, the sleeping pope is visited by Saint Peter. He is dreaming: a monk whom he does not yet know is holding up a church. In fact it is the Church itself, which is on the point of collapsing. The monk is a kind of weightlifter of the faith. The central image depicts the pope welcoming the monk, together with a number of other friars. He sanctions the rule of the newly founded Franciscan order. And on the right, Francis, followed by another monk, preaches to the listening birds. The building that he is preventing from falling down is leaning to the right, while the birds press forwards towards the left. The images to the left and right celebrate the saint's exceptional nature and draw the eye towards the central scene, which depicts the idea of obligatory obedience to the institution of the Church.

The gold background vibrates in the light of candles. In the church's gloomy interior, the painting guides the faithful who have come in search of a light unknown to them in their ordinary lives. They have no need of wisdom. The painting warms their hearts without asking anything of them. They recognize Francis from afar, the scene is always the same from one altarpiece to the next, and they know the principal episodes by heart. It is a very old story, but also a very new one. They need to remember it. God became flesh in the person of Christ. Centuries passed. In the end people had grown so used to them that the words had lost their meaning. Then, one day, poor Francis received the terrible stigmata. His faith was inscribed on his very body. Then everyone woke up and through this suffering human life rediscovered its intensity and its true weight. And also its state of grace.

In creating this image Giotto reinvents it along classical lines. He fashions the figure like a sculptor, hollowing out the folds in the monk's habit in order to fill them with shadows. In his painting, the figures can move and act. They have not yet had time to explore the vast earth, but they are certain of their own individual volume. Their physical presence is already a truth on which they can count.

Wherever he goes, Francis takes with him the heaven that dwells within him. The light around his head illumines all who approach him. His halo is a piece of divine perfection. He has chosen a habit that is the colour of earth and dust. He knows that it will not frighten the birds.

.

.

.

.

Saint Francis of Assisi (1181–1226)
●

It is to the saint's biographer, Thomas of Celano, that we owe the account of the miracle that made Saint Francis a living legend and a sort of second Christ. The event in question took place on Mount Alverna on the day of the Exaltation of the Cross in 1224: 'He saw in a vision from God a man with six wings like a seraph, standing above him with hands extended and feet together, affixed to a cross. Two wings were raised over his head, two were extended in flight, and two hid his entire body. [...] And as his heart was filled with perplexity at the great novelty of this vision, the marks of nails began to appear in his hands and feet, just as he had seen them slightly earlier in the crucified man above him.' Saint Francis founded the mendicant order of the Franciscans, whose rule was verbally approved by Innocent III in 1210 and by Honorius III in 1223. Saint Francis was canonized in 1228 and quickly became the most venerated Christian saint.

The altarpiece on a gold ground
●

A retable is a table placed to the rear of an altar so as to be visible to the assembled faithful, for whom it initially served a didactic purpose. Paintings were first found in churches in the thirteenth century and were associated with the liturgy and prayer. They helped the congregation to memorize religious history and played a unifying role in offering a prop for meditation. As a precious object, the painting also represented a form of offering or sacrifice, its value heightened yet further by the use of gold, which symbolized splendour and divine permanence. Here the panel is divided in two. The principal area captures our attention from the outset, while the predella beneath it is made up of smaller narrative compartments. These two types of approach to the subject maintain a balance between meditation and the active life. The episodes depicted in the predella belong to the repertory of images traditionally linked to the Franciscan order. From left to right, they depict the dream of Pope Innocent III, who sees Saint Francis holding up the Church in the form of Saint John Lateran in Rome. The pope then approves the statutes of the order. And finally we see Saint Francis preaching to the birds.

The Canticle of the Creatures
●

The Canticle of the Creatures is one of the few surviving texts by Saint Francis, a man famous for his love of nature: 'All praise be yours, my Lord, through Brothers wind and air, and fair and stormy, all the weather's moods, by which you cherish all that you have made. [...] All praise be yours, my Lord, through our Sister Mother Earth, who sustains and governs us, and produces various fruits with coloured flowers and herbs.' In the wake of Saint Francis, nature became an essential element in art, gradually replacing the abstraction of gold backgrounds.

comfort by contemplating a religious image capable of sustaining him while he is praying, whereas what he finds instead – just as we do today – is a moving representation whose forms hint at unlimited transformations to a world that we had previously taken for granted.

The process has already started. Events no longer occur in their natural order: the infant has the face of a newborn baby but the body of a child that has already grown much bigger. His tiny feet and hands ill match his height. We are uncertain whether to see in his posture a sensuous abandon or a sign of suffering, while his outstretched arms evoke the crucifixion. Nor can his pallid face be entirely explained by the shadowy reflections of the dress. His face is that of a child in the throes of death.

What are we to make of this strange game of appearances? Where do we stand with regard to history? The different stages jostle for our attention. What we see is not a child: he is too big or too young, not yet born or already dead, divided between his past and his future and endowed with a body that is impossible to comprehend in terms of what he should be like now, a little boy sound asleep.

The incoherence of the visible world relates to what we know about the real world at this time. The age-old dogmas of Christendom on which the balance of thinking was based were being called into question by the Protestant Reformation. Those who believed in an established order discovered that their time-honoured values were no longer unassailable but were as fragile and as vulnerable at the Sacred City itself, which was raided by Charles V's armies in 1527. Implausible bodies were no more astonishing than developments in the contemporary world. Their appearance is the direct expression of the sense of spiritual confusion that existed at this time. The world had lost its sense of orientation. It was no longer possible to be certain of anything.

And yet the Madonna with her delicate skin and delightfully intricate coiffure appears wholly unconcerned. Exquisitely fashionable, this young woman reminds us of a much loved princess rather than of a religious figure. There is even the hint of a smile on her lips. Can she really not see what we ourselves can see? Probably not. Whereas we are looking for the reality of a small child behind his apparent deformity, she sees a turning point in history. Tradition regards her less as a mother than as the incarnation of the Church. Il Parmigianino invests her with a nobility that contemporary upheavals may unsettle but cannot undermine completely. The distortions that they inflict on her merely serve to enhance her sense of majesty.

The column to the right initially seems incongruous and difficult to place. But the small figure holding a scroll at its base helps us to see it in scale and allows us to tell that the column is some distance away from the principal group and that it is in fact the first – or last – element of an entire colonnade. Its function is to reveal to us what is hidden and reflects the prophetic nature of the figure, whose words find material form in the Virgin and Child and in the row of columns – on the one hand we have the moral rectitude and permanence of the Church and on the other anxiety and confusion. Whereas the figures speak of the sufferings that they have endured, the architectural form signifies a structure both symbolic and real. The soft curves of the figures find their counterpart in the solidity of the columns. The long neck of the Madonna, in the form of a tower, reflects their harmonious union.

The adolescent angels meditate or observe us kindly. They know all about the mysteries that escape our understanding. One of them is carrying an amphora whose contents will continue to puzzle us.

The composition of the image affirms the perpetual state of a world teetering on the brink. But the point of the work remains its ambivalence, the admiration that it evokes coloured by a no less powerful sense of unease. Beneath the Madonna's bosom is a concentration of sharp folds and curves of extreme subtlety that form a circle round her navel, causing the viewer to waver between her intensely sensual presence and the theological purpose of the painting, the image of a woman offset by that of the Church that bears and sustains the Word incarnate. The sinuous lines are no more an expression of anatomical truth than the draperies that cover them. The undulating rhythm of the image mitigates the confusion felt by the faithful lost in contemplation, while continuing to remind us of the insidious – truly serpentine – presence of Evil in our lives.

The attributes of the Madonna
●

It is mainly from the Song of Solomon that painters have drawn the elements that symbolize the perfection of the Madonna. This lengthy Biblical poem has been interpreted in various ways, some readers seeing in it an expression of God's love for His people, others arguing that it describes the soul opening up to God. What is beyond doubt is that it exalts the beauty of the 'beloved'. The present painting, with its insistence on the Virgin's elongated neck, recalls a number of passages from the poem: 'Behold, thou art fair, my love. [...] Thy neck is like the tower of David builded for an armoury' (4:1-4) and 'Thy neck is as a tower of ivory' (7:4). These comparisons also bring out the visual link that the artist has forged between the Madonna's neck and the column, which provides a symbolic bond between earth and heaven. A frequent motif in Christian art, the column implies spiritual strength and the permanence of faith, recalling the 'work of the pillars' mentioned in the Biblical account of the construction of the Temple and the home of Solomon (I Kings 7:22).

The sleeping Christ child
●

Countless images of the Madonna and Child show the latter asleep in his mother's lap or in front of her. In paintings inspired by Christian thinking, sleep represents above all a symbolic detachment from the world, a state propitious to dreams and to revelation and union with the divine. Even when the child appears to be sleeping serenely, the image presupposes that he is meditating on death. In the case of the present painting, the artist has added a sign that is both discreet and spectacular and that takes the form of the amphora carried by the angel on the left. In it we can in fact make out the image of a crucifixion as well as a grief-stricken figure who is no doubt Mary Magdalene at the foot of the Cross. Although difficult to identify, the scene appears to be reflected as if in a mirror. Logically, the amphora should reflect the infant Jesus as he lies before us in the painting, but what it shows us instead is his image transported through time to the moment of the Crucifixion.

Mannerist elegance
●

The term 'mannerism' is used to refer to the various formal experiments undertaken by artists between 1520 and 1600, in other words, between the death of Raphael in 1520 and the classicism of Annibale Carracci (1560-1609). It has nothing to do with the pejorative term 'mannered' but derives from *maniera*, the 'style' of the great Italian Renaissance masters. The art of Raphael and Michelangelo (1475-1564) became the point of reference for all the artists of Parmigianino's generation, including Jacopo da Pontormo (1494-1556) and Rosso Fiorentino (1494-1540), and inspired countless variants in the course of the sixteenth century. The profound sense of disquiet provoked by the Protestant Reformation and the plunder of Rome by the imperial armies of Charles V in 1527 found a fertile soil for images whose subtleties were all the more accomplished in that they were concealed beneath an apparent nonchalance. The serpentine line gives concrete expression to this fondness for a more or less abstract elegance that was scornful of the laws of nature and anatomy. In this period such lines appeared to be a consummate sign of beauty.

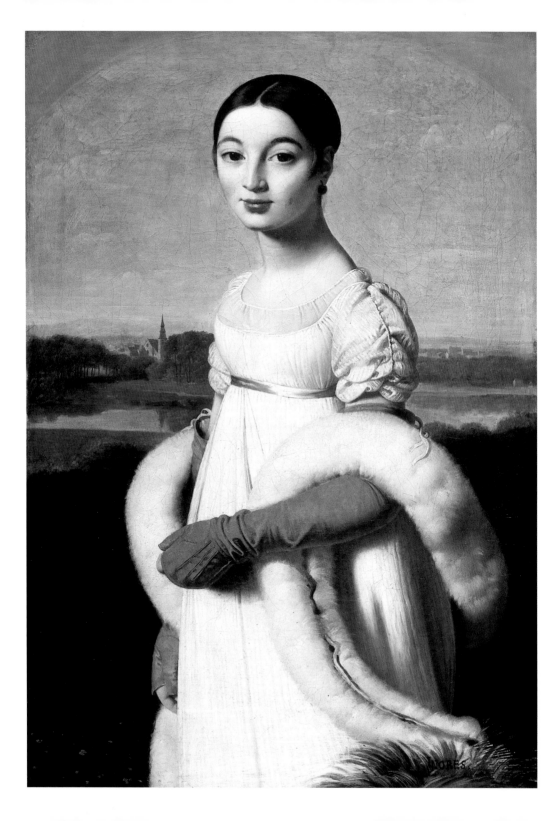

Sensing
a metamorphosis

Jean-Auguste-Dominique Ingres (1780-1867)
Mademoiselle Rivière, 1806
Oil on canvas, 100 x 70 cm (39½ x 27½ in)
Musée du Louvre, Paris

.

.

.

.

.

.

.

.

No doubt she is well-behaved, but waiting for the artist to finish is beginning
to try her patience. The session could go on forever and she has seen it all
before. If she were to start showing signs of being flustered, which seems
unlikely, Monsieur Ingres would take no account of it. He has already settled
on the harmonious calm of her portrait. Reality will have to accept this.

She is only thirteen years old, something that at first sight is not at all obvious.
Her expression may seem a little self-conscious, but this is surely a result of
the decorum required by the image. Nothing must seem impulsive or
spontaneous. This is a social question as much as it is an artistic one: the
young lady's portrait is to hang alongside those of her parents, also painted
by Ingres, and is intended to be a credit to the education that she has received
and to the values that she has acquired. The painting will attest to the quality
and prosperity of a family which in this way can assert its existence in the
eyes of the world.
 There is nothing, then, about the painting's pronounced sense of dignity
that should come as any surprise. Even so, there is something slightly
troubling about it, a lack of balance, a dislocation between the different parts
of the portrait that gives rise to a certain unease. The artist's contemporaries
noticed it at once, finding in the portrait a 'gothic' element which in the

language of the period meant the awkwardness apparent in the model's curious proportions. Her head appears to be rather too large. Her eyes, moreover, are strikingly far apart and draw attention to the flatness and length of the nose, while her fleshy lower lip draws the observer's eye to the lower half of her face, which is tiny compared to the breadth of her brow. Her cheeks tinged with rouge, and her neck unusually thick, while her shoulders have been almost entirely spirited away by the artist. In real life, one would have to pin the dress to the poor girl's flesh in order to prevent it from slipping off.

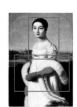

In the lower half of the painting, the register changes, and here the portrait breathes more freely. The bodice that was fashionable at this period has difficulty showing off a non-existent cleavage, but a slight movement causes the white muslin dress to billow, giving it volume and presence. The rather dry lines of the facial features blossom in the matching curves of the fur boa that is draped over her lower arms. In general, it seems that she is not entirely at ease, but her accessories offset her stiffness. Ingres did not like sharp angles and found here an ideal opportunity to hide the hollow of the sitter's arm and to lend this youthful body a sensuality of which she is as yet still innocent. The yellow gloves, the sheer brightness of which seems almost a violation of so understated an ensemble, play a major role in the image, implying a certain sophistication but also promising a revelation which, however decorous, suggests a symbolic progress towards greater intimacy. She is wearing them: she could remove them. But perhaps she knows or senses that a bare arm may induce desire.

And even if she herself is as yet unaware of this fact, Ingres knows it to his cost, for it was held against him when he exhibited this portrait in 1806. The gloves and the boa were not liked. They disturbed people, no doubt for the same reason that the artist was persuaded to include them: they suggest a sensuous femininity that we do not expect to find here.

Ingres painted many portraits of women and drew many pictures of children, but here he confronts a different prospect, working with a sitter who was no longer a child but not yet a woman. The period in which he lived had not yet considered the question of adolescence, and it is unlikely that he himself had done so either. But his trained eye was adept at seeing beyond accepted wisdom. He was bound to grasp the truth of the matter when it came to deciding between the young girl and the marriageable young woman. She is still growing, still incomplete, still confused. Her manners are those of an adult, but on the deepest level she lacks a grown-up's self-assurance, mimicking a pose whose logic means nothing to her body. No doubt she has been persuaded to demonstrate a certain allure and wear clothes that bear no

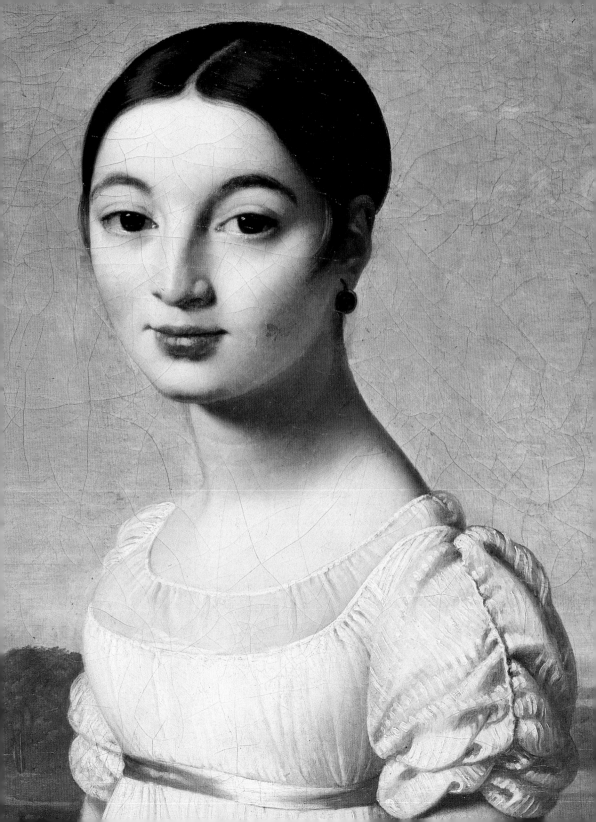

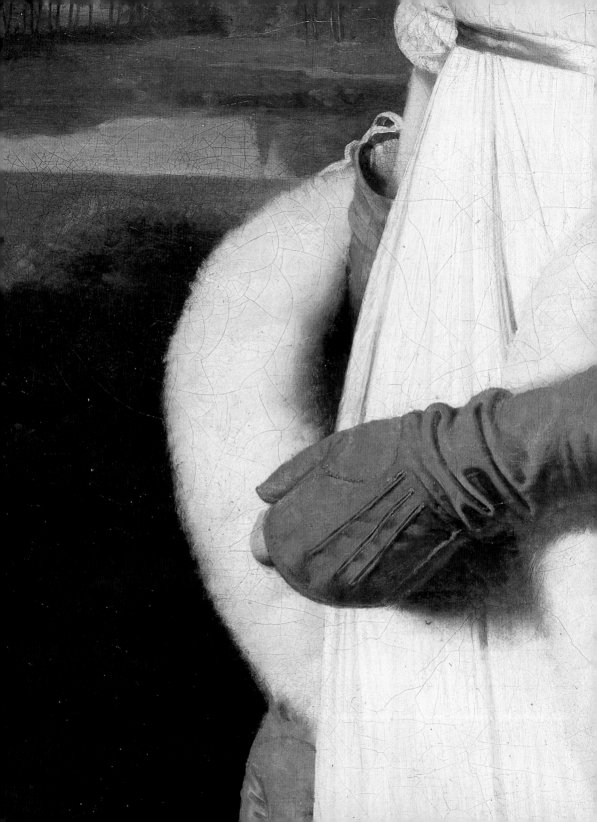

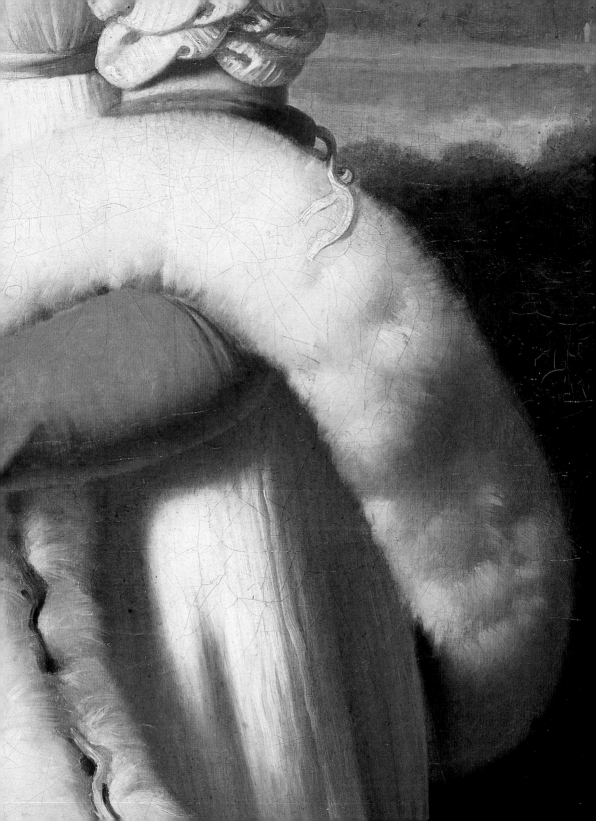

relation to her age, a demand placed upon her by the period in which she lives. This was how everyone behaved. And painting teems with images of young women whose age we should be hard pressed to guess. All of them appear accomplished. All except one: Mademoiselle Rivière.

Ingres conceals nothing. He professed that 'drawing is the probity of art' and here he gives proof of his punctilious approach. Young Caroline is undoubtedly a person in her own right, not some generic representation of youth. The artist reveals her complete with all her contradictions, her unattractive and hesitant proportions. Not everything about her has matured at an equal pace. This will come with time. Her awkwardness will fade. Ingres is actively teaching her to move, calming her with his curves. Her skin is fresh, untouchable, and even though the painting rests on the sharp balance between blue and green, the fur boa lends it warmth, making one want to reach out and touch it. Ingres draws the course of a caress.

Against the background of a passionless landscape, as calm as the water itself, he organizes a visual melody that unfolds around the young girl and acts as a prelude to the young woman that she will soon become. The form of the boa suggests another image, once again raising the question of the ambiguity of the painting. Apart from being an elegant accessory, it also recalls the outline of a swan's neck – the very bird that Jupiter turned into in order to seduce the beautiful Leda. Frequently found in Renaissance painting, the subject must have been familiar to Ingres, and a reminiscence of it, even if it were unconscious, cannot be ruled out. In any event, the coincidence is significant and adds to the image's latent eroticism.

Ingres has no time for exactitude: he prefers a beautiful curve to the particular shape of a shoulder, the stylized regularity of a face is invariably given precedence over some passing expression. But even if he insisted on the musical quality of the lines over the ordinariness of his model, his portrait cannot be reduced to an abstract exercise on his part, however inspired and however much such an exercise may be at the root of his reputation. For such an interpretation would overlook his perceptiveness and his respect for the truth. In its perfect sophistication, Ingres' portrait of Mademoiselle Rivière also shows – perhaps for the very first time – the potential awkwardness and embarrassment felt by young people growing up.

.

.

.

.

.

Ingres as a portraitist
●

Caroline Rivière (1793–1807) was only thirteen when Ingres – himself a young artist of only twenty-five – committed her likeness to canvas. By the following year she was dead. Her portrait was part of a triple commission, for Ingres was also invited to paint the girl's parents. All three portraits are now in the Louvre. In the course of his illustrious career, Ingres produced some sixty or so portraits, all of them among the most remarkable examples of their kind. And yet this type of painting was never particularly important in his eyes. As with many of his contemporaries, his ambitions lay in the field of history painting, a high-profile genre requiring extensive knowledge that was both technical and literary and bound up with major public commissions. Portrait painting offered the artist no more than a means of earning his living while waiting for large-scale projects. There is a certain irony to the fact that it is these 'secondary' works, rather than his large-scale and more conventional canvases that enabled Ingres to show what an extraordinary artist he was.

The form of the painting
●

Within the general harmony of the image, the choice of frame also plays a part, and the painter lavished great care on it. The rounded top of the portrait seems to echo the arched lines of Mademoiselle Rivière's eyebrows. Not only is the portrait of Caroline Rivière intrinsically well balanced on its own terms, it was also planned with a view to being hung next to the portraits of her parents. Caroline's father, Philibert Rivière, was an art lover who worked for the administration. Adopting an air that is both affable and serious, he is seen standing in front of a desk in his study. His portrait adopts the classical rectangular format. His wife, Sabine, is coquettishly curled up in an oval portrait. It is clear, then, that the young Caroline's portrait was intended to provide a logical transition between the solutions of the rectangle and the oval. The stiffness of her pose (the rectangular part of the arm) holds out the promise of a later softening (the rounded angles higher up). Ingres renders his model's age in abstract terms, relying on the relationship between the angle and the curve and suggesting an intermediary solution between the manly rigour of her father and the feminine gentleness of her mother.

Leda and the swan
●

Ovid mentions Leda – the beautiful wife of King Tyndareus of Sparta, who excited Jupiter's lustful desire – in Book X of his *Metamorphoses*: in order to facilitate his approach to the objects of his desire, the fickle god would change his shape. It was as a swan that he ravished Leda. The subject was often depicted by Renaissance artists, notably by Leonardo da Vinci and Correggio, and the formal allusion suggested by the ermine boa makes all the more sense when we recall Ingres' fascination with the art of the Renaissance. His favourite painter was Raphael, whose *Portrait of a Lady with a Unicorn* depicts a woman with shoulders similarly conspicuous by their absence and recalling the curious outline of Caroline Rivière. Above and beyond all individual points of detail, the constant references to Italy allow Ingres to invest the portrait as a genre with the dignity of the great classical tradition.

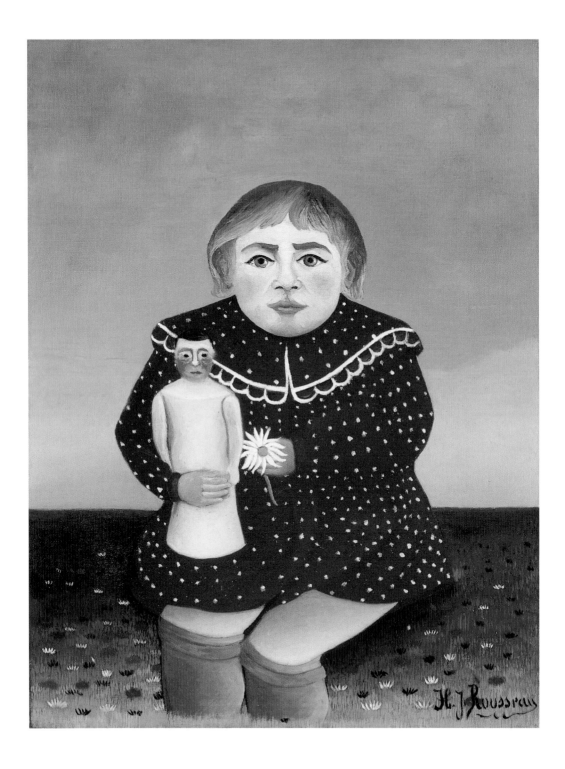

Glimpsing
primitive nature

Henri Rousseau ('Le Douanier') (1844–1910)
Child with Doll, c. 1906
Oil on canvas, 67 x 52 cm (26½ x 20½ in)
Musée de l'Orangerie, Paris

Everything is in place, properly arranged. Not a petal is missing from the flower: we can see at once that it is a daisy. It needs to be held up straight, but without being gripped too tightly, otherwise it will be crushed. It may already be starting to wilt. It is easier with the doll – at least it is solid. The clouds have been given the day off, and the sky is neat and tidy. Painting is a matter of some seriousness. There is no longer any movement. The child's head is forced down on its shoulders, her eyes fixed on the viewer without blinking.

The same can be said of the doll. True, the corners of its mouth are turned down, giving it a vaguely contrite appearance as if it could do nothing about it – it is here because it has to be, that is all. In comparison, the child has a look of wild determination in her eyes. The almost round face weighs heavily on the shoulders. But we all know that little children have chubby cheeks and no neck. The tiny hands stick out from sleeves that are just the right length.

We still have to decide where to put this plump little child. Any chair would do, her legs carefully tucked under the side. But that would be neither comfortable nor natural. The clean countryside is better suited to a young child, with little flowers as regularly spaced as on a floral fabric. But we also need to show a little imagination. After all, nature does as it likes. To add variety to the flowerbed, a little red recalls the colour of the dress, as

flavoursome as a strawberry, white echoes the daisy and little black shoots match the doll's head. This enables the artist to include his signature as discreetly as possible in the lower right-hand corner.

Is the child sitting on a chair or on the grass? It is hard to decide. A chair might be more appropriate, but grass would no doubt be preferable for the child. Whatever the answer, this type of model does not stay put, whether seated, standing or, as here, slightly askew. It would be better, then, to find some intermediate solution which would be more reasonable. And so we find the child caught between two poses, neither on the ground nor standing upright. Instead, her legs are buried in the grass up to mid-calf, thereby consolidating the pose. This undoubtedly suits Rousseau, who does not like painting feet, which have a way of hanging from the ends of the legs, without ever properly positioning themselves on the ground.

In essence, everything that Rousseau paints is true: the strange posture of the child, the limits imposed by her immaculate but constricting dress, the doll that has turned grey from being played with – a doll as important to the child as any living person and something that she certainly does not want to relinquish – and the socks pulled right up to her knees. The artist works by accumulating details. Once he has enough, his goal is achieved. He registers everything conscientiously and so diligently that he ends up exaggerating a little. He is not the man to beat about the bush or to get bogged down in vague allusions. The painting aims to say honestly what it is.

When one is keen on making oneself understood, it is no bad thing to insist on the essentials. The eyes, the eyebrows and the mouth obviously require the greatest attention, as these are distinctive elements in any personality. But the painter must have maintained a similar line of reasoning as he got further into his work, for all the different parts of it reveal the same degree of intensity. He imposes no sense of any hierarchy on things. The moment they appear in the painting, they all acquire the identical right of abode.

He concedes that the little flowers and the grass that join up with the horizon may grow darker and that the line in the distance may become blurred. After all, Rousseau is not unfamiliar with the tradition in which he is working or with the rules of perspective. But he prefers to restrict the use of artifice to the background of the landscape. It is a question of authenticity. The human figure, by contrast, maintains a frontal stance of undeniable dignity as in those medieval paintings in which Christ contemplated humanity head-on. This child is not a Biblical figure, and yet her portrait reminds us of the solemnity of ancient images and seems greater as a result.

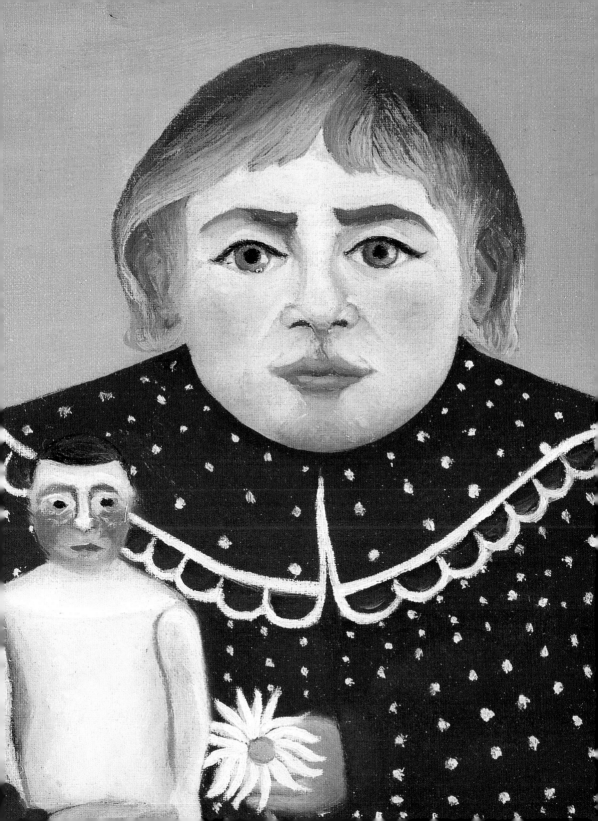

By accentuating the form of things, Rousseau ends up destroying their natural balance. He makes things larger or smaller or more precise. In order to stick as closely as possible to the world of appearances, he draws certain outlines with a stubbornness that finally distorts their meaning: his model possesses features so marked that it is difficult to recognize a child in them. She seems to be wearing eye makeup and her eyebrows have been redrawn, just as her mouth is too sure of itself. The lines in her skin are turned into folds, and the shadow that bathes the lower part of her face is so deep that we are inevitably reminded of a badly shaven beard.

If we examine them one by one, the elements that make up this portrait are all believable. It is the way in which they have been put together that is disconcerting. The child's hands and head seem uncertain as to whether they are attached to the same person, while her legs lead lives of their own. And her expression does not seem to belong to her.

In spite of all this, the image works. It has a disquieting aura that Rousseau almost certainly never intended for he was obsessed by the idea of 'realism' and dreamt of possessing the technique of an academic painter. In vainly pursuing what was in truth a trivial goal, he succeeded in achieving a different one, a goal whose scope he could never have hoped for. The force of his painting lies not in its ability to capture appearances but in its direct relationship with what those appearances hide.

Perhaps without intending it – for, much to his regret, he was excluded from the world of academic painting – he draws from his model something that had been buried until then, a fundamentally archaic element, which is why this image of a child, planted in the earth like some prehistoric statuette clutching its grown-up doll, is much closer to the idea of a primitive celebration and to the invocation of the life force than it is to a middle-class portrait. As such, it implies everything that we associate with vague power, seriousness and terror.

.

.

.

.

.

.

.

.

.

.

The child's dual nature
●

We may still suspect, of course, that the child's implacable seriousness, as painted by Rousseau, is the result of the technical limitations of an artist unable to capture the youthfulness of his model. None the less, it is by no means unprecedented in painting to find a discrepancy between the apparent age of a child and the adult expression on its face. Throughout the Middle Ages, religious iconography stressed the solemnity of the infant Jesus in order to underscore His dual nature, both human and divine. By the same token, there are many secular portraits of children in the seventeenth century that use this device to underscore the merits of a formal education. More spontaneous images first began to appear at the time of the Renaissance, and these included sacred subjects, but in gaining verisimilitude, they lost something of their ambivalence. Freed from all theological and social constraints and conventions, Rousseau's portraits of children hark back to this ancient duality, albeit on a different level. Although Rousseau himself almost certainly did not realize it, they reveal him to be a contemporary of Carl Gustav Jung (1875–1961) and of the latter's writings on depth psychology. In one of his autobiographical texts, Jung wrote that 'Somewhere deep in the background I always knew that I was two persons. One was the son of my parents, who went to school and was less intelligent, attentive, hard-working, decent and clean than many other boys. The other was grown-up – old, in fact – skeptical, mistrustful, remote from the world of men, but close to nature, the earth, the sun, the moon.'

Naïveté as a choice
●

Rousseau's sketches deal exclusively with landscapes and are very different in style from his completed works. Their light, rapid, impressionist manner belies the long-held view that he was unskilled as an artist. The polished quality of his paintings, their precise draughtsmanship and their organized, large-scale use of colour reflect a conscious choice and in his own words determined 'the original genre' that he had adopted. His various sources of inspiration, from magazine engravings to academic art and from Renaissance paintings to Persian miniatures and photography, were in this way absorbed into a style of studied ingenuousness. In a letter to André Dupont that he wrote shortly before his death and that was published in Les soirées de Paris on 15 January 1914, he explained that 'If I have kept my naïveté, it is because M. Gérôme [the famous academic painter Jean-Léon Gérôme (1824–1904)] always told me to keep it. […] You must realize that I cannot now change the manner that I have acquired with such stubborn labor.'

Rousseau's admirers
●

Among Rousseau's many admirers were the writer Alfred Jarry (1873–1907) who, like Rousseau, hailed from Laval and who was one of the first to leap to the artist's defence in 1894; the artist Robert Delaunay (1885–1941), one of his most fervent supporters, who began collecting his paintings when he was twenty-two; the poet Guillaume Apollinaire (1880–1918), who wrote several texts, including some highly fanciful ones, on the painter; and Pablo Picasso (1881–1973), who owned several of Rousseau's canvases and who in 1908 gave a famous banquet in his honour in his studio at the Bateau-Lavoir.

Adapting
to circumstances

Pablo Ruiz Picasso (1881–1973)
The Aubade, 1942
Oil on canvas, 195 x 265 cm (76¾ x 104¼ in)
Musée National d'Art Moderne, Centre Georges Pompidou, Paris

.
.
.
.
.
.
.
.

Two women. The anatomy of the one lying down is fairly clear, at least as far as the identifiable parts are concerned. But for the other figure, the situation is less obvious. Even so, it is possible to infer her femininity from her skirt – a kind of indirect proof.

She is holding a mandolin in her lap and observing her companion, while her other eye faces us directly. The companion seems relaxed, her hands raised above her head in an attitude of lazy indolence. Her dark hair is impeccably groomed and falls down neatly over the side of the bed, even if it looks as though a rake has been used in preference to a comb. The striped mattress is pitching and turning and seems about to tip over, enabling us to see the nude very clearly and to follow the complicated course of her curves and counter-curves.

The bed does not look very comfortable, its coverlet too thin and stiff. In general, it is at odds with the woman's apparent well-being. One thinks of a prisoner's straw mattress rather than a hotbed of prospective passion.

The year is 1942 at the time of the German occupation of France. Beneath a roof that is too low, there is a palpable lack of air. The colour of the cement runs the whole gamut from grey to black and from black to every shade of grey. The shadows taper to a point. In its corners, the room hesitates between

offering protection and posing a threat. The corners hollow out a space, or alternatively they turn in on themselves and project inwards, lunging at the people inside the room. Its interior is distorted like a cardboard box that has been forced out of shape. With the top of her pointed head, the woman with the musical instrument establishes a kind of strange harmony with these angles. The coincidence is merely apparent. The incoherence of the figures is dictated by an alternative logic.

The figures look as if they have been smashed to pieces and someone has then tried to put them together again without knowing quite how to go about it. In their haste, they found it impossible to recall how the pieces fit together, and it was equally impossible to find all the missing bits. Some must have rolled away, or else the impact reduced them to smithereens. Also, someone is watching, so speed is of the essence: the pose must be re-established, just as if nothing has happened. The result is a curious mixture of calm and turmoil. The world is out of joint and yet everything in it is still recognizable.

We recall a time of peace. Or at least we recall certain moments. Glances, mere trifles. Inconsequential things. Like history itself, the photograph has been torn up, and only fragments remain, fragments that will be stuck back together again only imperfectly. There is no longer any sense of continuity that might link one event to another, none of those insignificant moments that we felt slipping through our fingers but which still had time to last. A sense of urgency has broken this thread. All the fragments of reality have acquired the same degree of importance, each of them counting for even more than it did before. They bear witness to what has been saved.

It is an odd time, an odd place for an aubade. The subject recalls a long tradition extending from sixteenth-century Renaissance Venice to the nineteenth century of Ingres, all of whom celebrated the union of visual and musical beauty, combining the curves of the flesh with arching melodic lines. From the secrecy of an imaginary harem to the heights of Mount Olympus, odalisques and other goddesses of love would listen languorously to music invariably echoed by their bodies. They were images of desire in a world in which the art of love would always have the force of law.

One might think that little of this had remained. In her obstinate desire to mimic such models, Picasso's patched-up reclining woman might easily trigger a sense of sarcasm. As for the other figure, there is little risk of her playing her instrument, for it has no strings, and so becomes an ironic presence.

Why use a painting to mistreat a subject that had once expressed the notion of perfect beauty? But also, how can one see such a world with any

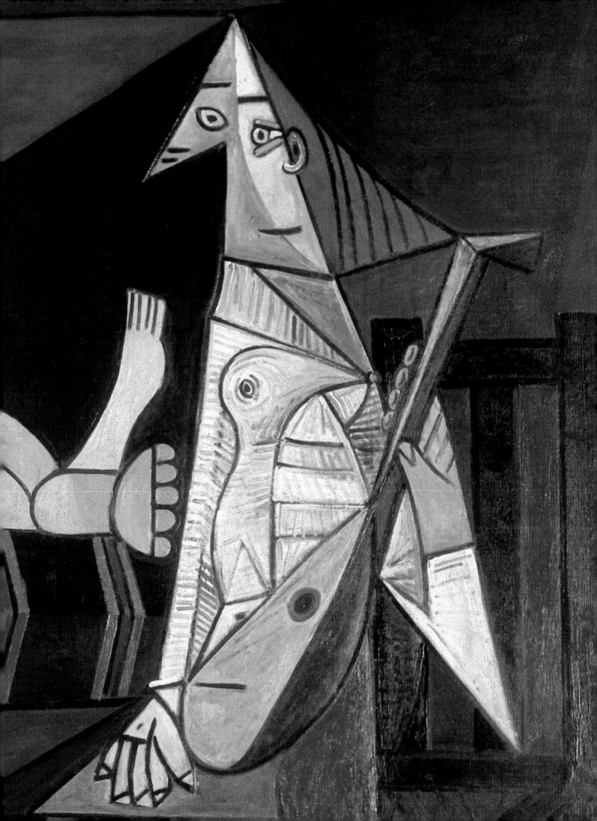

clarity in this time of horror? The proper proportions have been lost. The instructions on how to use beauty have been thrown away. How can we accept that history is suspended when the present is so appalling? Why not do everything in one's power to recall this beauty even if the result is no more than a distorted vestige of it?

The elements that make up these women could come from different people. It would not be the first time that an artist had proceeded in this way. Early artists, especially those of classical antiquity, used to choose the best parts of various models in order to produce an image so beautiful that it could not exist in nature: they would take the form from one, the small of the back from another, the face from a third, and so on. In this way a sculpted or painted body was a kind of compendium, a collection of parts which, taken together, created an ideal impression.

The heterogeneous quality of the bodies painted by Picasso may make one think that he, too, proceeded in the same way, deliberately stressing his models' disparate nature. His personal approach to classical customs becomes an apology for recycling. He paints a recycled nude. The criterion is no longer absolute beauty nor even beauty at all, but existence plain and simple.

Picasso does not destroy anything. Thanks to him, his figures maintain their pose, waiting for better times and seeming to meditate. He helps them to hold out. By giving them life, he lends a helping hand to hope. Moreover, the hand that grips the mandolin rises up in such a way that it is impossible to say for certain to whom it belongs: is it the left hand of the woman or the right hand of the artist? The painting brings together scraps. Its figures adapt to confused reality, playing along. A frame lies empty on the ground. Some images have fled, but others will come.

The mandolin player is seated, bent over the side of her chair, ever ready to rise to her feet, her soles covered in soft grey felt. On her belly is the outline of a bird. Her skirt is the colour traditionally associated with mourning: the scene that we can see here has something ceremonial and solemn about it. But her hair is green, her face entirely blue. Life is stirring. Nature is getting ready. The fields are not far away, nor is the sky. The painting offers the prospect of future freedom.

.

.

.

.

The theme of the serenade
●

The subject here is directly related to Ingres' 1839 *Odalisque and Slave*, now in the Fogg Art Museum in Cambridge, Massachusetts, a canvas in the pseudo-oriental tradition that was fashionable in the nineteenth century. In turn Ingres' painting is a variant on a theme already treated by Titian in his 1550 canvas *Venus and the Organ Player*, now in the Prado in Madrid and painted for Charles V, a work so successful that it inspired a whole series of imitations. Whatever the couple's erotic charm, the reclining nude and the musician expressed the harmony of a world which, like music, was based on numbers. Moreover, the glances exchanged by the figures were combined with the theme of music to underline the idea of the fundamental harmony between the senses of sight and hearing, a popular theme among the neo-Platonic philosopher of the Renaissance. But the theme of music acquires particular significance when associated with the Bible, which ascribes a healing power to it, claiming that it was capable of driving away melancholy. When King Saul was plagued by an evil spirit, his servants advised him to 'seek out a man, who is a cunning player on an harp; and it shall come to pass, when the evil spirit from God is upon thee, that he shall play with his hand, and thou shalt be well' (I Samuel 16:16–17). 'And it came to pass, when the evil spirit from God was upon Saul, that David took an harp, and played with his hand: so Saul was refreshed, and was well, and the evil spirit departed from him' (I Samuel 16:23).

The connection with history
●

There may be no visible sign of war in this painting, and yet war is its subject. Rather than depicting an episode from it, Picasso shows how it can blight our relationship with the outside world. Here actuality is not understood in the sense of a collection of subjects but as a constraining filter through which we see reality. To a certain extent the image is submerged in history, interdependent with the chaos that from now on determines its means of representation. Locating an image in its historical context is essential if we are to understand its significance. This is a general principle that is particularly well illustrated by Picasso's paintings. In a conversation with Brassaï on 6 December 1943, he asked: 'Why do you think I date everything I make? Because it's not enough to know an artist's works. One must also know when he made them, why, how, under what circumstances.'

The beautiful and the ugly in the painting
●

Painting traditionally reserved ugliness for the wicked. Villains and executioners, the practitioners of vice and demons had been monstrous and deformed for centuries, making it easy to identify them. It was an ancient convention dating back to classical antiquity and reactivated by the writers of the Renaissance, who equated beauty with goodness and truth. With Picasso, the equation no longer holds true. Truth is not necessarily beautiful, the ugly may be good and tenderness twisted. The reality of our sensations and the viciousness of the truth shatter all existing conventions: the artist pays his debt to life by allowing it to show itself without the need for makeup.

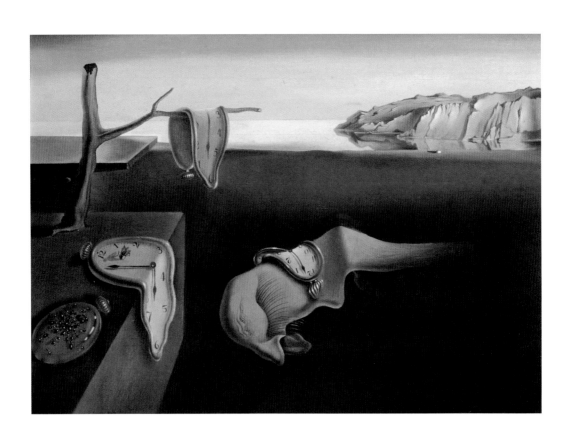

Abandoning the evidence

Salvador Dali (1904-89)
Persistence of Memory, 1931
Oil on canvas, 24 x 33 cm (9½ x 13 in)
Museum of Modern Art, New York

.

.

.

.

.

.

.

The clocks are starting to melt. They must have caught the sun while lying there on the beach. The metal could not withstand the heat. Normally it is time that is fluid. 'Time passes,' we say, an expression which, however banal, at least has the merit of clarity. The painting, too, is clear. And smooth. As regular as clockwork. But not anymore – we need to change our point of reference. How shall we manage if we can no longer rely on our watches? All those missed appointments. It is impossible to adjust these watches. Perhaps time is melting after all. Perhaps it has always done so.

The trouble is that time is not a great healer - in spite of what people say. It kills things, then causes them to rot. Left to its own devices, time enjoys itself. It cannot be controlled, no more than we can control these clocks and watches. Time attracts ants and releases flies. Not that we need to be specially wary of them: the eyes of flies are wonderful organisms, admirably faceted structures, and so precise. The artist envies them – he needs a jeweller's magnifying glass to trace things that a fly would have grasped at once. The fly that has settled on the largest watch outpaces the minute hand, suggesting that time is not yet passing quickly enough for it. But then the fly has precious little time at its disposal: from the standpoint of its very short life, it does not have a minute to lose. Certainly not five.

And yet even if the hands of time fight back, it will soon be impossible to make out anything at all, for the three clocks show different times. The internal mechanism of one of them has already gone wrong, which is hardly surprising, since it is here that the fly has settled. No matter, we shall go elsewhere. Given the time difference, there must be somewhere in the world that corresponds to the folly of these hands. And who says that we need to know what time it is anyway? The moment we consciously lose ourselves in our thoughts and dreams, we gain our independence. Faith can sometimes move mountains, but desire outstrips all time zones, transporting us wherever we want, no matter what time of the day or night. No one can find us there. There are no signposts on the pathways of our dreams and we can slip away without leaving a trace. Or else we can leave a false trail. People won't have a clue.

But why would one want to move mountains? The ones seen here are perfectly suitable and are certainly unmoveable. The rocks at Port Lligat had been there for as long as Dali could remember, which is fortunate, because everything else has the curious habit of slipping away.

If this process were to continue, the world would become viscous and turn into a veritable jellyfish – just like the one that lies sleeping beneath one of the watches, which serves as a miniature quilt. It is just right for the job, the type of very heavy blanket that keeps sliding to the floor while one is asleep. By the morning, you are chilled to the bone. Is it not a jellyfish? Oh well. Perhaps it is the idea that we have of one. Or not even that, rather the absence of an idea. A disturbing little creature, but it does not look too dangerous as its eyes, with their long lashes, are closed. A strange pointed profile with the flesh of a mussel. One never knows what to believe or what appearance to trust without taking too great a risk. It is the common-or-garden duplicity of life. Even so, it is a curious self-portrait. The artist has done himself no favours. He parades his nightmares and gives them fixed form with his implacable paintbrush. It is he who stuns them, turning them to stone with the fixed stare of the classical Medusa. He paralyses them, then lays them down with great delicacy like well-cleaned samples of delirium on a canvas that was waiting for nothing else. He is an entomologist of the brain.

Who will dispute that what Dali paints is real? Perhaps only someone who has never dreamt, never felt fear or admitted that their most private terrors extend beyond the blurred confines of our waking lives, when our fears leave the sheets soaked with sweat. They will have to be washed and left out to dry in the sun. Perhaps the clock, too, will dry out. It is hanging there over the branch of an olive tree. It is not solid, this branch, but dead, and will soon break off. The clock is liquefying, as thick as oil. Olive oil. Everything is becoming confused.

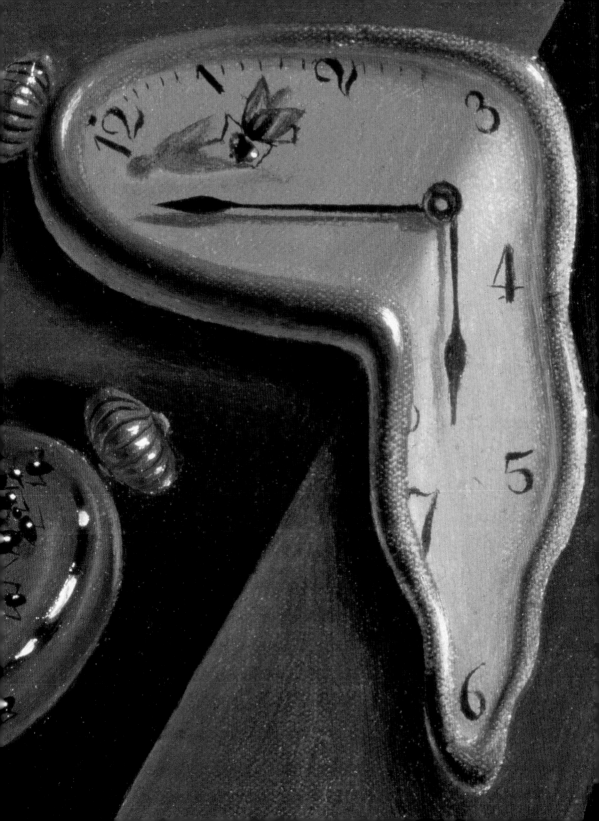

In the face of madness, the artist has a weapon to hand: his profession as a painter. It is not because reality threatens to fall apart around him that the image must do the same. Dali is not necessarily in control of his fears, but he has no difficulty in mastering the art of painting. Academic know-how has no secrets for him. The brush would no more slip from his hand than he would lose his hold on reason. The painter's invisible brushstroke is his final refuge. He reveals his unease by hiding between layers of paint so fine that the material is above suspicion. The result is a battle between the insidiously expanding reality and the paint that seeks to contain it. The assurance of the gesture upholds the forms that are about to fall apart. The painting articulates the dream and allows it to develop its own secret coherence. But it places limits on the hallucination, its four sides placing it under arrest.

The very act of painting holds the threat at bay, and Dali increases the effectiveness of the image by basing it on a paradox. The more incongruous the elements, the more they are held together by the details of the design. And the more clinical the description, the more disturbing the forms become. It is a vicious circle. The calm of the hand proves as frightening as the dull torpor of reality. The exercise demands the balance of a tightrope walker.

Objects no longer obey us. We do not know from which side to approach the simplest reality. There comes a point at which we grow tired of seeing definitions breaking their necks. In order to find a recognizable landmark we need to retrace our steps and go back to the very beginning. This is no doubt one of the reasons why Dali's work remained traditional even if the content of his images almost exploded and sanctioned this inner discourse that functions without a recognizable language. In this respect he comes close to the artists of the Renaissance. He is faithful twice over, both aesthetically and to himself. He paints in a way that recalls the masters of the past but also because he learnt to do so in his youth. The certainties of those early years provided him with a safeguard. From one painting to the next, his technique was never to vary, providing him with a defence against which his nightmares were powerless.

In the background, the cliffs of Port Lligat attest to the fact that childhood landscapes do not change. They are fixed in the mind, on the horizon of all our memories. Time leaves life misshapen, as if it has been washed too often. It may reduce it to rags and tatters, but what of it? The beach will always glisten.

.

.

.

The terror of softness
●

'It was on an evening when I felt tired,' Dali explained in his autobiography, 'and had a slight head-ache, which is extremely rare with me. [...] We had topped off our meal with a very strong Camembert, and after everyone had gone I remained for a long time seated at the table meditating on the philosophic problems of the "super-soft" which the cheese presented to my mind. I got up and went into my studio, where I lit the light in order to cast a final glance, as is my habit, at the picture I was in the midst of painting. This picture represented a landscape near Port Lligat, whose rocks were lighted by a transparent and melancholy twilight; in the foreground an olive tree with its branches cut, and without leaves. I knew that the atmosphere which I had succeeded in creating with this landscape was to serve as a setting for some idea, for some surprising image, but I did not in the least know what it was going to be. I was about to turn out the light, when instantaneously I "saw" the solution. I saw two soft clocks, one of them hanging lamentably on the branch of the olive tree.' Dali's fascination with the 'super-soft' is found in many of his works in which the terror of death merges with the nightmare of impotence.

The Catalan countryside of Port Lligat
●

Dali was born at Figueras, and his inspiration was bound up from the very beginning with the countryside around the Gulf of Roses, Cadaques and the coastline around the Cap de Creus. They are an integral part of his conception of the world and consequently occupy a large place in his paintings. It is the rocks around Port Lligat, where he settled in 1930, that provide the most frequent backdrop for his compositions. They are not only landmarks from his youth but also disconcerting forms in a state of constant transformation, introducing to his work a note of calculated ambivalence and a sense of incongruity that is one of the most powerful triggers for any surrealist image. 'The long meditative contemplation of these rocks has contributed powerfully to the flowering of the "morphological esthetics of the soft and the hard",' Dali wrote in his autobiography. 'All the images capable of being suggested by the complexity of their innumerable irregularities appear successively and by turn as you change your position. This was so objectifiable that the fishermen of the region had since time immemorial baptized each of these imposing conglomerations – the camel, the eagle, the anvil, the monk, the dead woman, the lion's head.'

Symbolic insects
●

In Dali's iconography, ants are associated exclusively with death, whereas flies enjoy a position of considerable symbolic esteem. He sees in the latter agreeable companions that follow his own line of thinking: 'They are the muses of the Mediterranean Sea. They inspired the Greek philosophers who whiled away the hot hours of the day lying in the sun, covered in flies.' The legend of the fourth-century Catalan martyr, Saint Narcissus, adds an element of local heroism to this belief, inasmuch as it was said that ferocious swarms of flies were released by his uncorrupted body in times of danger, as was apparently the case in July 1653, when the armies of Louis XIV were routed during the siege of Gerona. Dali also refers to the satirical Greek writer Lucian of Samasota who in his second-century dialogue 'In Praise of the Fly' notes that the eye sockets of this delightful insect take the form of parabolas, 'thereby constituting a pre-echo of the structure of the canopy over the station at Perpignan, which, as everyone knows, lies at the very centre of the world.'

Taking account of what appears confusing

It is common for people to feel perplexed by a painting. One reason is that it may deal with a subject which we know nothing about. Before we set foot in a museum or stand in front of a painting, we can hardly be expected to have familiarized ourselves with the contents not only of the Bible and the Apocrypha but also with the legends of myth, the events of history and the whole repertory of every known symbol. Temporarily frustrating though this inconvenience may be, it is relatively easy to rectify: we need simply to consult a dictionary or some other handbook to find an initial answer to our questions. The identity of the figures and the meaning of the scenes that have been depicted can all be explained, as can the justification for a particular setting or costume. Perhaps the enigma of a particularly subtle form of iconography may remain unresolved but only on a level that the intellect finds stimulating. As such, it is problematic in an entirely positive sense.

The real confusion arises when the viewer has no idea where to start looking as the painting contains no landmarks that would provide a point of entry. The title is not always of any help and may even add to the confusion. Some works are like shifting sands, causing us to lose our way even before we have set out on our journey. Depending on the case in question and our own state of mind, we may find the matter more or less discouraging, but at this stage the prevailing idea is simple: we understand nothing, or next to nothing.

But a painting rarely speaks in riddles. The canvas waits to be explored. It matters little where we start once we have agreed to devote our time to it, for it will give up its secrets only by degrees. By delaying that process, it gives us the misleading feeling that we are missing something essential, whereas it is in fact encouraging us to question the validity of what we can see. Nothing is handed to us on a plate. Sometimes we have to change direction and mentally put on a different pair of spectacles. A painting deliberately sows confusion in order to make us more vigilant and pay closer attention to the real world. Above all, it is the space within which a journey takes place, and the destination of that journey is ultimately only of secondary importance.

Making allowances for mystery

Anonymous Provençal artist, middle of the fifteenth century
The Boulbon Altarpiece, c. 1460
Oil on wood transferred to canvas ; maximum dimensions 172 x 227 cm
(67³⁄4 x 89½ in)
Musée du Louvre, Paris

.

.

.

.

.

.

.

The scene is implausible, harsh, cold and as cruel as the light that dissects it.
One wonders how to trust such an image. There is no sense of grace, no
promise of hope that invites us to linger over this painting. The pale figure of
Christ rises up from His sarcophagus, holding His hands crossed in front of
him as if they are attached to each other. Blood flows from His wounds. He
has already been crucified. But the painter depicts Him standing, both living
and dead, already resurrected but still suffering untold agony.

Beside Him are two people who seem unaffected by all that is going on. But
how could they notice anything? After all, they are praying, while we
ourselves, dumbfounded, simply seek an explanation. Serenely they
contemplate a scene that strikes us with the force of its cruelty. Words of gold
escape from their lips and are written in gothic letters on the black
background. The one standing figure undoubtedly holds the greater
authority. He is wearing a bishop's vestments and proclaims his faith, *'Haec
est nostra fides'* (This is our faith), while placing his right hand on the head of
the other man, who is kneeling down, his hands clasped together. The
benefactor who commissioned the painting, petrified in the presence of his
patron saint and of the oversized vision of Christ rising up from His tomb,
begs our Saviour's mercy with the words *'Salvator mundi miserere mei'*

(Saviour of the world, have mercy on me). A stone has rolled beneath the cover of the sarcophagus. The canon has placed his red biretta on it. Never has he been as close to Calvary as this.

Behind them the town lower down the hillside is indifferent to the scene that plays out before us – unless, for them, the events in question have already taken place some time in the past. A soldier raises his head. He was there. He knows. The ascending road may pass through Provence or the Holy Land: it is all the same. The banality of everyday life persists in spite of miracles. In this way we still have a chance to resume our daily lives after the terror of revelation. A window needed to be opened somewhere to allow the air to circulate. The artist did not forget this.

Between the two figures on the left and Christ in the centre is a further presence whose scale is well suited to the only space that was left for Him: God the Father is depicted on the other side of a wall that is as opaque as human ignorance. He fixes His eyes on His son. His grey hair sets him apart, but otherwise their features are identical. The theological debates of the time led artists to prefer this non-controversial symmetry. The two figures are linked by the dove of the Holy Spirit, one of its wings in each of their mouths and, as such, creating a perfectly balanced image of the Trinity, which in this way seems to be caught between two mirrors in a *mise en abyme* centred upon Christ's suffering.

The sombre solemnity of the image demands the believer's attention and indeed leaves us with little choice. The body of Christ is presented to us all like the host in the hands of the priest. His flesh is as pale as the bread of the Eucharist. His bright red blood has just flowed as freely as the wine of the Mass. The service, after all, is no commemoration but a celebration of something that is unceasing. The painting reawakens the believer who was dozing off during the Mass and projects us into the perpetual presence of Christ's sacrifice.

The vision deals a crushing blow. There is no doubt that the kneeling canon understands this: his presence in the painting is reassuring. We must be grateful to him for having commissioned the piece and even more so for appearing in it, human as he is, beside the Holy Trinity. From here he will intercede on behalf of those who are afraid for their soul's salvation.

Around these figures the painting abounds in allusions. The believer must not be allowed to do no more than brood on the Passion of Christ in the abstract. The objects depicted here help us to imagine it: each of them bears within it a memory and triggers an association of ideas, in the process reasserting the truth of the underlying facts. The episodes that have been recounted on so many occasions gradually fall into place: the container of water in which

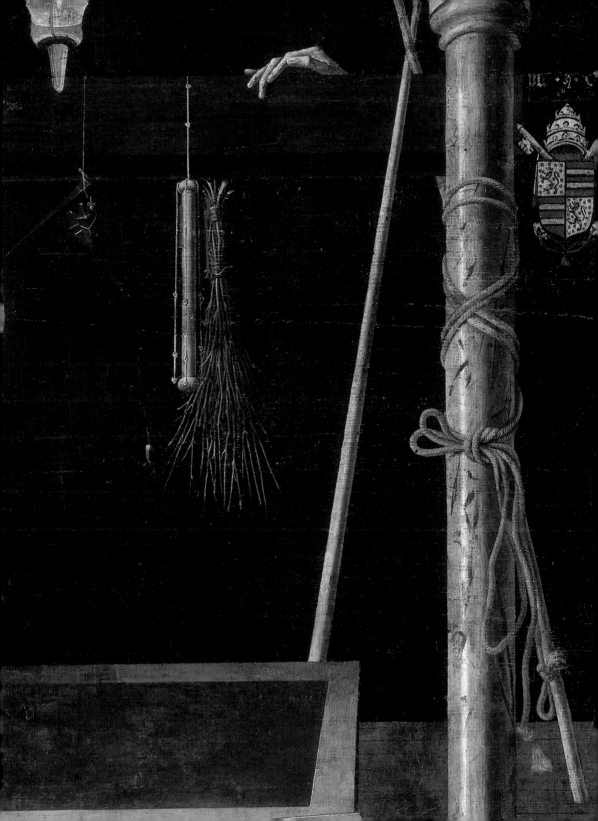

Pilate can wash his hands; the panel with the name of the condemned man suspended above His halo; a lamp to shed light on the act of betrayal; and the nails hanging from the transverse beam of the Cross. One of them is pointing towards Christ's flesh. Also here are the whip and the rods used to flagellate our Saviour; the main upright and the ropes used to lash Him to it; the sponge dipped in gall and stuck to the end of a pike; the lance that pierces His side; and a hand capable of smiting Him. So many scattered witnesses to the Crucifixion arranged in permanent readiness – we can observe them in any order and are free either to incorporate them or not. Whatever we choose, they all point to the selfsame horror. There is no escaping from that. It is like recalling a terrifying event whose details jostle for attention in our memories. As carefully as we can, we retrace the different stages, one by one, until a particular memory fails, emotion takes over, and everything grows confused. All that remains is the evidence that we shore up: the crucified body of Christ.

In this way the discontinuity of the composition reveals a twofold reality: the violence of the facts and the detailed links between them; the light that is too bright and the darkness; what we suffer and what we can barely decipher. The appearance of the instruments of the Passion is no less surreal than that of the crucified Christ, and the painting as a whole strikes us as if it were a vision. But in the uniqueness of the surreal experience, the viewer discovers different rhythms. Gripped by the painful immediacy of the figure of Christ, our attention is caught by the various objects that mark out His story and we veer between an immobile present and an obsessive succession of events. We meditate and reflect, we worship and remember.

Between the emotional force of the painting and the rational journey on which it takes us, the work is ultimately a lesson on the Passion. To those of us who contemplate it, the image also recalls that this world of ours is full of signs and that their meaning is often lost. What takes place here goes beyond the subject for a lesson, and the painting that teaches it continues at the same time to reaffirm its mystery.

The Man of Sorrows
•

The iconography of the Man of Sorrows is bound up with that of the Mass of Saint Gregory. This type of image was all the more popular in the fifteenth century in that it was possible to obtain an indulgence – a reduction in the time spent in Purgatory – by praying to it. It depicts a miracle that took place while Pope Gregory the Great (c. 540–604) was celebrating Mass: when one of his assistants questioned the real presence of Christ in the host, Gregory began to pray, and Christ Himself appeared on the altar, surrounded by the instruments of the Passion, the *arma Christi*. This late legend, which arose in Rome, locates the miracle in the Basilica of the Holy Cross of Jerusalem, to which the Empress Helena of Constantinople had once brought soil from Golgotha. The vision is said to have been inspired by a mosaic in the apse depicting the Man of Sorrows. The subject also recalls the writings of Saint Gregory, whose *Sacramentarium* contains the words of the Mass. In this way it symbolizes the priest celebrating the sacrifice of the Mass in front of Christ Himself.

Debates on the Trinity
•

The Latin Church argues that the Holy Ghost proceeds from God the Father 'and the Son', from the word *Filioque*. This word gave rise to lengthy theological arguments with the Eastern Orthodox Church, debates to which the Council of Florence put an end in 1439. From then on representations of the Trinity had to make clear the essential balance between the Holy Spirit (the dove), the Father and the Son.

Saint Agricola
•

The saint standing to the left of the painting was the bishop of Avignon from 650 to 700. He is seen here with the man who commissioned the painting and who is believed to be Jean de Montagnac, demonstrating his protection by holding out a benevolent hand. The painting was intended for the priory at Boulbon near Tarascon, but Jean de Montagnac was also a canon at Saint Agricola's Church in Avignon, hence the presence of Saint Agricola here. His attribute is the bird in the lower right-hand corner: storks had miraculously helped to rid his diocese of the snakes that had been infesting it.

The inscriptions
•

The *titulus* – the piece of wood hung round the condemned man's neck and then placed on the top of the Cross – bears the initials chosen by Pontius Pilate, 'INRI', which stand for '*Iesus Nazarenus Rex Indaeorum*' (Jesus of Nazareth King of the Jews).
The canon's prayer, '*Salvator mundi miserere mei*', is taken from the opening verse of Psalm 51, one of the seven penitential psalms: 'Have mercy upon me, O God, according to thy lovingkindness.'
The words placed in the mouth of Saint Agricola, '*Haec est fides nostra*' (This is our faith), are inspired by the First Epistle of John: '*Haec est victoria quae vincit mundum, fides nostra*' (And this is the victory that overcometh the world, even our faith; John I 5:4).
The reference to this last-named text is significant: the donor, also called John, is symbolically accompanied by his patron saint when he is presented by Saint Agricola. At the same time, only the Gospel of Saint John recounts the episode in which Christ was struck by an officer with the palm of his hand during his trial (18:22), an incident recalled by the hand placed on the wooden beam.

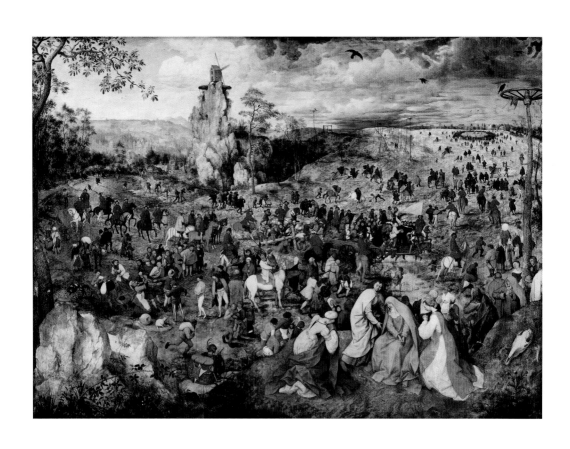

Taking time
to be wrong

Pieter Bruegel the Elder (1525/1530-69)
The Bearing of the Cross, 1564
Oil on wood, 124 x 170 cm (48¾ x 67 in)
Kunsthistorisches Museum, Vienna

The image teems with people. The viewer scarcely knows where to start, for the painting invites us to look everywhere at once without giving us any reason to linger longer in one place rather than another. Its lack of order is disconcerting. Sometimes the artist amuses us much as he might do with a game. The little figures, colourfully dressed and rushing in all directions, encourage us, too, to lose ourselves in the crowd. It is tempting to follow one or the other of them and watch them argue, share in some casual encounter or run after the man who is busying himself with his bags in the presence of some urchins who appear to be baiting him. The possibilities are endless, and they can end up making our heads spin.

In the foreground to the right of centre are four figures larger in size than the rest, their stillness setting them apart from the scenes of commotion behind them. The sight of their grief does not immediately throw any light on the meaning of the painting. They seem to be elsewhere, caught up in their own private story. The large blue veil of the woman who is clearly about to faint and the cloak of the man hurrying up to help are from another time, a time as ancient as their suffering. The Virgin with the pallid complexion and the figure of Saint John beside her are replaying the role they assumed in hundreds of other paintings. The Holy Women accompanying them echo their despair.

This is a scene that ordinarily unfolds around the body of the dead Christ when He is taken down from the Cross or His weeping mother cradles Him in her lap, as if He were still a child. But the painting depicts neither a Deposition nor a Pietà. Christ is no longer here. And we realize that their grief is increased by this sense of remoteness. History has already run its course and come to an end, extended into the present only in their memory, where it remains an open wound.

What we see in this image, initially only indistinctly, is the substance of their thoughts. A handful of landmarks guide the observer who, perhaps with feelings of regret, has stopped following the various figures whose company they had enjoyed elsewhere in the painting. Almost at its centre, a white horse helps to set its rider apart from all the others. There are so many other horsemen in this vast landscape, and in the end we get used to the way in which they dot the countryside with their bright red tunics. Sooner or later we discover, to our surprise, the tiny outlines of Christ, dressed in blue, bowed down beneath the weight of the Cross, one of His knees resting on the ground. This raises a question. Why did we not see Him straightaway, since He is at the very centre of the image? And this leads us on to a second question, even more legitimate than the first: why has He been painted so small? If this episode from the Passion is the real subject of the painting, why did Bruegel paint it in such a way that it is almost hidden from view? In general, Christ is depicted unambiguously, the image of His glory or His Passion implying no lack of certainty. Here we are caught in the act of enjoying ourselves, even if there are extenuating circumstances in the form of the apparent chaos that reigns here, it remains a fact that we are initially actively prevented from understanding what is going on. Bruegel deliberately delays the moment when we discover what his true subject is. He could have brought it to our notice but, no, he prefers to obscure it.

Why should we be so surprised? After all, the situation is not so very different from what we see every day. Who can flatter themselves that they can grasp the essentials of all that happens around them while in the grip of their own preoccupations? Who can say without hesitation what will change the course of history when distracted by so much trivia? Bruegel does not attempt to make the subject incomprehensible for the observer but gives us a plausible means of gaining access to it. Depending on our own individual temperament and on chance, we shall interpret the event with greater or lesser speed, a reading that may be riddled with diversions and be either brutally abrupt or nonchalantly casual, but in any event random. The artist foresaw all this, anticipating all our reactions from unawareness to indifference and from the difficulty of drawing a general conclusion to our failure to notice all manner of details.

Above and beyond his precise subject matter, he also takes account of the time that we need to take in the image, without presuming that we may also wish

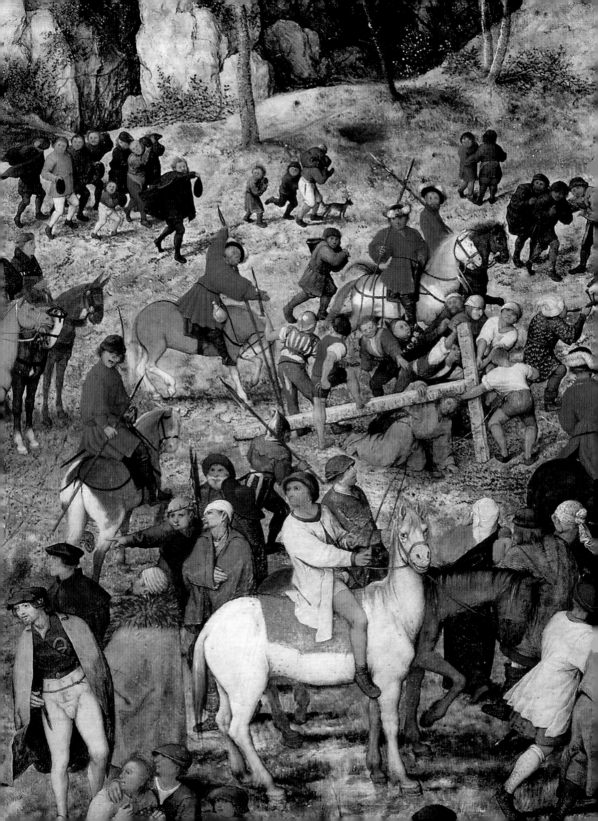

to then interpret it. Nor does he oblige us to home in on the image of Christ once we have managed to identify it. Rather, we are free to retrace our steps and resume our journey. But we know what we have seen, and we shall never be entirely able to forget this fact. Bruegel works on the observer's conscience, and with every step that we take he enables us to piece together the past by linking together each indispensable element to build up a logical picture.

The subject of the bearing of the Cross is particularly well suited to this kind of composition. The red patches of the horsemen that can be made out in the crowd provide the space with a sense of rhythm that soon begins to haunt us. They literally trace the route that is taken by Christ, which we can follow from left to right across the painting. The chaotic impression left by our initial approach reveals a line as clear as the ford in a stream. The succession of all these red tunics begins to resemble a trail of blood.

To the left of the picture, the sky is clear, but as we move to the right, it begins to cloud over. On the extreme right, in the distance, we can see a group of people standing in a circle around two crosses. All that is missing is the Cross of Christ Himself.

Absurdly perched on a rocky spur, a windmill stands out against the clear blue sky. The wind that causes its arms to turn brings with it the clouds that roll in and pile up. Inside the building we can imagine the wheat being ground by the mill. Christ is on the road to His crucifixion. The flour will be turned into bread. The bread of the Eucharist will be the body of Christ. From the sowing season to the harvest, the windmill repeats the cycle of life and death. The rhythm of work and of the passing days is inescapably linked to feelings of terror and mystery.

The Virgin, Saint John and the Holy Women have already lived through all this in Palestine, whereas Bruegel's landscape is emphatically Flemish, allowing him to combine past and present and invest his subject with an emblematic actuality. The sixteenth-century observer will have had no difficulty in identifying these soldiers dressed in scarlet as members of the occupying Spanish armies: this was a time when repression of the Protestants was prevalent, spreading terror throughout the country. Denunciations and summary executions were the norm. This was one of the most troubled periods in history, and the present image captures the sense of panic that it engendered.

Bruegel keeps his distance. He knows that in the upheaval of religious dogmas another view of the world is taking shape. His painting refuses to impose a unique and authoritarian vision. In giving so much space to all these anonymous figures coming and going in all directions, he restores a particular point of view to each individual in the crowd, a viewpoint that is necessarily relative and incomplete. Even more, he gives each individual the right to lose his way and change direction. In short, he gives us the right to make mistakes.

The Bearing of the Cross

Those who were condemned to be crucified had to carry their own cross to the place of execution. Without going into any more detail, the synoptic Gospels report only that the Roman soldiers made someone else do this for Jesus, who was too exhausted to carry His own Cross. To the left of the picture we can see Simon of Cyrene torn from the arms of his wife before the distraught gaze of a group of onlookers: 'And as they led him away, they laid hold upon one Simon, a Cyrenian, coming out of the country, and on him they laid the cross, that he might bear it after Jesus. And there followed him a great company of people, and of women, which also bewailed and lamented him' (Luke 23:26-7).

The treatment of the subject owes much to the mystery plays that depicted the Stations of the Cross as Jesus stopped to catch His breath on the way to His crucifixion. The account of the Stations of the Cross was spread by the Franciscans, who were entrusted with the task of looking after the holy places in Jerusalem. By the end of the Middle Ages, these accounts had assumed increasingly monumental proportions. Initially there were only seven such stations but by the seventeenth century that number had doubled. In creating the present painting, Bruegel depicted the 'great company of people' as a crowd made up of more than five hundred different individuals.

The political and religious climate in the Netherlands

In Bruegel's day the Netherlands were part of the empire of Philip II of Spain and as such were subjected to his policy of centralization. The regent of the Netherlands was Margaret of Parma, but she was unable to prevent the local Catholics from rebelling in the face of the Spanish government's interference in the workings of their Church. The situation was made even worse by Philip's cruel struggle against the Protestants, a fight entrusted to Cardinal Antoine Perrenot de Granvelle, a notably well-educated man who, as a great art lover, collected works by Bruegel in order to decorate his home in Mechlin. With the arrival of the Duke of Albany, the repressive measures became worse, leading to between seven and eight thousand executions within the space of three years. The crisis culminated in 1572 with the uprising of the seventeen United Provinces, which finally obtained their political and religious independence under William of Orange. From now on it was necessary to distinguish between Flanders in the south, which was Catholic and Spanish, and independent Protestant Holland to the north.

The family of Bruegel (Breughel or Brueghel)

The present painting is the work of Pieter Bruegel, the most famous member of this family of Flemish artists. He is usually referred to as Bruegel the Elder in order to mark him out as the first member of the dynasty to achieve fame as an artist. First documented as a master of the Antwerp Guild in 1551, he settled in Brussels following his marriage in 1563. He died when he was still only forty or so, leaving to the world some forty-five paintings, most of which are signed and dated between 1553 and 1568. He had two sons, Pieter the Younger (1564-1638), who was nicknamed 'Hell Bruegel', and Jan the Elder (1568-1625), also known as 'Velvet Bruegel'. The elder of the two sons was above all a good copyist of his father's works. He acquired his nickname as a result of the little scenes set in hell that were painted on copper but which were in fact the work of his younger brother. The latter was an artist of considerable stature and in 1609 worked at the court of Archduke Albert and his wife, Isabella. At the same time, he maintained his links with Antwerp, where he developed the art of landscape painting and often collaborated with Rubens. He owes his nickname to his finely worked flower paintings. The Bruegel family continued to produce artists of distinction until the eighteenth century.

171

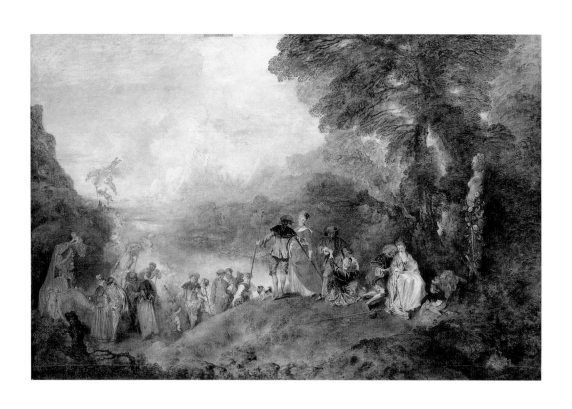

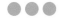

Appreciating
a way of thinking

Jean-Antoine Watteau (1684-1721)
Embarkation for Cythera (also known as *The Pilgrimage to Cythera*), 1717
Oil on canvas , 129 x 194 cm (50¾ x 76½ in)
Musée du Louvre, Paris

.

.

.

.

.

.

.

The air is balmy as if in a heat haze. The paint rubs lightly against the canvas, leaving behind it a few traces of leaves without weighing it down any further. A branch weighs no more than a brushstroke. Mountains fade into the distant brightness. A few couples are frolicking. To the right there is a bust of Venus watching over the couples' exchanges, decorated with roses. Seated close by, Cupid has slung his bow and quiver over it. No doubt he has done enough for today, leaving him free at the end of the day like a small boy who has finished his homework.

We may imagine the water's edge at the back. At the extreme left, a gilded seashell draped with a rose-pink curtain can be seen half immersed in the water. It is time to leave, although as yet there is no hurry.

The painting depicts a pleasant scene, a landscape peopled with well-dressed figures enlivened with a few mythological details that we may ignore if so inclined. There is nothing especially demanding about the painting. We are almost relieved to see an image in which everything is so easily understood. We allow the delights of the setting to cast their spell upon us and are happy to be beguiled by the elegance of the figures who succeed one another in the image like the links in a delicate chain. But then we reconsider, and think perhaps we have understood nothing at all.

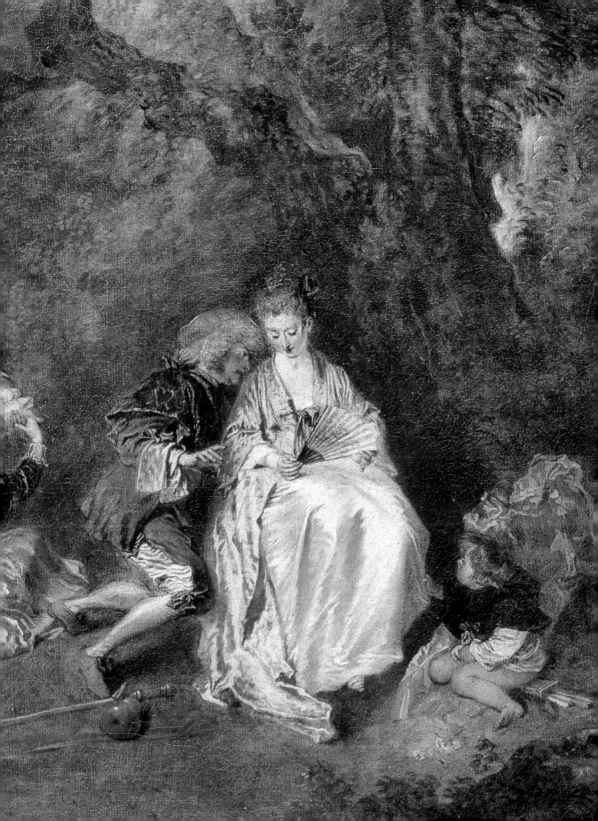

Who are these people? Where is all of this taking place? What are they doing here? And, more to the point, how can it interest us to know all this? Would it not be better to adopt their sense of calm nonchalance and submit to the pleasure of the moment? Has the light not already changed a little? What if we miss the ray of sun that is about to appear from behind the clouds? There is little doubt that we do not know what we want.

Let us be rational for a moment. The title refers to a pilgrimage to Cythera. We know the place: Venus, the goddess of love, settled there, and the island has so many attractions that it has been used as the setting for countless plays. The people whom we can see here may well be actors. And yet the landscape melts into a colourful transparency that eclipses anything ordinarily seen in the theatre. An almost palpable atmosphere bathes these figures, making it hard to believe that their lives are confined to the wooden boards of a theatre. Are they real people? Halfway between real life and the world of the imagination, between life and a game? The general ambiance counts for more than the piece, about which we know nothing. It must speak about love and the bonds that are formed and broken. The gestures and words will be no less subtle than the splashes of colour. The setting, convincing at first glance, soon reveals its artifice. And yet it remains impossible to tell if these figures are actors or not, for their clothes give nothing away. And who can say if actors would be less sincere than their audience? There is no doubt that the truth of what is taking place here continues to slip through our fingers.

The three couples to the right of the painting do, however, form a linear sequence, which is encouraging for those of us with methodical minds. The couple closest to Cupid is engaged in an amorous conversation, which is only natural, of course, for they are the most immediately affected by the love god's arrows. The man certainly seems to be in a hurry and has knelt beside the woman, who consents to listen to his flattery. Beside them, a second couple is preparing to leave. The man, who is standing, takes the woman's hands and helps her to her feet. The third couple, finally, closest to the centre of the painting, are about to resume their walk. Three different couples, three moments in their lives, three different moods. Perhaps they are also one and the same couple at three different moments in their lives. But nothing has been decided yet. The young woman who is standing casts a backward glance, but we do not know what she is looking at. Her companions? The woman she was only a moment earlier? Or herself on another day, differently dressed and accompanied by a different beau?

The man who is waiting for her is standing in the middle of the painting. Starting with his slender silhouette, everything can still change. Here he is like the beam of a set of scales. The two long canes that each is holding waver

with their indecision. Perhaps because his clothes are more brightly coloured, the young man seems more determined than his lady love. But he may still be overcome by regrets or by wistfulness. The golden brown dress may melt in the warmth of the leaves. They may still retrace their steps. At their feet, a little dog – the traditional symbol of fidelity – frolics around, hopping from foot to foot.

The other figures, to the left, melt into the painting's gentle colours. They belong to the rest of the world, a humanity both more indistinct and also more hesitant. The light that shimmers on the silken folds is lost in the bat of an eye. The little cupids who flutter around urge them on. Some of them cling to their legs like children impatient to return. Like all of Watteau's figures – and are we ourselves so different? – they have difficulty making up their minds. For each choice implies a sacrifice, the loss of opportunities that will never recur and that we have merely glimpsed in passing. Why go to one place rather than to another, to the left rather than to the right? Why leave instead of staying? The artist plays with the curve of a body, the slight turn of a head, stressing the contradiction between the direction of a glance and the direction that the figure is planning to take, contrasting the proximity of the figures with the indifference of their expressions. He leaves every avenue open, not favouring one at the expense of any other.

The attitude of the figures is so ambiguous that, like them, one hesitates to draw any conclusions. Are they already on the enchanted island of Cythera? Or are they on the point of leaving for it? Is this the end of a pleasant day out? Or are they still looking forward to its delights?

Watteau takes care not to answer these questions. With him, logic takes the day off, and the seventeenth century, which we had thought was so close at hand, bows out of the picture. The world is no longer so keen to draw a distinction between desire and memory, between the anticipation of happiness and the mere recollection of it. It is no longer even sure that this is necessary. Reason maintains that it is, whereas our sensibilities suspect that it is not. Before ... after ... is it really so different? Expectation is sometimes tinged by future regret, and memory relives our initial thrill, recreating it to perfection.

The world as a whole becomes as indefinable as the most fleeting sensations. It is they that from now on assail the mind from every direction. And their freedom is no different from the infinite interplay of light on a moiré silk dress.

.

.

The island of Cythera
●

Cythera is a Greek island situated between the Peloponnese and Crete. According to legend, it was here that the goddess Aphrodite was carried by the west wind after she had been born from the waves. In a more general way, the island symbolizes any place of enchantment that is devoted to the pleasures of love. But Watteau draws his subject matter less from the world of Greek myth than from that of the theatre. In 1713 a real venture took place on the stage of the Palais-Royal in Paris in Thomas-Louis Bourgeois' opéra-ballet Les amours déguisés to a libretto by Louis Fuzelier. The prologue represented 'a seaport in which the Fleet of Love is ready to set sail for the island of Cythera'. The theme was also taken up at the Foire Saint-Laurent and gave rise to all manner of light-hearted variations on the subject of infidelity: in popular plays, the travellers no longer set sail for Cythera but for the very real groves at Saint-Cloud.

The fêtes galantes
●

When the present painting to submitted to the Academy of Fine Arts in Paris in 1717, it was described as a 'fête galante'. The term did not correspond to any recognized subject in the hierarchy of genres that was acknowledged at this period. Neither a typical scene from a history painting nor a genre scene, it describes above all an attitude to life. In 1690 Antoine Furetière's posthumously published dictionary had defined galant as the word used to describe 'the enjoyment of respectable people'. This delightful gathering in the countryside introduces a diversionary note to the ceremonies familiar from the court, replacing the weighty burden of court etiquette with the freedom associated with love and its many games. As a true free thinker, Watteau exploited the shifts of meaning that are always possible between the subtleties of desire and the chatter of the mind. In this respect he proved a worthy precursor of the plays of Pierre de Marivaux (1688–1763), encouraging his characters to behave like those of his successor and engage in light-hearted banter and gallant exchanges. With the exception of Jean-Baptiste Pater (1695–1736) and Nicolas Lancret (1690–1743), Watteau had few rivals in the genre that he created.

Watteau and the art of misadventure
●

There is no doubt that the basic independence of Watteau's figures reflects that of the artist himself, for he had little time for custom: in the eighteenth century, an artist's official career was subject to certain rules, one of which required him to submit two works of art to the Royal Academy of Painting and Sculpture. The first had to be submitted at the time of his acceptance, the second on the occasion of his official reception. Watteau was duly accepted on 30 July 1712. Exceptionally, the members of the Academy allowed him to choose his own subject for his second submission, not that this prevented him from keeping them waiting for five long years, a wait interrupted by reminders from the administration in 1714, 1715, 1716 and January 1717. Their patience was finally rewarded on 28 August 1717, when Watteau delivered his Embarkation for Cythera. The lengthy gestation was combined with a speed of execution that his clients often had occasion to complain about, for Watteau mixed too much oil with his pigments in his haste for them to dry, making the canvases difficult to conserve.

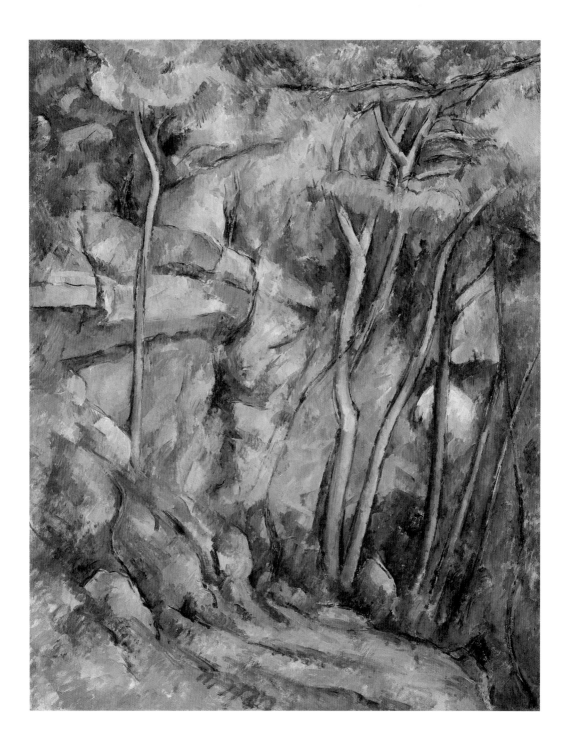

● ● ● ●

Measuring the difficulty of seeing

Paul Cézanne (1839-1906)
In the Park at Château Noir, c. 1900
Oil on canvas, 92 x 73 cm (36¼ x 28¾ in)
Collection Walter-Guillaume, Musée de l'Orangerie, Paris

.

.

.

.

.

.

.

.

There is no path in sight. We must have taken the wrong turning. The painting teeters on the brink of a void. To the left a wall of rock rises up like a rampart. There must be a passage behind the trees over there, a passage leading to that break in the vegetation.

We've already been here. That tree looks like one that we noticed a short time ago. Or was it yesterday? But no, the other was more willowy and closer to the rock. But we arrived here from the other direction, so it could well be the same tree. We can no longer be certain. Also, the light has changed in recent days. The soil has dried out and become lighter in colour. It crumbles beneath our feet. The landscape is no longer the same.

There is the constant risk of slipping. The brushstrokes keep skidding. The choice of colours is restrained, but the constant shifts between ochre and green are enough to disconcert us. The space between the rocks looks big enough for us to slip through, but one wouldn't like to swear by it. The outlines are a little unclear. Some lines break off just at the point at which we were starting to trust them. Or else they grow thicker as if to emphasize certain forms. Then, suddenly, they blur and cause those shapes to shimmer. It is hard to judge distances, difficult to make out the edges of things. Nature is full of snares.

Rocks, some trees, that is all: next to nothing. And yet this painting creates an entire world out of these few objects. Would it not be simpler and quicker to draw things as they are and give each of them their actual shape? The situation would then be clearer. And the path would open up of its own accord.

But that is precisely the point. We do not see things exactly as they are: they are either too far away or too close. Or a tree suddenly leans across our path and partially blocks our view of the rock that we were looking at. Or the sky clouds over and the green of the leaves turns grey. Or nature is too dense for us to count all its parts. Or our eyes are tired. We are incapable of taking in everything at a single glance. But, above all, we cannot immerse ourselves in the world of nature while at the same time objectively listing everything present.

Cézanne looks long and hard. He has no wish to jump to hasty conclusions. Is he really certain about what he can see? Or is he allowing himself to be influenced by what he has learnt? He tries to work as if he knows nothing and had never seen anything previously. Those leaves over there are floating like clouds. Where have they come from? The green of the highest branches is fragmented, plunging down to the foot of the rocks. Leaves, moss, reflections. They are all green: from where he is standing, Cézanne can see no more than this. Why pretend otherwise? After all, he is not illustrating a handbook on botany, but simply showing us what he can see. Anything else is more difficult. Nothing must be added, nothing imagined. He still asks questions of himself. Perhaps that really is a leaf. But in the end he paints only the shapeless green mass he can make out in front of him. No cheating. He captures a sensation of colour, a luminous green here, another more transparent green over there, and a green that is almost black. As we get closer, we can see that the colour spreads over the surface. The brushstrokes accumulate, sometimes superimposed on one another, constructing the image. Taken in isolation, they represent nothing. It is impossible to know if they indicate an object that is distant or close, something solid or air, space. But they convey as closely as possible what the artist gleans from nature.

Cézanne himself claimed that he painted like a fisherman catching fish in his net, the result being this colourful wicker basket on the basis of which the landscape organizes itself as best it can. The trees tremble a little, perhaps because of the wind, or shadows move between the leaves. Cézanne cannot decide whether or not to contain them within a simpler outline. But there is something else, something that does not depend on external circumstances. The artist's gaze moves to and fro between the landscape and his canvas. He

observes nature and examines this or that tree, the outlines of which are not
very clear from a distance, and then he returns to his palette. He chooses a
brush. Once again his gaze lingers on the trees. Then the painting. The series
of discontinued lines take account of this interruption and of the micro-
seconds when the artist removes the imperceptible spaces between the lines.
He keeps painting over the same line, each brushstroke bearing witness to
the time that it has taken to look at the object, to look away again, and then to
continue painting.

He knows that his painting attests first and foremost to what he himself,
as a private individual, wanted to see and that this is by no means trivial. The
features that stand out the most from the image are those that impressed
him the most: the line of a tree, the outline of a rock. They bolster the
position of the viewer, providing us with a few scraps of evidence. Beyond
this, everything else remains more or less vague or, at best, secondary.
Cézanne treats what he looks at – the focus of his attention – differently
from the rest of what he sees. His field of vision allows him to perceive,
more indistinctly, many things on which his attention is not focused.
Certain details that are heavier and darker underline the structure of the
painting. Other areas like the scumbled layers that are coloured so lightly as
to be almost transparent suggest the rest, which we might grasp without
difficulty in another painting. The subject is nothing. But it is infinite. The
other day, in front of this rock, a young tree was casting its shadow. It is
perhaps the one that can be seen here now. Each painting is a unique and
solitary journey. We shall have to return.

The artist bears responsibility for the world that he paints. Things happen in
those places where his eyes alight or his brush takes him. Each splash of
colour, however light, keeps chaos at bay and confirms that something may
be said with a clear conscience. The image that results from this is partial and
imprecise. It is barely articulate. Reality does not give up so easily. It is a fight
every inch of the way. Cézanne's intransigence means that he prefers what
little he can take from the world of appearances to any other image whose
certainty would strike him as insincere. What else could he do without
compromising his integrity by paltry imitation? The truth is all that matters
to him. For Cézanne, painting is an ethical imperative.

.
.
.
.
.
.

Château Noir
•

Cézanne frequently worked on the Château Noir motif between 1887 and 1902. Situated five kilometres (three miles) to the east of Aix-en-Provence, the place was sufficiently remote to ensure the peace of mind of a painter who guarded his solitude jealously. The estates comprised two isolated buildings begun in 1850 by a coal magnate but never completed. Cézanne rented a room overlooking the central courtyard and stored his materials here, ready to spend the occasional night on the property. He tried to buy it in 1899, after it had become a place of experimentation for him, a private laboratory where he trained himself to capture the essence of things. Local legend believed that the Château Noir was cursed as a result of its former association with alchemy. Such a legend was bound to attract a painter like Cézanne who, for all his sound common sense, was likewise engaged in his own transmutation of matter.

The clear-sighted artist
•

On 8 September 1906, only a few months before his death, Cézanne wrote to his son Paul, who was one of his closest confidants. He spoke of his difficulties and of his admiration of the richness of the countryside that rendered useless the diversity of his subjects: 'Finally I must tell you that as a painter I am becoming more clear-sighted in front of nature, but that with me the realization of my sensations is always very difficult. I cannot attain the intensity that is unfolded before my senses. I have not the magnificent richness of colouring that animates nature. Here on the edge of the river, the motifs are very plentiful, the same subject seen from a different angle gives a subject for study of the highest interest and so varied that I think I could be occupied for months without changing my place, simply bending a little more to the right or left.'

'Cézanne, you see, is a sort of god of painting'
•

Matisse famously summed up his colleague in a conversation with Jacques Guenne reported in *L'art vivant* on 25 September 1925, and it aptly encapsulates the impact that Cézanne's work had on later generations, beginning with the posthumous exhibition of fifty-seven of his paintings at the Salon d'automne in 1907. The immediate response to Cézanne's approach to space, which bore no resemblance to the classical tradition of an earlier generation where the rules of perspective applied, was in part to determine the Cubist experiments of Braque and Picasso. Other aspects of his work also helped to confirm the experiments that led to abstraction. But the essential question, above and beyond all aesthetic considerations, remains that of the artist's own commitment and his desire to produce 'truth in painting': an emotional as well as a representational truth. For Cézanne, each and every work was virgin territory where the same uncompromising attention had to be paid. By constantly questioning the validity of his perceptions, he had, as it were, displaced the painter's centre of gravity. In his wake no one could ignore any longer the scale of the challenge. To be a painter was necessarily to take one's place in the spiritual line of descent that could be traced back directly to Cézanne.

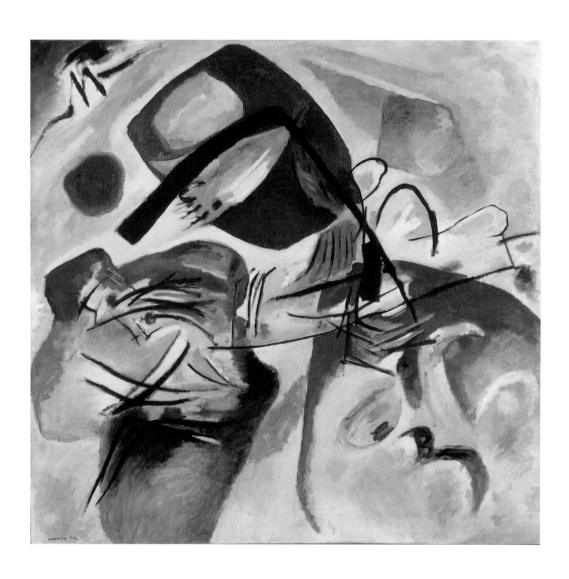

● ● ● ● ●

Welcoming a new freedom

Vassily Kandinsky (1866-1944)
With the Black Arch, 1912
Oil on canvas, 189 x 198 cm (74½ x 78 in)
Musée National d'Art Moderne, Centre Georges-Pompidou, Paris

.

.

.

.

.

.

.

.

Coloured shapes collide on the surface of the painting in an indefinable space that the canvas is not large enough to contain. As a work, it depicts no specific scene but finds itself on the flight path of a number of curious, weightless meteor-like objects. A few black lines emerge here and there and scratch the surface without attaching themselves to it. Indistinct masses float in space. Blue, red and, at the top, a third mass that veers towards violet. The brushstrokes are visible, helping to modulate the thickness of the paint and adding depth. We can see the complexity of the technique and the desire to manipulate the material that finally produced this image. But the result escapes our comprehension.

It seems at first sight as if chance alone was responsible for this strange collection of shapes. Nor does the title of the painting – *With the Black Arch* – throw any light on the matter. At this point, it makes little difference if there is a black arch or not.

We need to change our whole approach. We have to stop trying to relate the painting to a particular reality. There is no point in ransacking the world of nature in search of a key to understanding this image. To do so would be a waste of effort. It could evoke a feather or a boomerang or the transparency of a cloud, depending on which part of it we examine. Each of us will look for

what we want, drawing upon the reserves of all our available vocabulary within the world of our own imagination in an attempt to bring some semblance of order to our immediate perception. But the words that we use are no better than a makeshift solution, a temporary convenience at best. Behind all the unsound analogies that we may think we can uncover here, the image resists all attempts at identification. And the more insistent we become, the more we lose sight of it. In short, it resembles nothing.

Having exhausted all other possibilities, we are left with no alternative but to turn to the evidence itself. The painting shows shapes, pure and simple. Nothing else. To regard the black arch as the representation of an external reality is the quickest way to find ourselves at a dead end. We need to return to the title. What it indicates in its understated way is clear: the only thing that matters about this arch is that it is here at all, which is the same as saying that without it, the image would be altogether different. The coloured areas that we can see more or less distinctly gravitate around the arch as if drawn to it by a magnet. In this way the arch produces a coloured triad. The other strokes are added or bury themselves in it, and all of them vibrate around this central point. The painting thus finds its own raison d'être within itself. Its sense of balance no longer depends on our establishing the correct relationship with something we already know but on its own internal organization. It is now an autonomous object.

The year is 1912. With Vassily Kandinsky, painting no longer takes account of the visible world around us.

The tendency to regard a painting as a reflection of nature is so firmly entrenched in our minds that even today, a century later, this customary habit of ours continues to affect the way we look at works of art, so that we are often disconcerted by an abstract piece. It is as if it had failed in its duty and the artist was admitting his own inability to copy what he can see.

We must not make the mistake of thinking that Kandinsky's painting falls below a certain level of reality that he has simply failed to reproduce. Rather, he broke free from it to spectacular effect, discarding it as if it were some troublesome parasite.

Painting had sought to imitate real life since classical antiquity, articulating ordinances that taught people what they needed to know about religion and history. It had reproduced worlds resembling those of the theatre and the novel, the epic and the world of dreams. It had seized possession of every possible aspect of the visible world, surpassing them by rendering them more beautiful, more noble or, indeed, more terrible. But it had never previously abandoned them.

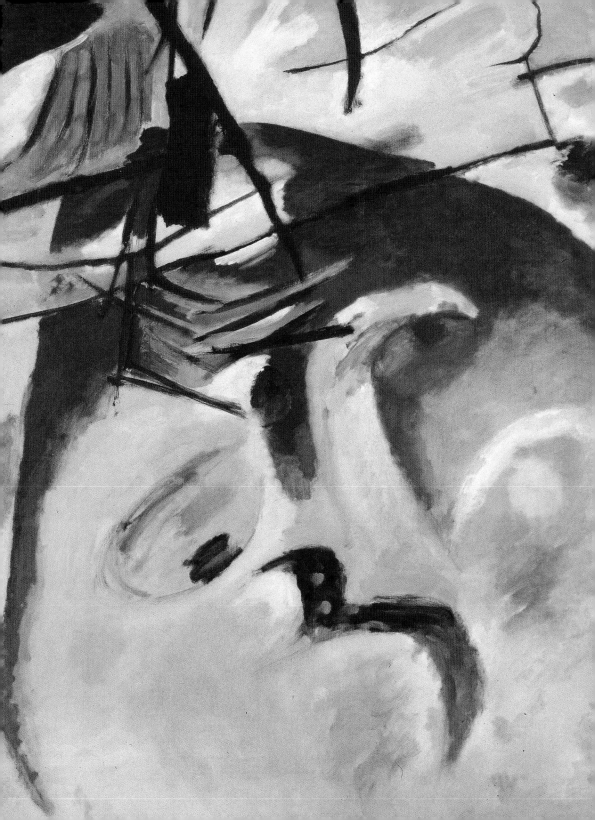

Then suddenly it had had enough and was no longer interested in all this. And so in 1912 painting set off on its own as if it had just discovered that what had up until that moment constituted its fame had ultimately enslaved it.

There was no longer any question of its remaining submissive or of allowing its space to be invaded by the words of others. Colours and brushstrokes, forms and lines, traces, opaque blocks and the subtleties of light, the power or hesitations of the brush replace figures and all the rest. Painting acquires an independence that was previously inconceivable. And yet it does not grow light-headed in consequence. Even when it feigns anarchy, it still retains its knowledge and its rigour. The canvas is not suddenly abandoned to an imagination lacking in rhyme and reason. True, the artist leaves behind him the lands with which he was familiar, but like any navigator, even when he is deprived of a map and a compass, he is not unaware of his vessel's potential. He draws the eye to traps, carries it away into false perspectives, causes it to founder and then proceeds to rescue it. The coldest colours cause the space to shrink and then to expand again, further than the eye can see. Other colours explode beneath the rule of red, causing the canvas to burst open almost literally. Black scars impede all progress. A voyage has begun. The destination has no name.

Kandinsky is a composer. Before him, poets had underscored the link between sounds and colours. But Kandinsky paints the equivalent, working with his black arch as others might write a symphony in C major. The arch indicates a scale. The tonalities of the painting depend on it. Painting makes an ally out of music, relying on their long association, which was by now invested with canonical status: notes can take our minds anywhere, they do not imitate anyone or anything. The artist claims the same right for painting, and he wins.

Abstraction exposed something that history required some time to understand, offering an alternative to a world that was preparing to destroy itself in the ignominy of the trenches. Just before war broke out in 1914, Kandinsky raised painting to a level where it was impossible to follow. No one could deny his intention. His images drew on the unverifiable reality of his own consciousness. What he was producing had no more than a tenuous connection with reality and exercised him alone at a particular point in his career. He painted what impelled him to paint, his awareness of his own vitality. He painted what was exempt from all commitments, what he called 'inner necessity'.

We may object to all this and claim that work produced in this way is essentially egotistical and does not aim to convey any meaning. As a result, the viewer has no chance of understanding what he sees, since the keys to unlock the meaning are either inaccessible or never existed. This is partly true. But it misses the point. The painting that does not imitate anything forces us back on ourselves and obliges us to push back the walls and, with them, existing definitions. It is a model of liberty.

Abstract painting
●

Abstract painting abandons all attempts to represent the world in identifiable ways. In doing so, it expresses not so much a retreat from reality as a different kind of relationship with it, conveying certain aspects of it, colours, a sense of geometrical balance, materials and a particular texture, without always providing an obvious point of reference. The title of an abstract painting may, it is true, refer back to some identifiable reality on which the work is based, but it may also be as indeterminate and as enigmatic as the image itself. Such paintings still aim to convey physical sensations and mental or emotional impulses. By being given a form, they produce an impression equivalent to that of music. In short, abstraction has no meaning in itself but is one type of vocabulary among many. Its emergence in the years around 1910 in the work of Kandinsky, Kasimir Malevich (1878–1935) and Robert Delaunay (1885–1941) marked an extraordinary broadening of the field of pictorial expression. It is worth stressing that the radical distinction that historians draw between abstraction and figurative art has more to do with their own convenience than with the realities experienced by painters.

The black arch
●

The indecipherable form may have value as a memory and may belong to a repertory of signs that are unique to the artist in question. For example, in this image, the black arch recalls Kandinsky's native Russia. In Russian, the title is *Kartina s tchernoy dugoy*. The word duga is used to describe a wooden harness more or less semicircular in shape. Lacking any mimetic intent, the image is thus based on everything that quite literally goes with the black arch and that anchors it in real life, namely, a particular dynamic, a colourful climate and the balance of power in space.

The gradual abandonment of the subject
●

Abstraction did not arrive on the scene abruptly. The importance of subjectivity championed by the Romantics, the use of arbitrary colours from the 1880s onwards and the visible brushstroke at the expense of descriptive precision are only some of the elements that altered the appearance of images in the course of the nineteenth century. The decline of interest in the subject of a painting in favour of an exploration of its aims and resources laid the foundations for abstraction over a lengthy period of time. Kandinsky's account of the shock that he felt on seeing a canvas by Monet at an exhibition of French Impressionist art in Moscow in 1895 is worth quoting in this respect: 'And suddenly, for the first time, I saw a picture. That it was a haystack, the catalogue informed me. I didn't recognize it. I found this nonrecognition painful, and thought that the painter had no right to paint so indistinctly. I had a dull feeling that the object was lacking in this picture. And I noticed with surprise and confusion that the picture not only gripped me, but impressed itself ineradicably upon my memory, always hovering quite unexpectedly before my eyes, down to the last detail. It was all unclear to me, and I was not able to draw the simple conclusions from this experience. What was, however, quite clear to me was the unsuspected power of the palette, previously concealed from me, which exceeded all my dreams. Painting took on a fairytale power and splendour. And, albeit unconsciously, objects were discredited as an essential element within the picture.'

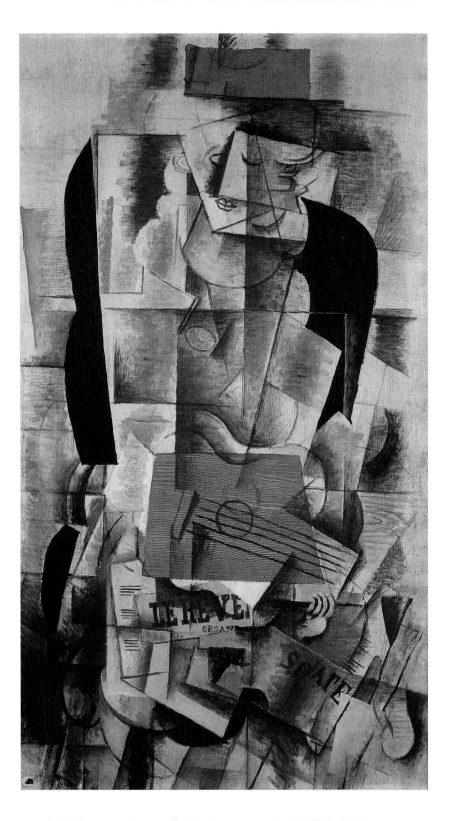

Feeling
our way to reality

Georges Braque (1882-1963)
Woman with a Guitar, 1913
Oil on canvas, 130 x 73 cm (51 x 28¾ in)
Musée National d'Art Moderne, Centre Georges-Pompidou, Paris

.
.
.
.
.
.
.

.

The interplay of transparent areas of grey. An ochre surface that blocks our way. Accumulations of black, a network of lines leading nowhere. The translucent strips of colour that float on the surface of the canvas are crossed by angles and curves that wander as lonely as any cloud. The title of the painting clearly indicates a subject that is almost impossible for us to identify.

This tangled mass of forms floating within the painting does not depict a woman. Or a guitar. What kind of an artist complicates even the simplest things? The viewer hesitates. We dismiss the suspicion that this is some gratuitous joke at our expense, for this does not equate with the painting's tranquil gravity. Instead, we assume – with just as little justification – that this is some cerebral game bearing no relation to everyday reality.

The painting is teeming with clues and with traces that the artist has left here like signposts. It is enough to seize hold of any one of them. The rest will follow.

At the top of the image there is a small full-lipped mouth, a heart-shaped mouth that is the epitome of sensuality. The woman of the title is entirely present in this single signifier that sums her up in the form of a kiss. At both sides are outlines of clouds suggestive of wavy hair falling over the woman's

shoulders. And then there is the rounded shape linking them together, that of an understated collar. One after the other, two little half-moons signal the arch of the eyelids. Her eyes are closed. Is she asleep? Rather, she is listening to what we are looking at: the symphony of subtly shaded browns and light beiges, the intangible fabric of a melody rocking her to sleep. The black area behind her starts to resemble an large armchair, heavy and solid, in which she can relax.

The guitar weighs heavily on her lap. Braque has stuck to the canvas a piece of light-coloured wood based on the conventions of painters in the building trade: imitation wood that does not attempt to pass itself off as the real thing, like those that used to be painted in the corridors and stairwells of apartment blocks. By means of a simple gesture, Braque opens up a multiplicity of avenues: a homage to the expertise of workmen who have no time for fine words and a reference to the tradition of trompe-l'œil still lifes to which he delivers the coup de grâce. Painting has ended up deceiving the world and is no longed tempted by illusion. On the real / inauthentic wood, parallel lines indicate the strings of the guitar. Higher up, the instrument's curved outlines push back the resonating chamber, allowing the sound to gain in depth and echo throughout the other curves, some of which undoubtedly belong to the woman herself. Braque does not insist on this. What matters most is the allusion. The woman's curly hair resembles a cloud. A passing cloud makes us think of diaphanous hair. It caresses her cheek. The clouds or her hair. Some confidences must remain unspoken. The artist will not insist.

The body of the figure can be deduced little by little as a succession of volumes and contours. But it remains incomplete: its outlines are absent. The female musician knows that she is sitting here with her eyes closed. She is familiar with her own image. But, deprived of a mirror, she can have only an incomplete perception of herself. Or a general idea, lacking in outlines. In the absence of any particular pain or pleasure, she can grasp the reality of her body only at those points where it touches something else: the strings of her instrument beneath her fingers, the weight of her lowered eyelids, the firm back of the armchair behind her. The little black, curved lines to the right do not constitute the schematized shape of a hand but mark the pressure of her fingers on the wooden fretboard of the guitar.

Instead of offering us the physical appearance of his model as something self-evident, Braque conveys the subjective truth of its relationship with the world. Painting abandons its affinities with photography, retaining only the contact areas, the areas of friction. This is reality, but reality from the inside. Within a limitless space.

As a viewer, we may close our eyes in turn and imagine what we might retain about ourselves – or someone else – when we have to admit that the gaps are as crucial as the parts that provide us with a starting point. The exercise demands time, and it forces us to distinguish between what we feel and what we can put into words: the little we know and the mass of information that we glimpse without ever really paying attention to it and that we sometimes retain without wanting to.

Like the newspaper, whose name we catch in passing. The printed characters are traced with extreme precision, but the word is incomplete. The painting as a whole is based on the gaps that suddenly open up in our relations with things, interrupting them and changing their course. 'LE REVE': all papers assume that we have time to read them and that we are interested in the outside world and perhaps even in current affairs. But here the truncated name encourages our thoughts to drift off into other areas. The atmosphere is calm. We can hear a piece of music coming from another room. Habit is a powerful force and so we automatically replace the missing letters: 'REVEIL' (Reveille). The penny drops. The newspaper regains its name, and the reader can again see clearly. The painting reasserts its grip on reality.

Braque plays with words just as he plays with forms, appealing to our memory even more than to our imagination. We know these things only by groping our way towards them, feeling for them with our fingertips and struggling to find the right words for them. What exactly was the colour of their hair? We hear a word spoken in passing. We thought we had understood it, but it was only the beginning of a phrase. Or the end of history.

Black and white, brown and grey establish a sense of balance. The music has not stopped. We notice it only intermittently, but now we have a clear memory of this sonata. The mind grows numb and allows itself to be invaded by the torpor of this unfathomable space. The score is badly positioned. The 'n' of 'sonata' has been lost in a yawn.

.

.

.

.

.

.

.

.

.

Cubism
●

Established by Picasso and Braque following their discovery of Cézanne's works at the 1907 Salon d'automne, Cubism developed as an independent movement between 1907 and 1914. Among the artists who joined it in 1911 and 1912 were Jean Metzinger, Albert Gleizes, Juan Gris and Louis Marcoussis. Their works were unfamiliar to the wider public before 1911, when they were exhibited in Room 41 at the Salon des Indépendants. It was at this time that the term 'Cubist' was pejoratively used to describe a whole generation of painters who viewed reality from a more or less geometric perspective. But Picasso and Braque were seeking to convey space and volume in a direct and truthful manner without any sense of a system. For them, each painting represented the visible accumulation of a whole series of sensory experiences instead of describing forms photographically.

The history of Cubism is generally divided into three periods. The first period, from 1907 to 1909, is pre-Cubist or proto-Cubist and was still relatively descriptive in character and still clearly indebted to Cézanne. The second period ran from 1909 to 1911 and has been described as analytical or hermetic. As such, it is the most indecipherable of the three periods in terms of its translucent harmonies of grey and beige. Between 1912 and 1914 synthetic Cubism evoked concrete reality by means of collage techniques and real materials such as paper and printed characters. There was often also a greater use of colour.

Writing in a painting
●

Writing in a painting is not new, it was also found in the Middle Ages and the Renaissance, both in religious subjects and in portraits, where it was used to clarify certain elements, either indicating the words spoken by the figures by means of scrolls or simple inscriptions or identifying the sitters or, finally, appealing to the viewer's sense of pity. The need to decipher the text or to consider it as such – it was often written in Latin – encouraged the observer to meditate on the image. From 1912 onwards such writing reappears in Cubist art, and here the stencilled lettering adds stability to the composition by underlining the plane of the canvas. The words are often divided up or left incomplete, constituting open-ended propositions that viewers must complete once their imagination has been fired. They bear within them meanings that are allusive and yet comprehensible, giving us to understand that the image too can free itself from explicit forms.

The transposition of the real
●

Speaking to Gelett Burgess in 1910, Braque explained that 'I couldn't portray a woman in all her natural loveliness. I haven't the skill. No one has. I must, therefore, create a new sort of beauty, the beauty that appears to me in terms of volume of line, of mass, of weight, and through that beauty interpret my subjective impression. Nature is a mere pretext for a decorative composition, plus sentiment. It suggests emotion, and I translate that emotion into art. I want to expose the Absolute, and not merely the factitious woman'.

Getting over the shock of our first impression

The painting that shocks us defines from the outset the balance of power that exists between the artwork and the viewer, for it forces us to take account of the precariousness of our own position and to regain our balance or catch our breath in the presence of the image that we see in front of us.

In every instance, it is the painting that seizes the initiative. It provokes and unsettles us. Speed is the key word. We are swept up in a process in spite of ourselves. We feel that we have been violated not only by what we see but by the intensity of its impact. We are confronted by a vision that has absolutely nothing reassuring about it. We may detect scraps of a familiar world, but it is a world in which we no longer feel in control and that we were not prepared to contemplate.

It is not so much the novelty of the experience that causes us to react in this way but the threat that it implies to our established views of the world and of ourselves. The painting challenges us to go beyond habits whose rigidity we discover at the very moment that they are shaken. It is always possible to turn away from the painting that upsets or displeases us. If we remain, we have to revise at least temporarily our way of approaching the image and to consider the painting within a wider framework. In short, we genuinely have to reflect on it. From this moment onwards, everything is possible.

Everything about a painting may shock and offend us: not just the subject, which we may consider indecent or abnormally violent, but also the artist's vocabulary. Assailed by the painter's choice of colour or by the excesses of an image that seems to overflow its rightful space, the viewer has no means of retreat. Instead of appearing as a space in which a narrative can be left to unfold or an object can be represented, the image seizes hold of our mind, allowing us to advance by leaps and bounds and at that very moment projecting us into a reality of altogether explosive intensity.

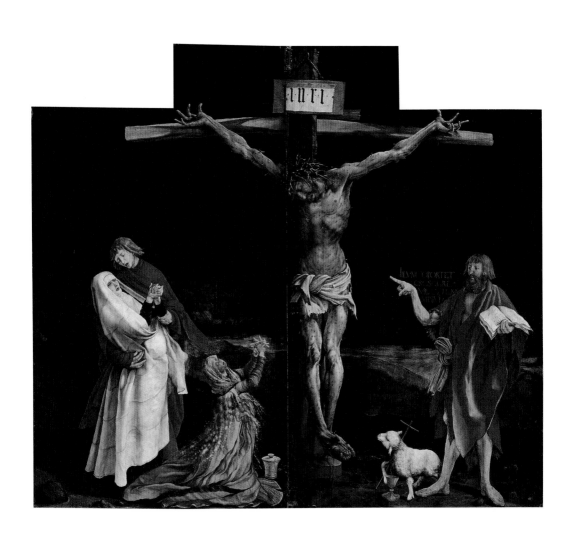

Considering the function of a painting

Mathias Grünewald (Mathis Gothart Nithart) (1475/1480-1528)
The Crucifixion, 1511-16
Oil on wood, 269 x 307 cm (106 x 121 in)
Musée d'Unterlinden, Colmar, France

The body of Christ is almost green, as if it is starting to decompose. It is covered with swellings and pockmarked with large splinters like the heads of arrows. It is a scene of torture greater than anything seen in real life, an image unbearable in its intensity. We would prefer to be elsewhere. The incomprehensible wounds leap out at us, as do the wild-eyed gestures of the others who fail to intervene. The executioners have left. Why should this horror be allowed to continue?

And yet this is not the first time that Christ has died in a painting. The subject is hardly shocking. After all, we have seen so many crucifixions that we have forgotten most of them. But nothing has prepared us for this one. It will not be erased from our memory. We are condemned even before we realize it.

What were the other images like? Most of them were more serene. Sometimes a crowd of gaping onlookers may invade the edges of the scene, expressing their pain or horror, but the general atmosphere is invariably one of peace. Not all painters insist to the same extent on the wounds and blood. The Virgin and Saint John may be seen set back from the crowd, while Mary Magdalene stands at the foot of the Cross. All them will be meditating on the incommensurable nature of their grief. In every case the painting will

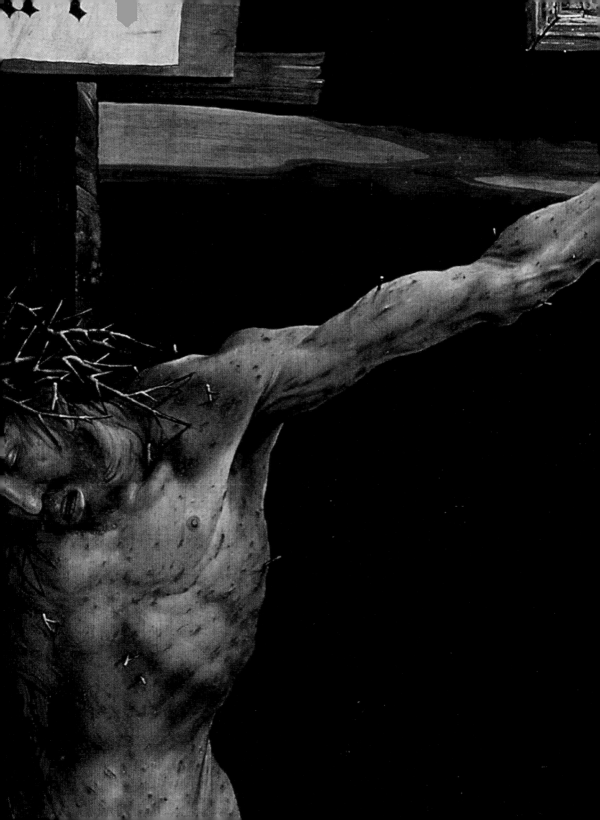

suggest the omnipotence of God and the eternal delights that follow our earthly deaths. We have learnt that the torments of the Cross add humiliation to cruelty, yet Christ's supreme dignity always seemed to diminish their power. A distant landscape may also help us to transcend the appalling present, suggesting in its way the promise of resurrection upon which the Christian faith is based. But Grünewald paints as if he were unaware of all this, as if death must have the final word. The spiritual dimension of the event is lost amid the spectacle of a terrifyingly agonizing death.

For today's observer, the discomfort caused by Grünewald's painting stems from the fact that it strikes us as arbitrarily violent. But the people who looked at it in the sixteenth century undoubtedly took a very different view. Even if some of them could appreciate the work of the artist, they could never be sufficiently detached to see in it an aesthetic example of questionable beauty. For them, the image was necessary in that it had a function to perform, and to the extent that it reflected the truths of their own particular lives, it met their expectations.

With his over-sized body, this Christ figure does not die on Golgotha but in the church attached to the hospital at Isenheim, where the monks of the order of Saint Anthony cared for the sick who came to them in vast numbers from every corner of Europe. Here they nursed the victims of Saint Anthony's fire, a terrible illness that slowly devours its victims' bodies. Many lost one or more limbs – the monks were said to be experts in the field of amputation – but most sufferers succumbed to their illness. Only a few escaped. Their suffering was beyond words. If such words did exist, the dying surely did not know them: their illness robbed them of their minds as well as afflicting their bodies.

Grünewald's painting shows their suffering. He tears it from their bodies and sets it apart from them. All that torments and haunts them is suddenly somewhere else. It is no longer simply deep inside them but is visible on the body of this Other. They discover the image of a Christ who takes upon Himself the sins of the world and shoulders its sufferings together with these wounds and swellings that reduce them themselves to nothing. And the proof is that He dies from them.

Of what use to them would Christ be if He were as fair as Apollo? How could they feel themselves understood and believe that they were saved while their bodies were rotting and falling apart? That would be too much to ask and would open up yet further the gulf between them and a paradise that is still too far away. Grünewald's crucified Christ is neither noble nor perfect. This man may be the son of God, but He is without doubt the twin brother of all the cripples and the poor wretches who drag their broken bodies across the ground to be with Him.

They are not entirely sure about what they can see nor what they can hope for: the figures depicted here are not all the same size but are close to each other, yet without being together. Christ's immense arms are too long for His body and stretch out over the Cross, making it bend and topple. It mirrors Christ's drooping head, weighed down by its crown of thorns. In the foreground Mary Magdalene is the smallest of the figures. Overcome by humility and tiny in size, she is already far removed from Christ. She prays to Him as if she already knows that He cannot hear her. She sees only Him. Soon He will no longer see her. But a halo hovers over her clasped hands. To the right, John the Baptist points his finger at the man whom he heralded and before whom he now withdraws. His words ring out in the darkness: '*Illum oportet crescere, me autem minui*' (He must increase, but I must decrease).

Behind him, in a hollow in the rocks, the purifying water recalls that the final prophet once baptised Christ as the 'Lamb of God', now being sacrificed on the Cross, His blood reddening the earth. The whole of the image is spattered with that blood. It is in the red of the cloak of Saint John, in the red of the mantle of the Baptist, and in the red of the dress of Mary Magdalene that blazes beneath her gilded hair.

Saint John did not know that his arms could be so long or his hands so strong, but they need to be if he is to support Mary's broken body. Her veil envelops her like a shroud, a white veil as pure as the lamb in its innocence, as white as the book and as imperative as the sacred ordinance of the Holy Writ.

The haunting colours stand out starkly against the dark background. The shifting proportions of the different figures trouble our perception, taking us closer to the edge of madness. We think we can feel the earth quaking beneath our feet. The painting dismantles the story of the Passion and disturbs our points of reference. What we see here is a space filled with loose stones and shrouded in darkness. Water to slake our thirst, the wilderness for solitude and revelation. Saint Anthony's fire breaks the body and clouds the mind. Grünewald's Christ takes upon Himself the madness of the images that torment the sick. His painting teeters on the brink of the abyss.

Crushed fingers stretch out and twist. Christ has monstrous hands that curl up as dry as vine shoots. If only they would flower again.

Grünewald has created a work that we initially thought of as unpitying, whereas in fact it howls with compassion.

.

.

.

.

Saint John the Baptist

●

The Gospels name several witnesses to the crucifixion: Mary, the Holy Women, Mary Magdalene and John the Apostle. To these, a number of other anonymous figures were added by later artists. Conversely, the unusual decision to include Saint John the Baptist, who was already dead by this point in the narrative, is based on an original iconographical choice that may perhaps be traced back to Guido Guersi, the preceptor at the Antonite monastery at Isenheim from 1490 to 1516 and, as such, responsible for commissioning the present painting. The presence of Saint John, who was both the last prophet and the forerunner of Christ, underlines the symbolic significance of the scene. His attitude and his words, which appear here in Latin as 'Illum oportet crescere, me autem minui' (He must increase, but I must decrease; John 3:30), reflect the transition from the Old to the New Testament and from the law to grace. This idea is emphasized by the lighting, which uses contrast for symbolic ends: the days grow shorter with the birth of the Baptist at the time of the summer solstice in June, whereas they begin to grow longer with the nativity of Christ at the time of the winter solstice in December. The lamb recalls Saint John's reference to Jesus: 'Behold the Lamb of God, which taketh away the sin of the world' (John 1:29). Christ's blood, caught in the chalice, recalls the sacrament of the Eucharist.

Saint Antony's fire

●

Saint Anthony's fire was identified in 1597 as an illness due to ergot poisoning. It ravaged Europe between the ninth and thirteenth centuries. Those who were affected by it suffered disfiguring muscular spasms and hallucinations, dying from gangrene in extreme agony. The Antonine monks who owned the church at Isenheim in Alsace for which Grünewald's altarpiece was painted belonged to an order founded in 1095 by a nobleman from the Dauphiné, Gaston, who wanted to show his gratitude for the recovery of his son. The Antonines were originally lay brethren but from 1297 they were subjected to the rule of Saint Augustine and devoted themselves to the treatment of Saint Anthony's fire as well as epilepsy and syphilis, some of whose symptoms were similar. The monastery was a centre of learning with a hospital that enjoyed a high reputation for the medical practice of amputation. The panels of the altarpiece when open symbolically amputate the arms of Christ.

The transforming altarpiece

●

The Crucifixion is painted on two close-fitting panels and is only one image within a vast polyptych. The altarpiece comprises two sets of wings that are painted on both sides and that are hinged, producing a total of three different configurations. We do not know exactly how the altarpiece was displayed, though it was evidently bound up with the liturgy and various religious festivals. The three groups of subjects suggest the transcendence of death and the contemplation of the eternal truths. When the altarpiece was closed, the faithful would see representations of death in the form of a Crucifixion flanked by images of Saint Sebastian and Saint Anthony on the wings, and a Lamentation of Christ on the predella. When the outermost wings are opened, the images suggest the triumph of life with scenes depicting The Annunciation, the Incarnation of the Son of God and The Resurrection. The innermost view shows images that depict the power of the Church in the form of a pre-existing carved gilt-wood altarpiece by Nicolas Hagenau representing Saint Anthony, Saint Augustine and Saint Jerome with the Donor, while the painted side panels depict the Meeting of Saint Anthony and the Hermit Paul and the Temptation of Saint Anthony.

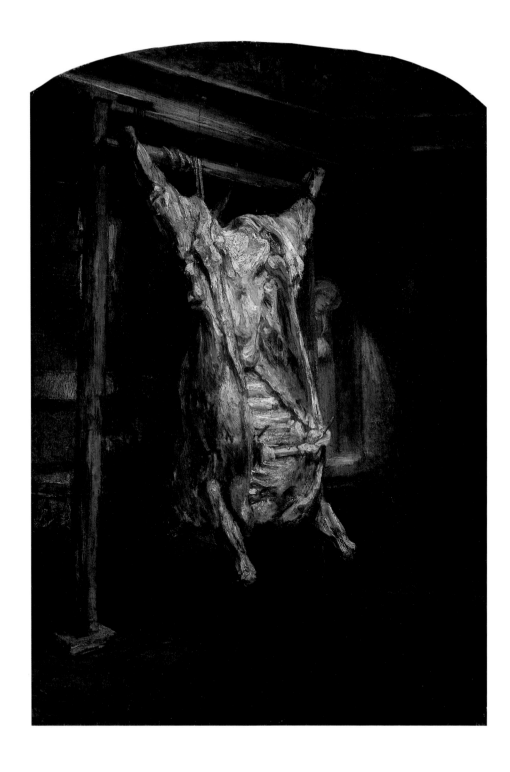

Seizing the grandeur of a ritual

Rembrandt (Rembrandt Harmenszoon van Rijn) (1606-69)
The Flayed Ox, 1655
Oil on wood, maximum dimensions 94 x 69 cm (37 x 27 in)
Musée du Louvre, Paris

.

.

.

.

.

.

.

.

The ox carcass is hanging by its back legs from a wooden beam. The light strikes the flayed animal directly and ignores all else in the room. The artist has placed this piece of meat at the centre of his canvas, and it is all that he offers the viewer. We now have to deal with this image, which is uningratiating, brutal and almost brutish in its straightforward immediacy.

There would have been ways of toning down the subject, which was a commonplace image in seventeenth-century Holland. Each November enough animals were slaughtered to last the coming months. They were then cut into pieces, shared out and salted. It was a time of celebration, and the neighbours were invited. Everyone was involved and the work brought the community together. In this way, the artists who painted the backyards where these preparations were made conveyed the passing of the seasons that was a part of their own lives too. Here they set up the genre scenes whose popularity was due not least to the fact that they reinforced the agreeable feeling of prosperity.

But there is no trace of any of this here. Rembrandt has sent the revellers home. He wanted none of the noisy conviviality that traditionally accompanies such moments. Events unfold as if he had approached the scene by saying nothing, remaining to one side and perhaps holding back in order

to examine more closely an occasion that people normally did not hesitate to join in. A flayed ox was not thought to attract attention beyond its immediate purpose. It was needed as food, not as the source of a public spectacle.

But the artist has chosen it as the main subject of his painting, investing it with a value that transforms its entire scope. It is no longer the traditional pretext for a genre scene, but nor is it really a still life. The tight focus would be better suited to a full-length portrait of a member of the nobility. In reality we are not entirely sure what we are dealing with here. It was perhaps not worth our while to look at it so closely only to see it so badly. The indistinct outlines take only imperfect account of the animal's anatomy. The dominant colours are browns and reds and dirty whites. We are wrong-footed or, at best, surprised. Not knowing what to call the work in front of us, we fail to see it properly. Our powers of observation are a function of our attitude. And here we lack the detachment necessary to understand the image. This piece of butcher's meat is not being sold as separate cuts but is available only in its entirety.

Rembrandt adapts his subject, arranging a mass of paint in such a way that it evokes reality rather than representing it. But it is also possible that he is describing very precisely what happens when we are struck by an unexpected image: the eye does not have time to adapt and find a point of reference but is distracted by sensations unrelated to what it might see in a different state of mind. It encounters a banal reality but is taken aback by unspoken emotions that chose this very moment to well to the surface. No doubt we need the right moment to lower our guard. Confused ideas invade our minds and superimpose themselves on reality. The flayed ox blinds the viewer who has lingered a little too long in its presence. The painting evokes a stifling sense of solitude.

Rembrandt plays with the viewer's reaction, treating it like a ball that he throws up and then catches just before it is out of his reach. What he paints is not so much the object itself as the effect that it is capable of producing. Here the shock is not always immediate but is craftily prepared just when we least expected it. The image is too gloomy for us to mistrust it. Initially it does not disturb us any more than it attracts us but simply produces a very mild sense of disgust and a vague curiosity. Why should we devote any further attention to such a subject? We think that we have finished with a painting that has so little to tell us. But the image will not go away.

In removing the subject from its normal context, the artist also isolates the viewer, depriving us of a reassuring scene from everyday life and forcing us into an encounter that is positively disconcerting. The sheer size of the carcass removes it from the world of familiar objects. When faced by a still

life, we feel we are still in control. Its subject matter plays a subordinate role and flatters us into thinking that we can assess or appreciate what we can see. With Rembrandt's painting, this tacit hierarchy no longer holds. We are dealing here with a one-to-one confrontation. The unease that it causes increases as we begin to grasp its origins. Stripped of its role in the food chain and of the social ritual that justifies its display, the flayed ox is no more than a carcass, the body that is left when the animal has been put to death.

The image awakens others, allowing them to slip surreptitiously into our mind. It summons them into existence. We think of all the images that we have seen of Christ on the Cross and of martyred saints. There is no rational link between this image from our day-to-day lives and the repertory of religious images – it stems from a simple mechanism deep in our memory. Scenes of bloody death are commonplace in painting. Prior to this one, we have seen many others, each of which has left a trace on our memory. The outlines of the flayed ox are ultimately those of any tortured body.

Images of martyrs encourage us to reflect on the afterlife. By insisting on the hallowed finality of pain and the strength of those who suffer it, such images suggest that death is no more than a necessary transition to the next world. For its part, the flayed ox leaves no room for these metaphysical considerations. The animal is not a person. Indeed, it is not even an animal any longer. Its head has gone. Its bones will never become relics. Its flesh couldn't care less.

A woman has stuck her head through the window. She had been waiting at the back of the painting, where Rembrandt has quietly let her in. It is only when we notice her that she arrives. The artist has given her a deciding role to play at the last minute. Her function is to step forward when the viewer loses their bearings and bring them back to earth. Perhaps she asks a question that we did not hear. She asks why they are dawdling here. The confusion is over and we feel a little embarrassed at having allowed ourselves to be distracted in this way. We didn't realize that we were so impressionable. It is nothing. There was nothing to see in this courtyard apart from a carcass. It is a fine piece of meat. Nothing happened. We're safe.

.

.

.

.

.

.

The influence of Judaism

Living, as he did, in seventeenth-century Protestant Holland, Rembrandt was surrounded by Jewish culture. His home was in the Jewish quarter of Amsterdam and he often chose his models from the local population. In particular we know that he was very friendly with Rabbi Menasseh ben Israel (1604–57), one of the most cultured men of his day and also a close neighbour. In the Jewish tradition, the slaughter of animals has to follow strict guidelines if the meat is to be considered kosher. Although it may not illustrate this point precisely, we may assume that the austere dignity of Rembrandt's flayed ox reflects the spirit of such a ritual. The Christian notion of the memento mori – a reflection on death – may thus be less important, the link with the Jewish practice being in itself sufficient justification for the fusion of the ritual and the trivial that is so typical of this painting. In support of this interpretation, it is also worth bearing in mind that although Rembrandt frequently uses the motif of the carcass in his work, he never painted a pig, a point on which he differs from his contemporaries. We may also recall the series of flayed oxen painted in the 1920s by Chaïm Soutine (1893–1943) as a homage to Rembrandt, paintings that also evoked the violence of the scenes that Soutine had seen in his youth on the premises of the village's shochet, or official slaughterer.

Scenes in the slaughterhouse

The representation of scenes depicting the slaughter of animals dates back to classical antiquity and continues without a break in painting and sculpture from the Middle Ages onwards. It brings together two different levels of reality that are sometimes merged with one another. On the one hand we have the tradition of ritual sacrifice found in classical and Old Testament texts; and on the other hand, we have the more trivial concern of the need to feed ourselves. As a result the subject may give rise to numerous variants extending from the description of a butcher's stall to the actual slaughter of the animal. Other scenes include the cutting up of the meat and more sophisticated still lifes. Some of these paintings were commissioned by corporations, others by individuals, and were intended both to praise the expertise of the former and to enhance the prosperity of the latter. By insisting on the colours of light yellow and red and all their intermediate shades, Rembrandt underlines the quality of the meat, which was valued for the richness of its fat. Even so, we know nothing about the circumstances in which the present painting was made.

The tasks associated with different months

The tasks associated with each month are part of an iconographic system that also includes the four seasons and the signs of the zodiac. Since classical antiquity their symbolism has implied a cyclical view of history, decorating Christian buildings, including church pediments and baptisteries, and later providing the subject matter that accompanied the prayers in books of hours. Images of work recall one of the consequences of original sin. When driven from the Garden of Eden, Adam and Eve were cursed by God and thenceforth obliged to earn their own living. From then on the cycle of the seasons obliged them to serve Creation. In the form of genre scenes, moralizing representations of grape-picking and harvests evoke humanity's duties on earth. The slaughter of the ox or pig in November or December was one aspect of the work that it fell to man to perform in order to expiate his sin.

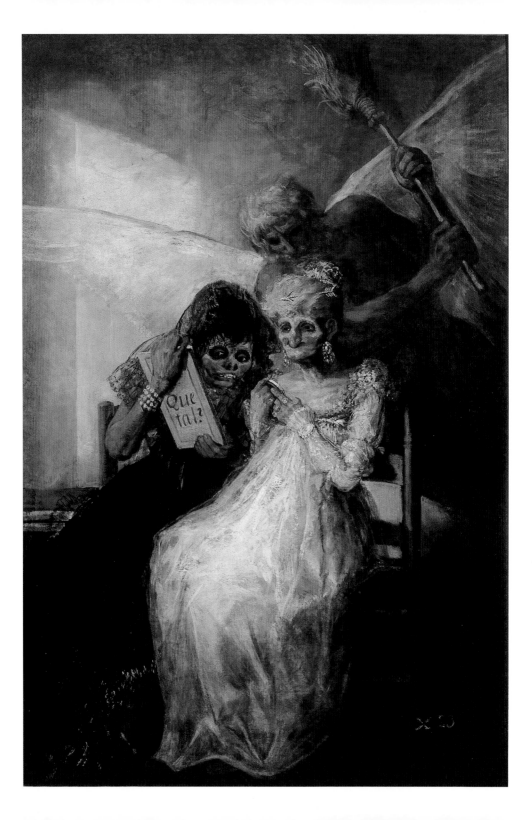

Passing through the mirror

Francisco José de Goya y Lucientes (1746–1828)
Las Viejas or *Time*, 1808–10
Oil on canvas, 181 x 125 cm (71¼ x 49¼ in)
Palais des Beaux-Arts, Lille

.

.

.

.

.

.

.

.

We do not know whether to laugh or cry and whether the image is dazzlingly brilliant or simply monstrous. We have nowhere to hide between its blinding brilliance and the darkness that swallows it up. We are held in a vice, riveted by the ravaged faces of two *viejas*. Although the Spanish adjective is feminine, it remains unclear if the sitters are women at all. The title is as implacable as the image. It has lost all sense of decorum. Old age has eaten away at these women until even the word for them has disappeared. All that remains is a sorceress wearing the dress of a fairy.

Which of the two is worse off? There is no doubt that it is the one who is more luxuriously dressed, for it is at her that everyone stares. She has dressed with that in mind. And she has succeeded. She has put on all her rings and wears earrings so heavy that they will tear her skin, but they catch the light so well. She has placed a diamond arrow in her hair, which is so natural in colour that it looks like a ray of sunshine, a nod in the direction of Cupid and his tricks, perhaps a little costly, a foolish gesture. 'But at my age one can show off. And you never know, you have to be ready. This evening, perhaps? People still find me attractive, you know.'

No one who stops in front of this painting can fail to feel how heart-rending it is. Or else we may grow indignant at its obvious sense of derision.

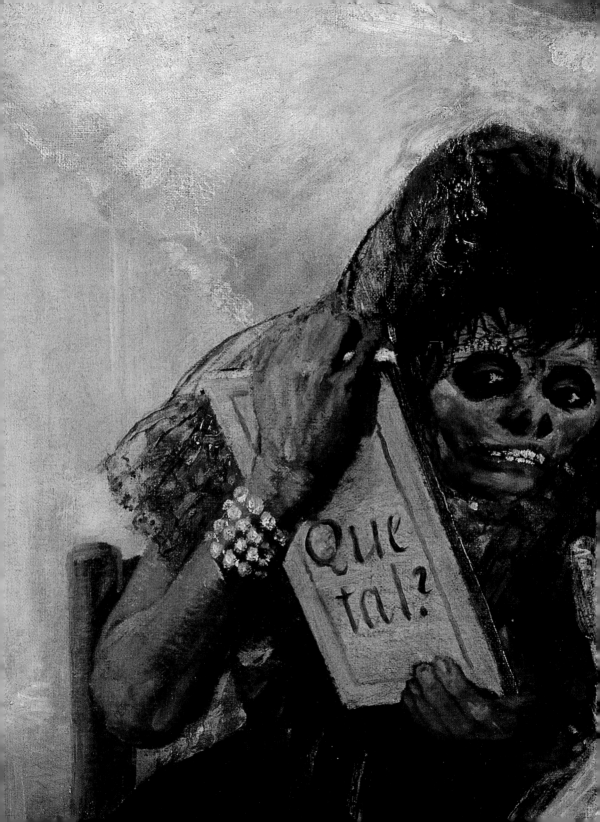

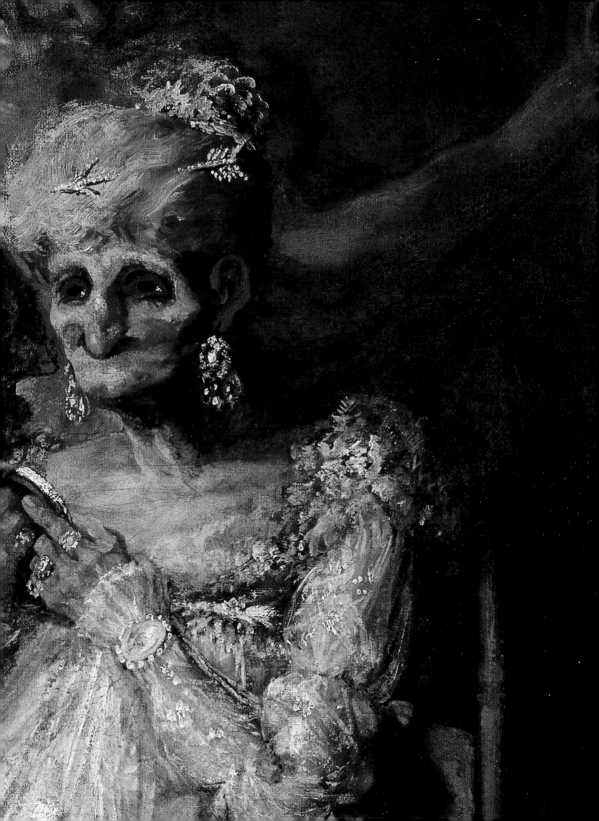

But its power will surely leave no one unmoved, unless we are so young that decrepit old age still belongs in the realm of fairytales where wicked stepmothers ask anxious questions of their mirrors. Am I still the fairest of them all? One has to be absolutely certain of being Snow White or Prince Charming to smile at such an image for any length of time. One has to be certain that one is immortal.

She has put on her very best dress. Her lady-in-waiting – there is no doubt which is the subordinate figure – is dressed more soberly, acting as a kind of shadow to her mistress. The eyes in her pig-like face are heavily ringed – she has evidently not lost the habit of wearing make-up. Or perhaps the oblivion of death has hollowed out their sockets. Beneath her black mantilla, her hair resembles nothing more than the coat of a dog. She is a faithful servant. But faithful to whom? She holds up a mirror on the back of which two words can be seen: *'Que tal?'* How are things? What a question! Is it she who is asking, or is it the dull object that she is holding? Is it the woman who is playing the part of the beauty in her wonderful dress? Or the old man with the white hair who symbolizes Father Time? Armed with a broom by way of a sceptre, he is clearly the master of ceremonies. Who ultimately is speaking? But then, does anyone really want to know the answer? And who will speak for the woman who no longer has any teeth? She has made such an effort to look beautiful. And she once was. Yes, you remember…

The dress, at least, is new. It is the latest fashion – so light on summer evenings. Goya does not swathe her in silk or muslin but veils her in a fabric that does not even look to be there. A miracle of a dress. Both the most magnificent and the most lowly. A dress for one's first ball. Or one's last opportunity. The paint did not think of describing it but walked freely over the old woman's body, giving her another reality, with this dress that does not exist in a colour that is almost no colour at all. She would need to have passed through oblivion to reach this point. These veils, these mad gestures. She knew everything on the way here and has lost everything too, everything apart from the light.

In her hand is a small mirror, or perhaps a painted medallion. It does not leave her hands, which are not in fact so old. It is a private object whose task is to verify what the other person says, a reflection that murmurs very softly in her ear.

She is concentrating too hard to understand what is happening right next to her. The sudden warmth is not that of a summer breeze. She thought it was a caress. But it is the breath of Father Time that is brushing against her neck.

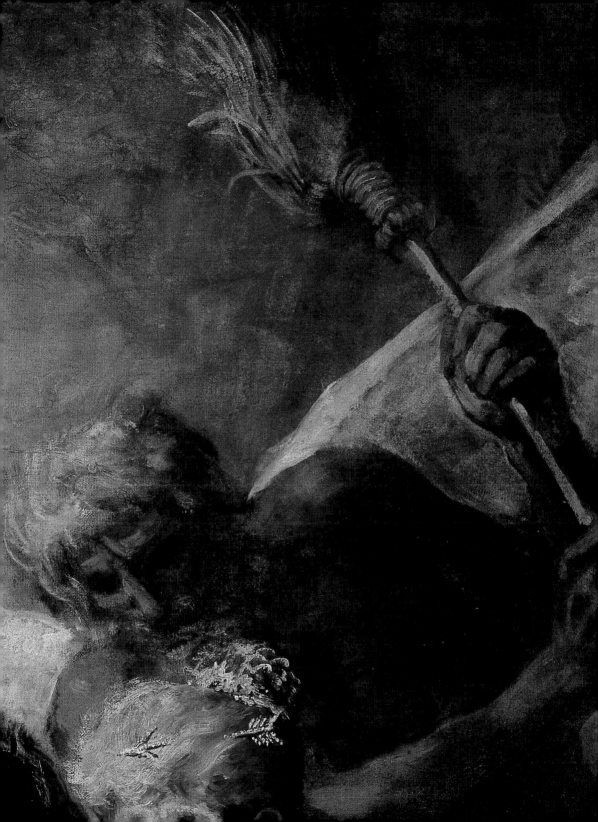

He appears from nowhere. Having nothing else to do, he passes by and leans over her shoulder like a vigilant companion, attentive to her every concern, but it is purely out of self-interest. He is, after all, Father Time himself. He keeps his list up to date and never sees the end of it. Are there enough wrinkles and signs of weariness, enough disjointed thoughts and obsessive memories, enough sleepless nights and lengthy waits, enough mad delights and drunken distractions? And yet if she could see them, she would no doubt admire the delicacy of his large wings, like pearls, so well matched to her own particular tastes. She might even envy him his elegance.

The allegorical figure of Time is part of a traditional repertory of images, and yet Goya gives it a disturbing freshness. His figure has the same sort of presence as a living person and is a protagonist to be reckoned with. Time is not an idea or a subject for reflection but a reality that creeps up on us from behind, lacking the good manners to announce himself, a foul-mouthed visitor, a scourge who furrows our flesh and reddens the rims of our eyes, draining us dry and leaving us shrivelled.

One suspects that these chairs are getting harder and harder. The whole atmosphere is a little oppressive today. Father Time leans further forward. It is the briefest of reprieves. She is not suspicious. He will sweep her aside without her even realizing. At a single stroke. But perhaps she has been watching him from the outset, clear-sightedly observing her enemy's progress, while never giving him an inch.

The first shock was perhaps no more than a foretaste. The various elements that make up the painting conspire against the viewer and help to throw us off the scent. The cruellest mirror is not the object that is offered to this woman, it is the woman herself. For us. Her old age is our own. No matter who we are, all vanities and all faces are the same.

Here we are fascinated by the ravaged flirtatiousness of this ageless woman. We were predisposed to feel sarcastic. But Father Time has more than one trick up his sleeve. In clinging to the image, we failed to see him arrive.

The background to the painting no longer seeks to describe anything. It is beyond time. The distance has become an indistinct space where colour vanishes in unheard-of brightness. It has explored reality and, having completed its exploration, finds reality derisory. On the woman's dress, the paint runs like candlewax. Goya allows it to run and turns it into a miracle. Here it has definitively left the visible world behind.

.

.

.

The allegory of Time

Iconographical representations of Time can be traced back to the *Iconologia* of the Italian theorist Cesare Ripa (1555/60–1622). This famous dictionary of allegorical symbols was published in 1593 and had an unprecedented impact on the visual arts of the next two centuries. Ripa describes Time as an old man with wings, dressed very simply in a loincloth and carrying various attributes, including a serpent which, by biting its own tail, symbolizes the cyclical nature of time. The choice of a reaping hook or scythe as the most obvious motif associated with the allegorical figure of Time stems from a confusion between two different Greek words: *chronos*, the word for time, and Cronos, the god of agriculture who was traditionally represented carrying a scythe. The Romans later identified this figure with the agrarian god Saturn, who likewise carried a scythe. Time was often also depicted with an hourglass and / or a book of reckoning. He was additionally shown in the company of other allegorical figures whom he helps or fights and who include Truth, whom he reveals, Envy and Discord, whom he defeats, and Love and Beauty, whom he destroys. The mirror that reflects only the present is also one of his favourite accessories. Goya makes the myth his own by rejecting the traditional scythe in favour of a broom which, although more trivial, is no less effective.

The Spain of Maria Louisa and Ferdinand VII

The jewel in the old woman's hair has been identified as the diamond-encrusted arrow given to Queen Maria Louisa of Spain in 1800 by her lover Manuel Godoy. This fashionable jewel can be seen in Goya's vast canvas *The Family of Charles IV*. On the basis of this identification, most writers argue that the old woman here is the queen herself, a woman condemned for her dissolute morals and her lust for power. At the time that *Las Viejas* was painted, Spain was under foreign rule: in early May 1808, Maria Louisa's son, Ferdinand VII, abdicated in favour of Joseph Bonaparte, who was placed on the Spanish throne by his brother, Napoleon I. The years between 1808 and 1814 were dominated by the insurrection of the Spanish people, who were helped in their war against the French by British troops under Wellington. The words *Que tal?* are thus addressed to a face consumed by old age but perhaps also to the Spanish monarchy, which at this time was incapable of taking responsibility for its actions in the face of a whole series of historic disasters.

The theme of Vanity

Vanity is classed as a secondary vice in contrast to the seven deadly sins of Pride, Covetousness, Lust, Envy, Gluttony, Anger and Sloth. It is related to Presumption. Allegory depicts it as a naked woman at her toilet, looking at herself in a mirror. Among her accessories are a comb and a jewel, both of which underscore her coquettish nature. The term Vanitas is also used to describe a specific genre in art, that of still lifes found more especially in the seventeenth century and intended to denounce the futility and transient character of the things of this world. This use of the term derives from Ecclesiastes: 'Vanity of vanities, saith the Preacher, vanity of vanities; all is vanity' (1:2).

incredible presence of a man and an angel, here right before them, is more important than anything else. What matters is the overwhelming confrontation with the irrational, not an expert commentary on it. Now is the time to marvel.

In fact the subject of the painting – Jacob wrestling with the angel – is easy to identify. There are no questions to be answered here, no enigmas to be resolved. We have no more need to waste time idly speculating on the identity of these Old Testament figures than we do on the importance of their relationship to these Breton women. The link is a random one that is the result of a chance sermon, which on this particular day was sufficiently impressive to fire the imagination of the whole congregation. That is all there is to it. One is tempted to say that it could hardly be more personal. A vision is not the same as an apparition: Jacob and the angel appear unaware of the eyes fixed upon them. They clearly have no message to impart, no news to announce. It is the Breton women who see them. They are not part of some divinely ordained visitation.

The rudimentary nature of the draughtsmanship conveys all the candour of these women. The quality that Gauguin came in search of in Brittany, where he settled in 1888, was very much this combination of rustic piety and superstition: the locals had an instinctive relationship with the world and, although ignorant of elegant conventions, they were open to the mysterious quality of even the most trivial spectacle. The wayside crosses erected by the side of country roads were among the models that the painter used most frequently in his search for artistic renewal. Far from Paris's salons and studio practices, he discovered a truth of expression in tune with his own private needs. The 'savagery' that he often claimed as an essential part of his character could take root here as if in a soil that was already familiar to him.

Although the motif itself may seem primitive, the same cannot be said of Gauguin's approach to it. Indeed, he has clearly gone out of his way to increase the number of allusions to other works of art. The two wrestling figures, for example, and the tree that dissects the image are inspired by the sort of Japanese prints that had become fashionable in France around the middle of the century. The stylized branch cuts right through the heart of the painting, creating a barrier between the Breton women and their vision. There are clearly two worlds that are articulated in this image, two levels of experience, the quotidian and the world that transfigures it. For us, it is an insurmountable obstacle representing a kind of brute force that cuts us off from the miracle while at the same time underlining it. The hats of the Breton women that block off the foreground create an almost abstract image,

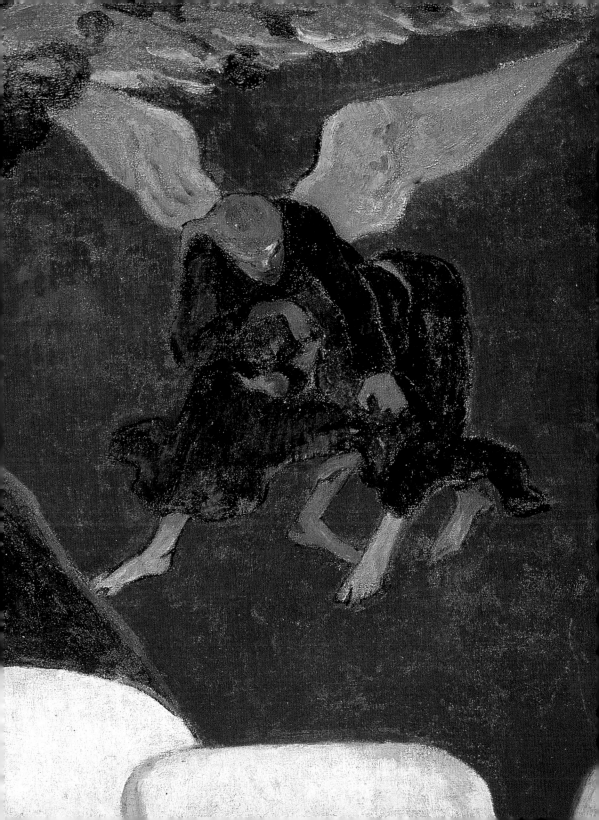

ponderous and yet harmonious, but their faces are denied to us. The painting introduces impasse after impasse, insisting on the inaccessible dimension of objects and on their irreducible strangeness. As observers, we are as disorientated as the figures in the painting and suddenly find ourselves transported to an age-old Brittany thanks to these quotations from Far Eastern art.

Our first impression is an abiding one: the shock of white against red, the headdresses against the field. It is the scarlet landscape that strikes us first and continues to surprise us with its incongruity. We might suspect that the artist was being fanciful or trying to provoke us. But that is unimportant. What Gauguin is doing here is reversing the natural order of things by playing with complementary colours.

It is very simple. There are three basic colours that are known as primary colours: red, yellow and blue. By mixing two of them, the resultant colour and the remaining primary colour are known as complementary. To take an example: green is produced by mixing yellow and blue and is thus the complementary colour of red.

In this way the miracle is demonstrated with unshakeable logic. In the familiar world, grass is green, but at the moment that Jacob and the angel take on physical form in the presence of these Breton women, it becomes red. What we see, with their eyes, is no longer nature but another, complementary world that is bathed in a contradictory colour. The rout of green necessarily leads to the gushing forth of red.

By depicting the subject of the vision – whether the result be dazzling or meditative – the painting takes its place in a classical tradition, but by virtue of its having been freed from all symbolic complexity and moralizing intent, the tradition is completely rejuvenated. No lesson will be drawn from this event, whose essential quality no longer resides in some theological or doctrinal point but in the state of mind of the figures and in their ability to see red where we ourselves see only green.

If their situation is exceptional, it is still only one particular instance of our general relationship with the visible world. The true miracle that Gauguin invites us to share would be to abandon the dead ends to which we are condemned by an unduly dutiful way of seeing things. If we were to do so, we should begin to share his ability to glimpse the function of every image in a sort of dazzled stripping away of all but the barest essentials.

Jacob wrestling with the angel
●

Jacob was one of the Old Testament patriarchs who was forced to spend a whole night wrestling with an unknown figure that turned out in the morning to be an angel: 'And Jacob was left alone; and there wrestled a man with him until the breaking of the day. And when he saw that he prevailed not against him, he touched the hollow of his thigh; and the hollow of Jacob's thigh was out of joint, as he wrestled with him. And he said, Let me go, for the day breaketh. And he said, I will not let thee go, except thou bless me. And he said unto him, What is thy name? And he said, Jacob. And he said, Thy name shall be called no more Jacob, but Israel; for as a prince hast thou power with God and with men, and hast prevailed' (Genesis 32: 24–8). Quite apart from the theological significance of this encounter and its various interpretations, the subject has often attracted painters as a metaphor of the artist's struggle with nature and his attempt to gain nature's blessing, if necessary by force.

Japanese art
●

Examples of Japanese art had been exhibited in Paris at the World Fairs in 1867 and 1878. The prints in particular attracted the attention of painters by virtue of their unusual design: off-centre frames, unmodulated colours and the absence of shadows were quickly adapted to the western repertory, allowing the traditional composition of the painting to abandon the scenographic principles that had existed since the time of the Italian Renaissance and to undergo a veritable revolution. Manet, Degas, Whistler, Van Gogh, Bonnard and Vuillard were just some of the artists to be seduced by the art of the Japanese print, several exhibitions of which were organized by Samuel Bing, who in 1888 founded the journal Le Japon artistique.

Pont-Aven
●

Pont-Aven is a small town in Brittany some fifteen kilometres (ten miles) to the east of Concarneau and owes its fame to the artists who settled here from the early 1860s. Between 1886 and 1896 a group grew up around Gauguin, drawn there by the uniqueness of the local countryside and the cheapness of the inns, where these penniless artists could find board and lodging for themselves. Gauguin himself stayed at the Gloanec, which was well known for allowing artists to live on credit. Starting in 1888, he developed synthetism, a pictorial vocabulary based on flat colours and forms outlined in dark colours, a technique reminiscent of stained glass windows, cloisonné enamelling and Japanese prints. His success led to a violent debate with Émile Bernard, who claimed to have developed the style first but whose work lacks Gauguin's artistic qualities. The paintings that Gauguin produced at Pont-Aven, together with those of colleagues such as Charles Laval, Armand Guillaumin, Louis Antequin and Bernard himself, were exhibited for the first time at the exhibition held at the Café Volpini in Paris in June 1889.

The simultaneous contrast of colours
●

This theory was first stated by Eugène Chevreul (1786–1889) in his 1839 study De la loi du contraste simultané des couleurs, which was translated into English in 1854 as The Principles of Harmony and Contrast of Colours. His conclusions concerning chromatic rules were crucially important to artists in the 1880s but are now applied to other fields. Traffic lights, for example, employ green as the opposite of red, thus making practical use of a principle that Gauguin had grasped as early as 1888.

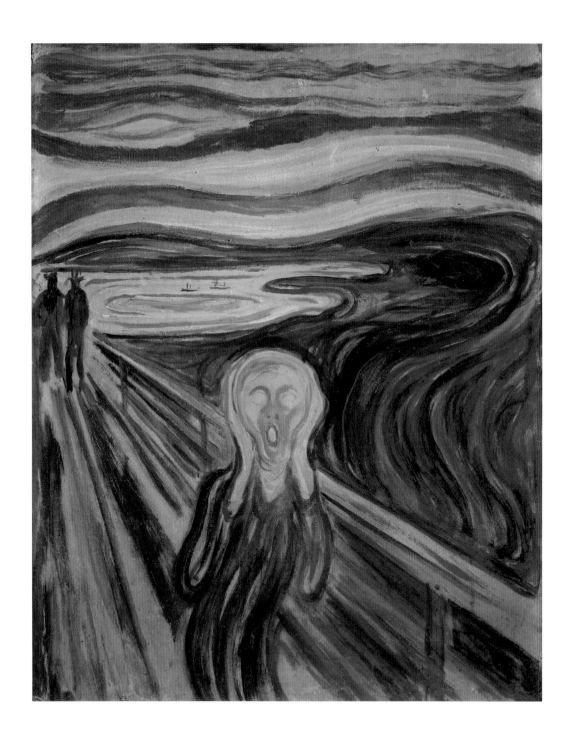

Seeing
life unravel

Edvard Munch (1863-1944)
The Scream, 1893
Oil, distemper and pastel on card, 83.5 x 66 cm (32¾ x 26 in)
Munch-Museet, Oslo

.

.

.

.

.

.

.

.

The paint flows like lava, running madly in all directions. The brush cannot keep up with it on the surface of the canvas, knowing neither where to run nor where to seek refuge. Suffused with red, the sky weighs so heavily on the scene beneath it that it seems as if it will come crashing down in a single glutinous mass. It is no longer simply a sky.

We must not listen, we must not hear what is happening. We must scream until it stops, until it no longer threatens us. We must block our ears and shout until we are deaf in an attempt to make it all disappear. Until it is no more than a nightmare.

The other people on the bridge have seen nothing. They do not know what is happening. They do not understand. For them, everything is normal. It is not possible. They should realize what is going on and come running or at least show some emotion. But they continue just as before, walking along, hats on their heads, as stiffly formal as on any other day. They give the impression of knowing where they are going. It ought to be possible to speak to them. But what to say? And anyway, who knows if they are not in fact right and that we have not imagined it all?

The bridge's orange handrail dissects the painting like a blade. On another day we might almost feel that we could reach the horizon by following this rail,

with its beautiful straight line. It is a quiet walk, a landscape that holds no surprises as it extends far into the distance, calm and vast. We know each step of the way.

Today the bridge is endless. We can no longer recall where it starts, nor when we arrived here. Which direction would we need to take in order to retrace our steps? Why did we come here? Where were we going when everything changed?

We need to leave before the landscape is completely unrecognizable. But the ground gives way quickly. The brush has coated it with a paste as slippery as soap. Yellow and red lines try clumsily to draw anything they can on this surface. Wooden planks, the reflection of the light perhaps? Beyond the bridge, the blue is so harsh that it destroys all sense of distance. The view lower down comes so close that it is on the point of turning into a wall. Terror pulls our legs from under us. And so does the painting.

He is holding his head in his hands, clinging to himself. He squashes his face against the canvas as if against a pane of glass. The painting is like a window closed so firmly that it can no longer be opened. No one is listening. The man's body sways like a blade of grass tossed to and fro by the wind. The touches of colour are unable to steady him. A brown thread licks at his side. But to no avail. His body no longer has any shape to it. If only there were a strong wind, a force of nature unleashed, something to which we could submit, knowing that finally it would blow itself out.

We desperately want to find a rationale for what is happening, an acceptable pretext. A natural disaster, a scourge of the kind that Romantic painters liked to depict: shipwrecks and other disasters that challenged men to face the might of the elements. A particularly bloody sunset. It was often enough for the hero to cast a thoughtful glance at the turmoil of the world in order to glimpse a grander purpose. The uncertain outcome of these battles did not undermine their greatness but taught us that a disturbing image can seduce us as much by what it promises as by what it shows.

Munch's painting does not fill us with any great desire to wait and see what happens. It does not promise a spectacular outcome of any kind but suggests only the disappearance of a world that is slowly dissolving. The waves of colour that unfurl have no intention of stopping. They cause the landscape to freeze for a moment as if offering it one last favour. The artist seizes his chance. Everything becomes clear: the long diagonal and the elegant curves, and the frame that cuts right through the figure. He, like Gauguin, knows how effective the formal language of Japanese prints can be – the age demands as much. But in Munch's work, the flat tints of these famous prints no longer stay in place. They unravel on the canvas, relentlessly drawing people and things in their wake and causing them, too, to dissolve.

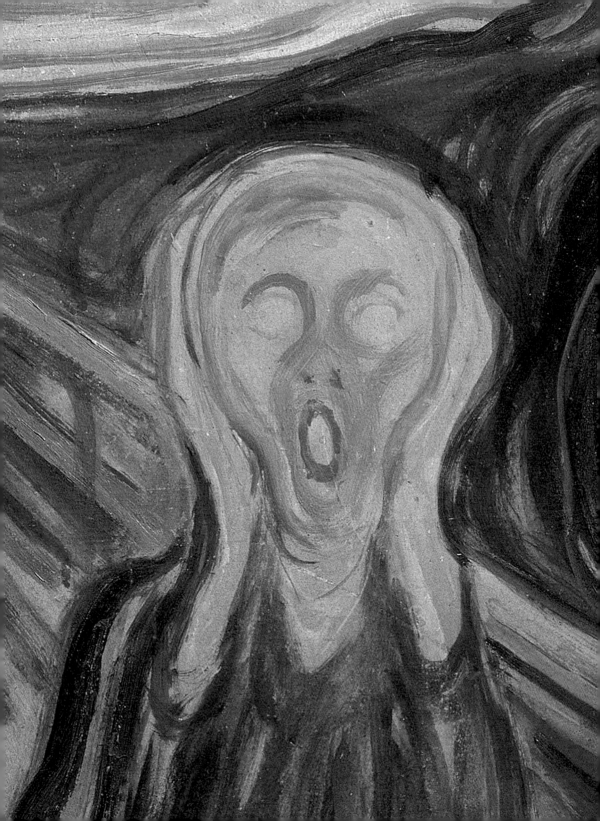

The blushing sky gives off no heat. The strident orange turns to ice on contact with the earth, rending the horizon as far as the eye can see.

Those must be boats in the distance. And perhaps a beach. But everyone is so far away that they are bound to remain strangers. There are no familiar faces and, indeed, no faces at all.

The man who is standing here is about to lose his own. The gust of wind that rattles the image has blown away everything that once made him an identifiable individual, someone to whom we could say hello and listen, someone whom we could approach and touch – in a word, a person. He is no longer anyone. The features that remain are barely enough for a mask. He looks like a corpse, his mouth filled with paint and already full of earth. His eyes have been rubbed out or are glued shut. He is worse than invisible: present and yet robbed of all existence.

If he pressed his hands a little more firmly against his cheeks, his greenish head would vanish completely. It would yield like potter's clay. The gesture would deliver the coup de grâce. All that he would be left with would be a mass of inert matter, compact and lifeless, the work of a very poor sculptor.

His body no longer seems real but has swapped its substance with the world. It was impossible to break entirely free, impossible to find the right distance from it, impossible even to think of a living space to which it might have had a right. It is, after all, identical with all that surrounds it, having merged and melted into it. The artist blends things together, creating an agglutinative mass, sticking them together and stretching them out like thick mud. This man is a prisoner. The world absorbs him and digests him. And then it vomits him out.

What he saw cannot be put into words. His failure to make himself heard can be read in the deliberate poverty of the forms and in the swamp-like emptiness that he inhales. Munch creates his compositions out of little, clarifying and removing things, and retaining only a handful of forms that are too fluid to offer us any purchase. And this is precisely why he chose them. Reality ebbs away like the sea. And all that remains is the feeling of anxiety within the hollow of his hands.

.

.

.

.

.

.

.

'The infinite scream of nature'
●

In 1895 Munch returned to the subject of
The Scream in a lithograph, noting down on
the back of it the following brief
explanation, which describes both the
immediate situation in which he found
himself at this time and the countryside
around Christiana that can also be seen in
the painting: 'I was out walking with two
friends. The sun began to set. I felt a breath
of melancholy. Suddenly the sky turned
blood-red. I paused, deathly tired, and
leaned on a fence looking out across the
flaming clouds over the blue-black fjord and
town. My friends walked on, and there I still
stood, trembling with fear – and I sensed a
great, infinite scream run through nature.'

'They cannot understand'
●

'It would be quite amusing', Munch wrote in his
diary, 'to preach a bit to all those people who
for many years now have been looking at our
paintings and either laughed or shook their
heads reproachfully. They do not believe that
these impressions, these instant sensations,
could contain even the smallest grain of sanity.
If a tree is red or blue, or a face is blue or
green, they are sure that is insanity. They will
not get it into their heads that these paintings
were created in all seriousness and in suffering,
that they are the products of sleepless nights,
that they have cost me blood and weakened
my nerves.'

The phenomenon of the red sky
●

According to a hypothesis advanced by Donald
Olson of Texas State University and published
in *Sky & Telescope* in February 2004, the red
sky in Munch's painting may reflect a natural
phenomenon. In 1883 there was a particularly
violent eruption of the Perbuatan volcano on
the Indonesian island of Krakatoa. It was
followed by a tsunami that caused thousands
of deaths along the coasts of Java and
Sumatra. Air-borne particles of lava were
carried all round the globe, causing the light to
be diffracted. Wine-coloured sunsets could be
seen as far away as Europe and the United
States. The phenomenon, which was widely
reported in the Norwegian press, lasted three
years, and so Munch could indeed have seen
the sky appear to catch fire. Whether this is
true or not, it does nothing to alter the
visionary character of Munch's painting but
simply indicates the way in which the artist was
able to establish a close link between the
objective world of nature and his own
particular state of mind.

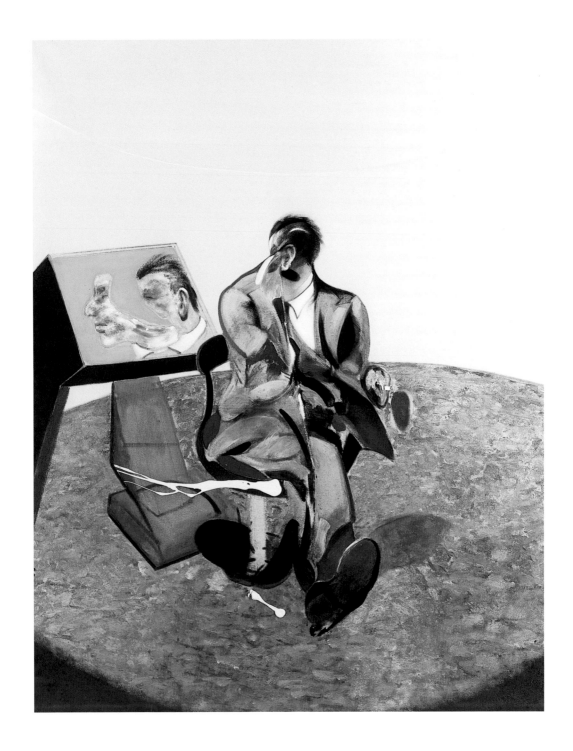

Gaining access to the opposite side of things

Francis Bacon (1909-92)
Study of George Dyer in a Mirror, 1968
Oil on canvas, 198 x 147.5 cm (78 x 58 in)
Collection Thyssen-Bornemisza, Madrid

.

.

.

.

.

A battered man, beaten to a pulp. A man in the form of a splash of paint. Only his outlines are still visible. The lines of his shoulders, his spotless shirt and the shadow of a tie, his shoes, his luxuriantly smooth suit – everything attests to the fact that here is a man concerned about his appearance. He is well turned out. Or at least he was before the painter got hold of him. The canvas looks like an accident report. Not a violent death because, strangely enough, he still seems to be alive – which is perhaps the most troubling aspect of it all. How could anyone survive something like that and continue to function as if nothing had happened, looking at oneself in a mirror, a cigarette in one hand?

He is seated, unremarkably, on a chair, a kind of office swivel chair. All on his own in front of this odd sort of mirror that reminds us of a desk but also of a screen. An elegant man checking his appearance. On an unstable chair. And the whole painting is affected by his movement because he clearly finds it hard to face the right direction. It is all about coincidence: about being there in the right place at the right time. But reality wants none of all this. Objects quickly forgo their function. The chair revolves too quickly or too slowly, making it impossible to get used to. The mirror is already behind him. His awkward position threatens to twist his neck. The effort robs him of what remains of his face. There he is, crushed, in an outsized reflection.

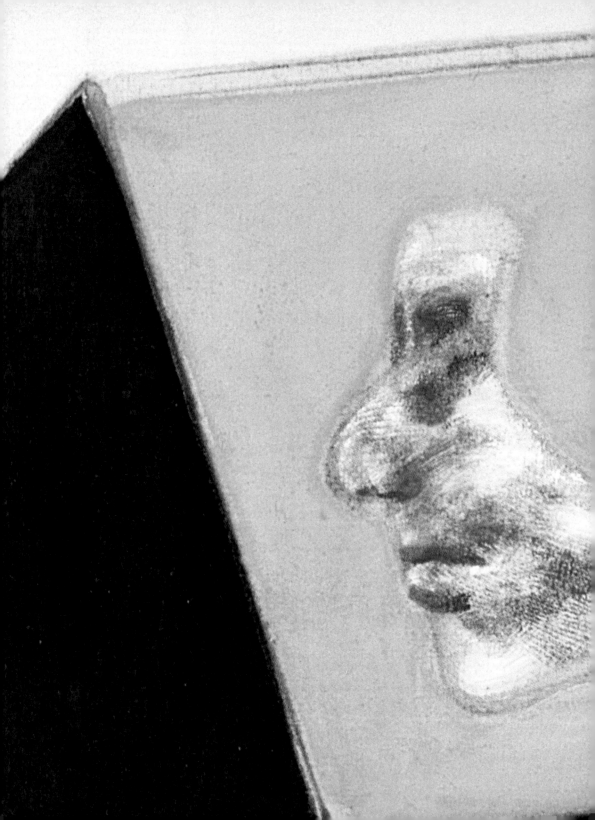

George Dyer appears badly bruised in the mirror. His reddened flesh still bears the traces of the palette knife that scraped away at his skin. Bacon looks at a face and sees that skin turned inside out. He paints it like a jacket, both inside out and the right way round at the same time. The two faces are equally necessary: a man and his double.

In a painting in which everything has become rounded and mangled, the rectangle of the mirror stands out. By resisting the general sense of wear and degradation, its very shape implies the adoption of a particular stance, which it clearly signals by reproducing a reflection that bears no relation to external reality. Having been spirited away, Dyer's face is reflected here in what seems to be a magnifying glass. But this man who expands in all directions has no chance of seeing himself from the side, even from the corner of his eye. And in any case he no longer has an eye. The intense blue of the background confirms the disharmony between what we can see of the model and what he can see of himself. The mirror does not lie. It is more like another painting than a mirror, producing an alternative image, not a reflection. The dream of a portrait. Or the battered portrait of a dream.

It is almost like one of those profiles that one sees on medallions painted against a pure blue sky: the serene and emblematic image of humanity as conceived at the time of the Renaissance. The resemblance isn't close: something disastrous seems to have happened in the meantime. Not much, really, but a disaster none the less.

A halo of light forms a circle on the ground. The regularity of the shape exposes it all as something staged, the careful calibration of a projector. Beyond the area that it circumscribes the space remains ill defined, its limits vague. It has something of an arena about it, or a circus ring, a place appropriate to a story that keeps on going round and round until all its participants are exhausted. The darkness isolates it from the rest of the world. In his dizziness, can this man really ignore the fact that it is the earth itself that is turning beneath his feet? It is a fairly derisory world from this point of view. Here is a man reduced to shreds on this planet of ours. And the sky retains its icy composure.

.

.

.

.

.

.

.

The model and his suit
●

Francis Bacon met George Dyer in the autumn
of 1963 and they soon became lovers. Bacon
painted him frequently, even after Dyer's death
in 1971. His lover's suicide affected him deeply
and he continued to work from the model who
had seduced him many years earlier. The
paintings in which Dyer appears, often wearing
a suit, might give the impression that they are
generalized images showing businessmen or
bureaucrats. But in general Bacon painted only
people whom he knew personally, working
either from memory or from photographs. If he
invests conventional clothing with such a sense
of importance, it is because it can burst at the
seams all the more spectacularly and open up
the possibility of a truth that is truly disturbing.

The point of departure for
a painting
●

'I begin in the same way as an abstract artist –
although I don't like abstraction at all,' Bacon
explained to the French art critic Jean Clair in
1971. 'In other words, I begin by making marks
on the canvas and if a mark suddenly seems to
offer me an idea, I can start to build on it and
create the appearance of the subject I'm
wanting to capture.'

Lifting the veil
●

For Francis Bacon, the true subject of a work
of art and hence its primary force lay in its
ability to lay bare the world of appearances:
'We nearly always live through screens - a
screened existence,' he told David Sylvester in
the early 1970s. 'And I sometimes think, when
people say my work looks violent, that perhaps
I have from time to time been able to clear
away one or two of the veils or screens.' The
painting thus expresses a process that is taking
place in the whole of human existence and, as
such, one that goes beyond the sufferings of
any one individual: 'What interests me more
than anything', Bacon told a French interviewer
in 1971, 'is to seize in the very appearance of
human beings the death that is working away
inside them. With each second they are losing
a little more of their lives.'

Relations with early painting
●

Bacon's work often refers to other paintings, the
most famous example being Velazquez' 1650
Portrait of Innocent X. Other works that have
functioned as catalysts include the *Crucifixion* by
Cimabue that was painted for the Basilica di
Santa Croce in Florence in around 1285 and the
nudes of Michelangelo. Even a postcard was
enough to trigger the creative process. His
paintings were not so much about distorting and
deforming the human body as an explosive
reflection on the image of that body. As such,
they reveal the fundamental contradiction
between the idea of beauty and harmony that is
embodied in the works of the past and the reality
of the world in which we live, a reality that
ceaselessly undermines that ideal, while not being
able to live without it. The profile of George Dyer
in the mirror recalls Florentine portraits of the
fifteenth century, at the same time undermining
their fictitious balance. In doing this, Bacon
invests the earlier work with an expansive quality
that suddenly allows it to start shouting after
centuries of pent-up reserve.

Abandoning
ourselves to
the gentleness
of a painting

In the Middle Ages painters belonged to the same guild as doctors and apothecaries. While their colleagues prepared potions and decoctions, they themselves ground powders that provided the colours for their paintings. Their gestures were the same. But even more than that: in their different ways, they restored order to the human body, rebuilt the faith of the weary of spirit and assuaged troubled minds. The images of saintly figures brought peace to their sorrowful souls. People could find consolation from the villainies of this world in the presence of the beauty of the angels. The context in which images are used has changed over the centuries, but they have retained this ability to calm us, an ability that exists independently of their subject matter.

The painter filters reality, ridding it of its dross and of all that weighs it down and allowing the viewer to do the same. The artist no longer holds out the promise of Paradise, nor does he always embellish the things of this earth. He can even speak about time without tricking us and address the question of transience. But he does so without undue haste, breathing in time with the viewer who was planning to pass by without pausing. The lines unfold broadly, forms interlock and coil up, light and shade are now balanced, the colour melts into the canvas.

In gazing at the image that gradually envelops us with its calming gentleness, we feel our tangled thoughts become less tightly knotted. The harmony of the painting, the story that it tells or the silence that it invokes will all explain this feeling. We know that we can return, in a minute or much later. But in the meantime a sense of calm will come over us and we shall be reconciled with the world and perhaps even with ourselves. In the protected environment of the painting we shall find a moment of respite on this lengthy journey of ours and finally be allowed to divest ourselves of our baggage.

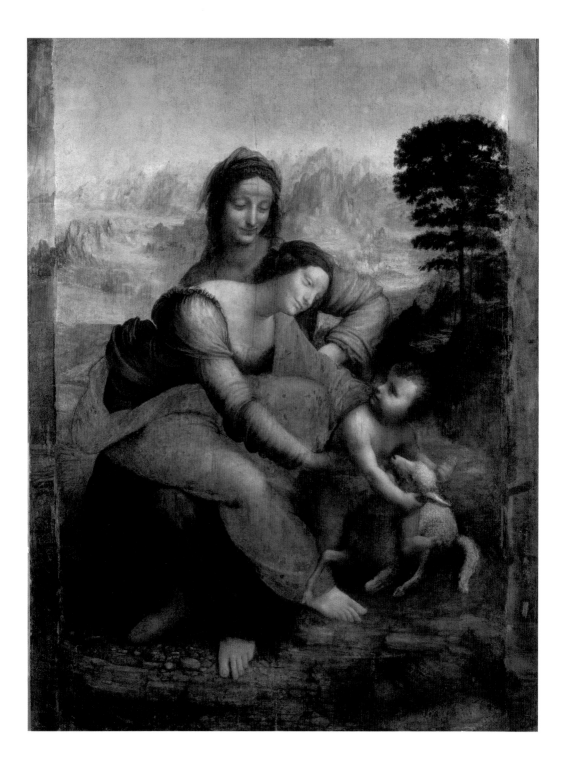

Abandoning our fear of shadows

Leonardo da Vinci (1452-1519)
The Virgin and Child with Saint Anne, c. 1508-10
Oil on wood, 168 x 130 cm (66 x 51 in)
Musée du Louvre, Paris

.
.
.
.
.
.
.

Twilight covers everything with its sable cloak, softening outlines and blurring boundaries both at dawn and at dusk. It takes its time. It is like a living creature that we nurture and reassure in order to assist our passage from one state to another. From day to night and then from night to day. From childhood to adulthood. From old age to innocence. The variations in the light free us from our restraits. The lines of the landscape waver. No one is yet fully defined. The outlines admit that they are not yet sufficient to establish a real sense of presence. They dissolve. And yet these beings exist. It is, in fact, their instability that allows them to live. Leonardo observes the phenomena of nature, the constancy of its impulses, the repetition and variety of its manifestations. A woman, and then a second one, younger, in her lap, then a child in the latter's arms. And the lamb that the child is holding. The figures succeed one another with the generations and the seasons, the slightly bent bodies, the smiles resemble one another – these are the expressions that have been passed down in one particular family since the beginning of time.

The mother, Saint Anne, is watching her daughter, Mary, who in turn is watching her son, Jesus. She will have to let him grow up and leave home. But here he is now, playing with this lamb and catching it by its ear. His actions

are natural and spontaneous and could be those of any small child who has just found a new toy or playmate. He seizes it, then turns back to his mother to show her. But this child is not like any other. He knows what his future will be. He embodies the Word of God, and the world around him is nothing more nor less than the visible expression of the scriptures. He understands this like an open book. His companion is a familiar animal but also a symbol of the innocence traditionally sacrificed to God. What we see here is an image of that sacrifice, a picture of the ritual that is being prepared.

By insisting on the light that shines on the infant and his mother, Leonardo highlights more than just their faces. He also indicates their degree of awareness and the extent to which the heavens throw light on their thoughts. At the very heart of the picture are the glances that they exchange. In any ordinary genre scene, the child would seek its mother's approval or simply her attention. Here he calmly presents her with an image of what he must face in the future. In doing so, he tells her nothing that she does not already know. But he invites the observer to understand that the painting shows something more than merely a scene of filial tenderness. He announces the inescapable course of events in the form of the death of Christ as a new Lamb of God.

They are a close-knit group, and yet they are about to fall apart. Their imminent separation can be guessed from the unstable links between the different figures, whose bodies form a pyramid. A ray of sunlight strikes the earth and warms it. The scene is a triangle of calm that shelters those who know how to build it. But it will not last for ever, at least not here on earth. Time gains the upper hand, gently but implacably dismantling what seemed as if it must last for eternity. Now is the hour: it is the half-light when the creatures of the night begin to stir, a moment that the painter relishes because it drives away the obvious. We have to leave behind the day, abandon the night. We are always on the move, always between two truths, that of heaven and that of humankind. One story comes to an end, and another one begins.

The mountains that reach up into the sky in the distance have taken on its grey-blue colour. It seems that the air up there has grown increasingly heavy, gradually taking on physical form and finally materializing as these vast desert rocks. The painting goes back to the dawn of time. The three generations that are embodied here symbolize something far greater. We can almost see these mighty summits turning to stone, then diluting their colours and producing seas and lakes. The water in the folds in the landscape has started to flow more freely, irrigating the plains. The stones have yielded to it. Softened by the water, the brown earth has put forth shoots. The fertile soil has brought life. Close to these holy figures, a dark tree rises up, reflecting the fecundity of the earth all around them. Their breath is the same

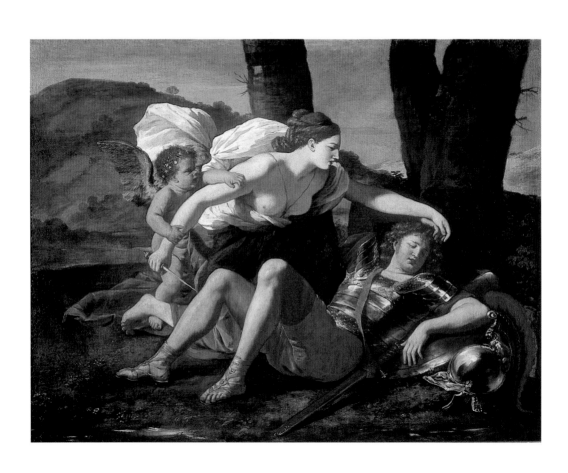

Seeing history in the making

Nicolas Poussin (1594-1665)
Rinaldo and Armida, c. 1625
Oil on canvas, 80 x 107 cm (31½ x 42 in)
Dulwich Picture Gallery, London

A woman is bending over a sleeping soldier at the foot of a tree. His sword lies beside him, and he has rested one arm on his shield. His helmet is also close by, in the corner of the painting.

She is kneeling, her hand resting on the young man's. It is not clear if she is actually touching it. We sense that she is anxious not to wake him, while observing his features without his knowledge. If the gentleness of her gesture were not sufficient proof, it would be clear from the way she watches him that she feels a very real tenderness for him. It is a very special moment.

And yet the young woman is holding a dagger in her other hand, and this undermines our initial impression. The story is now more complicated. A little winged child who is none other than Cupid, the personification of love, is clinging with all his might to the woman's arm and demonstrably preventing her from using the dagger. To judge by the intensity of his expression, he is having some difficulty achieving his aim.

The incident is set at the time of the Crusades. The Saracen sorceress Armida is resolved to kill Rinaldo, a Christian knight. Driven by her vengeful fury, she prepares to deal the fatal blow. She has drawn close to him without making a noise. From where she is positioned, it would all be very easy and would be over in a second. But that would have been too quick. Instead, Cupid

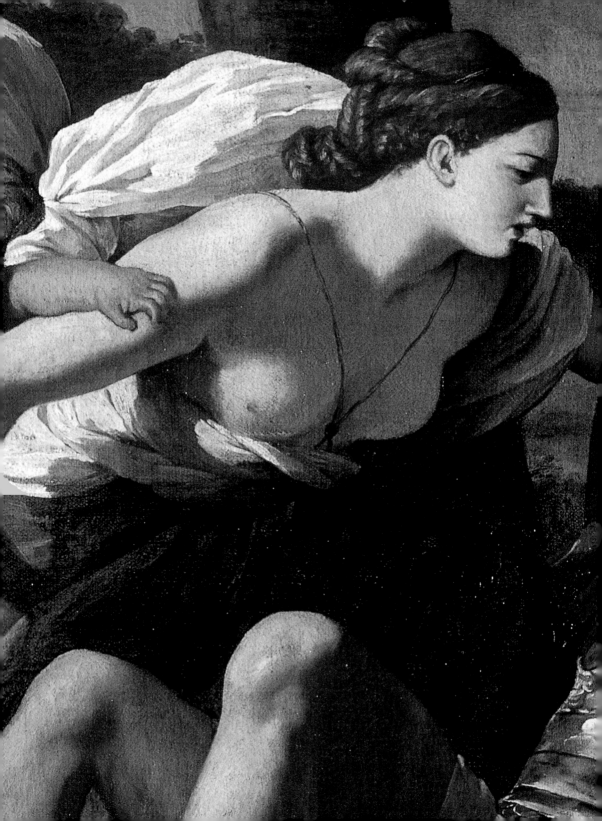

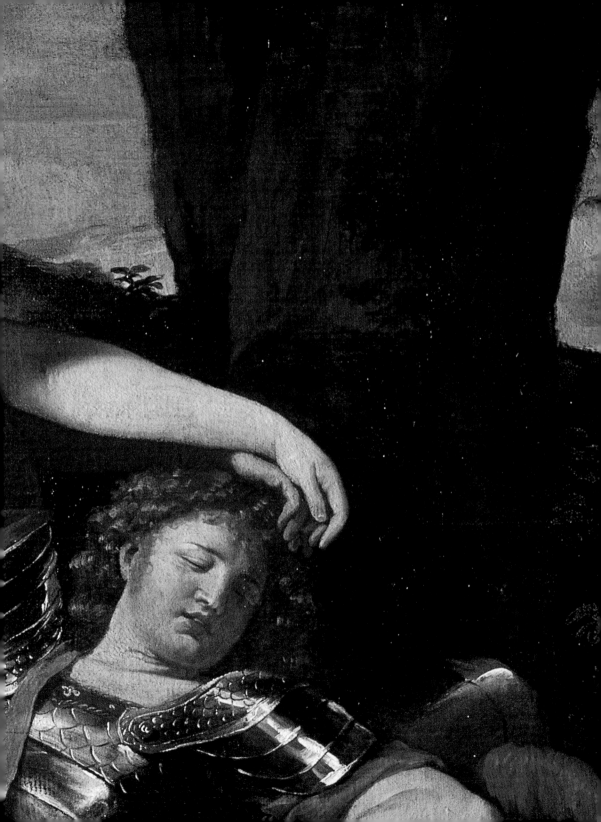

intervenes, the god of love who likes to cloud the issue and create complications that leave none of us unscathed. He inspires in her a love so great that she now renounces her plan to kill the knight. She had come to put him to death, but instead she feels a desire to stroke his hair. She does not know what is happening.

Myth seems so remote from real life, and the paintings that depict it can feel so meaningless for those of us who are unfamiliar with the classics that it is difficult to take any interest in them, and all the more so when the characters are as remote from us as Rinaldo and Armida. And yet it is by no means necessary to undertake a detailed study of Tasso's *Gerusalemme liberata* of 1581 nor to know each and every one of the hero's adventures in order to grasp their essence, with their strangely dispassionate mixture of love and murderous hatred.

A true voice of the Age of Reason, Poussin does all in his power to ensure that his painting is clearly comprehensible. More concerned to comment on the hidden agenda of a story than in illustrating its more obvious aspects, he chooses to depict the subject by basing it on this emotional ambivalence.

He has placed a tree behind Armida. Perhaps it is no more than a simple piece of decorative scenery, and yet its trunk also blocks off our view, imposing a line that she is about to cross, a threshold, the mark of a frontier that she is going to transgress.

Nor is it insignificant that behind Rinaldo we can see two trees. In the axis of the figure, above his head, two trunks growing close together rise up: in wanting to get to Rinaldo, Armida discovers a potential duality. He is both her enemy and the man she loves. The truth is no longer unequivocal.

And here she is torn between two conflicting passions: the desire to kill and, suddenly, an entirely new feeling for the stranger. In his other works, Poussin has recourse to a repertory of obvious facial expressions borrowed from the theatrical masks of classical antiquity. But that is not the case here. The purity of Armida's profile and her slightly open mouth convey her beauty and her power of seduction by the simplest of means, expressing her newfound ingenuousness when she, herself a sorceress, finds herself in thrall to another's spell. Everything happens as if Armida's mind is not involved and she has no need to show the turmoil that affects her: as we have seen, she herself does not yet understand what is happening to her. She is shaken by unknown sensations which for the moment do not reach her conscious awareness. Her body alone registers all that is going on.

As a result, it is her body, rather than her face, that reflects the sequence of her emotions, describing their progression as clearly as any words could. Her

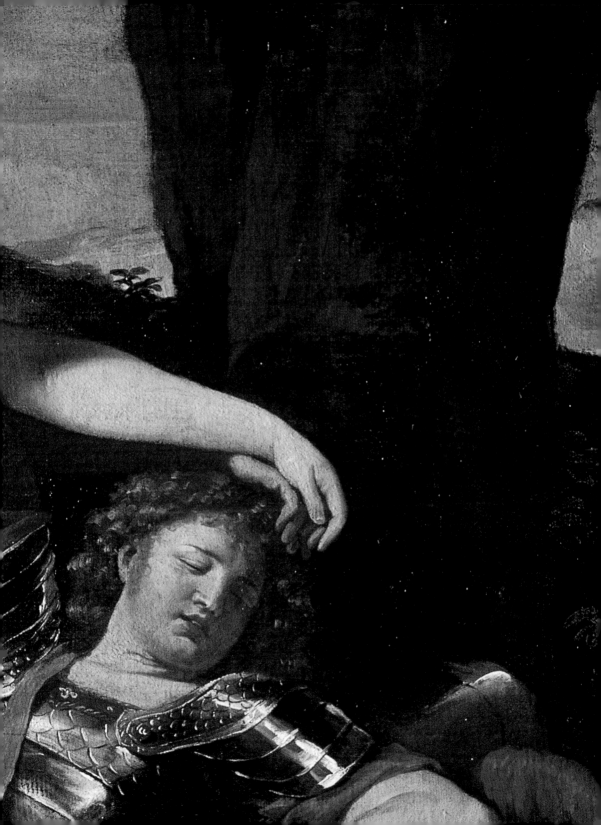

intervenes, the god of love who likes to cloud the issue and create complications that leave none of us unscathed. He inspires in her a love so great that she now renounces her plan to kill the knight. She had come to put him to death, but instead she feels a desire to stroke his hair. She does not know what is happening.

Myth seems so remote from real life, and the paintings that depict it can feel so meaningless for those of us who are unfamiliar with the classics that it is difficult to take any interest in them, and all the more so when the characters are as remote from us as Rinaldo and Armida. And yet it is by no means necessary to undertake a detailed study of Tasso's *Gerusalemme liberata* of 1581 nor to know each and every one of the hero's adventures in order to grasp their essence, with their strangely dispassionate mixture of love and murderous hatred.

A true voice of the Age of Reason, Poussin does all in his power to ensure that his painting is clearly comprehensible. More concerned to comment on the hidden agenda of a story than in illustrating its more obvious aspects, he chooses to depict the subject by basing it on this emotional ambivalence.

He has placed a tree behind Armida. Perhaps it is no more than a simple piece of decorative scenery, and yet its trunk also blocks off our view, imposing a line that she is about to cross, a threshold, the mark of a frontier that she is going to transgress.

Nor is it insignificant that behind Rinaldo we can see two trees. In the axis of the figure, above his head, two trunks growing close together rise up: in wanting to get to Rinaldo, Armida discovers a potential duality. He is both her enemy and the man she loves. The truth is no longer unequivocal.

And here she is torn between two conflicting passions: the desire to kill and, suddenly, an entirely new feeling for the stranger. In his other works, Poussin has recourse to a repertory of obvious facial expressions borrowed from the theatrical masks of classical antiquity. But that is not the case here. The purity of Armida's profile and her slightly open mouth convey her beauty and her power of seduction by the simplest of means, expressing her newfound ingenuousness when she, herself a sorceress, finds herself in thrall to another's spell. Everything happens as if Armida's mind is not involved and she has no need to show the turmoil that affects her: as we have seen, she herself does not yet understand what is happening to her. She is shaken by unknown sensations which for the moment do not reach her conscious awareness. Her body alone registers all that is going on.

As a result, it is her body, rather than her face, that reflects the sequence of her emotions, describing their progression as clearly as any words could. Her

right arm – the one holding the dagger – is bathed in a light that shows off its musculature. The shadow that spreads over her breast extends from her powerful shoulder right down to her hand. Cupid must be gripping her with all his strength in order to hold her back. The billowing movement of the drapery behind her speaks volumes about the force with which she was planning to act. There is no doubt about her own strength. But the passion is spent as quickly as it was born. Extending beyond the shadows, Armida's other arm describes a gentle curve, and in a pool of light her hand is curled above Rinaldo's.

The lines of the landscape mirror her. The hillside on the left of the image forms a dark and compact block, but it descends gently and regularly, so that the horizon gradually sinks, like the young woman's loving gesture. The feather adorning the soldier's helmet continues the gentle arc of the line, falling with the elegance of a closing parenthesis. The world is evolving in tune with Armida's emotions. Perhaps the sheer grace of this encounter will suddenly allow her to find herself in accord with the whole of nature.

The painting reveals a veritable metamorphosis. We see Armida changing. The very suddenness of the feeling that overwhelms her brings about this transformation, and she comes to vibrant life. The blue and white coldness of the fabric enveloping her yields to the red that could have been Rinaldo's blood but which is now that of the passion that possesses her.

Poussin paints her feelings of gentleness as she discovers them and as those feelings blossom within her. It is a gentleness that turns out to exert an educative force, and in creating the space for his image the artist has also given it its structure.

Armida the enchantress will create a magic palace in which to house her lover. Above him, her arms are already arched in the shape of a protective shelter.

The first meeting between Rinaldo and Armida
●

Poussin provides a scrupulously exact account of the relevant episode in Canto XIV of *Gerusalemme liberata*, which Torquato Tasso (1544-95) wrote between 1560 and 1575 and which was published in 1581. Rinaldo, the brave Crusader, has fallen asleep: 'Now from her ambush the false sorceress flies, / and looms above him, vengeance in her eyes. / But when she fixed those eyes on him to see / his calm face as he drew breath, soft and light, / his eyes that seemed to smile so charmingly, / though closed (if they now opened, what delight!), / she halts, transfixed, and next him presently / sits down to gaze, feeling her rage and spite / stilled as she hangs above him, marvelling, / as once Narcissus hung above his spring. / [...] / Thus (who would credit it?) the slumbering heat / hid in his eyes melted the ice that made / her heart harder than adamant, and lo! / she was turned lover who was once his foe.'

Poussin, a French painter in Rome
●

One of the most famous of all French painters, Nicolas Poussin chose to spend much of his life in Italy, arriving in Rome in the spring of 1624 and remaining there for most of his subsequent career. Having been introduced to Cardinal Francesco Barberini, the nephew of Pope Urban VIII, he enjoyed the stimulating company of Barberini's private secretary, Cassiano dal Pozzo, who as an art lover and man of letters opened countless doors for him. Thanks to the patronage of private collectors, Poussin was able to devote himself to painting in circumstances that allowed him to reflect on art. In turn these reflections were sustained by his familiarity with the works and writings of classical antiquity and by the major examples of Renaissance art that he found all around him. He sent his own paintings back to Paris, where his reputation was eventually such that from 1640 to 1642 he was obliged to return to France and serve at the court of Louis XIII. Although overwhelmed with honours and with commissions for vast works, the fame that the latter brought him meant little to him, and he could not rest until he returned to Rome, where he remained until his death. Submission to authority of whatever kind was incompatible with his desire to meditate on humankind and its history and to pursue a train of thought uniquely suited to a man of his great erudition.

History painting: the 'grand genre'
●

Founded in 1648, the French Royal Academy of Painting and Sculpture saw it as one of its functions to establish the principles of art, and so it defined a hierarchy of genres starting with history painting - subjects from ancient and modern history, as well as religious and mythological themes - and placing portrait painting, genre painting, still lifes and landscapes on a lower level. The superior status accorded to history painting acknowledged the complexity and scope of the knowledge expected of such artists. This included a knowledge of books that was essential to an understanding of their subject and an ability to represent anything and everything, from architectural forms to nudes and from moving crowds to the world of nature and the diversity of human passions. For others, this would have been sufficient to create a work of art in its own right, but for the history painter it was no more than a detail in the composition. The portrait and the still life, by contrast, seemed to be content to imitate nature, without elevating the mind of the spectator in a way that characterized the 'grand genre' favoured by the public commissions that were an essential source of income for artists.

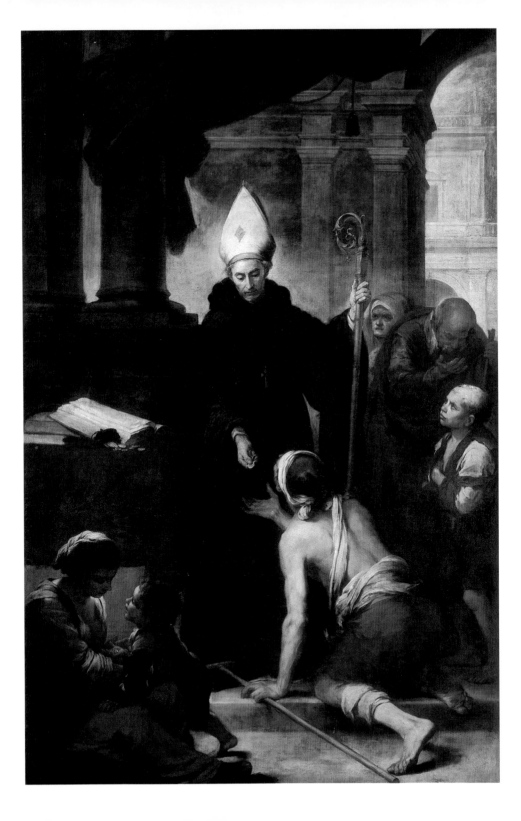

Forgetting the weight of the world

Bartolomé Esteban Murillo (1618–82)
Saint Thomas of Villanueva Distributing Alms, 1678
Oil on canvas, 282 x 188 cm (111 x 74 in)
Museo de Bellas Artes, Seville

.

.

.

.

.

.

.

Shrouded in a large black coat, the bishop rises up in the middle of the painting, distributing alms. His white mitre, a symbol of his status, attracts the light. A simple cross glitters on his breast. The long gilded crosier that marks him out as a shepherd of souls in the manner of Christ stands out against the architectural background. The poor and destitute press around him at his feet. They do not seem especially surprised to see such an important man in their midst. But nor do we feel surprised to find these tatterdemalions in such luxurious surroundings. The scene unfolds with an obviousness that discourages contradiction.

Was it he who came to them? Or the other way round? The table covered in a red fabric to the left of the image suggests an interior, as does the large drapery wrapped around the columns. But the light that fills the other side of the painting is an outdoor light. In short, it is impossible to know where the scene is set. The painting locates it somewhere between indoors and outdoors, between the intimacy of some shadowy recess and the majesty of a large open-air square. Each space succeeds the last one with such subtlety that we scarcely notice. The eye passes from one to another without realizing that not only are we in a different place, but that the moment too has passed and our minds have moved on.

The painter seems to be telling a simple story and relating events as they must have happened. With Murillo, painting appears straightforward. His technical ability creates an illusion of spontaneity, as if he needed only to follow the outlines of an unproblematic reality with his brush. But we must not allow ourselves to be misled. The ease with which we interpret his work is not only because of the subject matter but also his skill as an artist: the main figure in the painting is a well-educated man, a saint and a theologian who is drawn towards crowds that are totally destitute. Patrons who commissioned a painting from Murillo knew that they would receive a work capable of taking account of this fact, a work of undoubted spirituality that would also be understood by the masses in general.

Each of the people who looked at this canvas in the Capuchin Church in Seville must have been able to identify with the figures that are represented here. Only in this way would the image be effective: a young mother with her child, a grown-up, a young boy, an old man, an elderly woman. The ages of man file past us at the same time as their faces and their attitudes. The old woman seems to be in a bad mood – perhaps she has not yet received her alms. Her companion is checking what he has in his hand: his eyesight is not very good. The young man who is suffering from ringworm is waiting or wondering, a sombre expression in his eyes. After Saint Thomas, the most important person in the painting is the man kneeling at the saint's feet, his right hand outstretched. The message would appear to be that however many people there may be, charity is extended first and foremost to the individual. The hand that gives and the hand that receives are part of the canvas's central axis: Murillo treats this solemn and yet private moment as if it were a pact. The looks that they exchange safeguard the pauper's secret and his dignity.

The man who is kneeling is an invalid. This much is clear from his cane and, even more so, from the greyish rags that are wrapped around him which bind him like some derisory chains from which he cannot yet free himself. He is in the prime of life and yet a slave. No doubt he symbolizes humanity as a whole as we all await our deliverance.

In the presence of the assembled people we see the grandeur of the Church. Murillo has chosen an eloquent setting. The heavy architecture adds stability to the composition and gives material expression to the force of an institution faced by the casual cruelty of time. The painting brings together the protagonists of a story that perpetually repeats itself. Seventeenth-century Seville was sinking into a state of famine. It was ravaged by the plague. The sick and destitute could count on no help except for that which was organized by the Church. The present image reflects the way in which society functioned at this time. It views poverty with no sense of outrage but

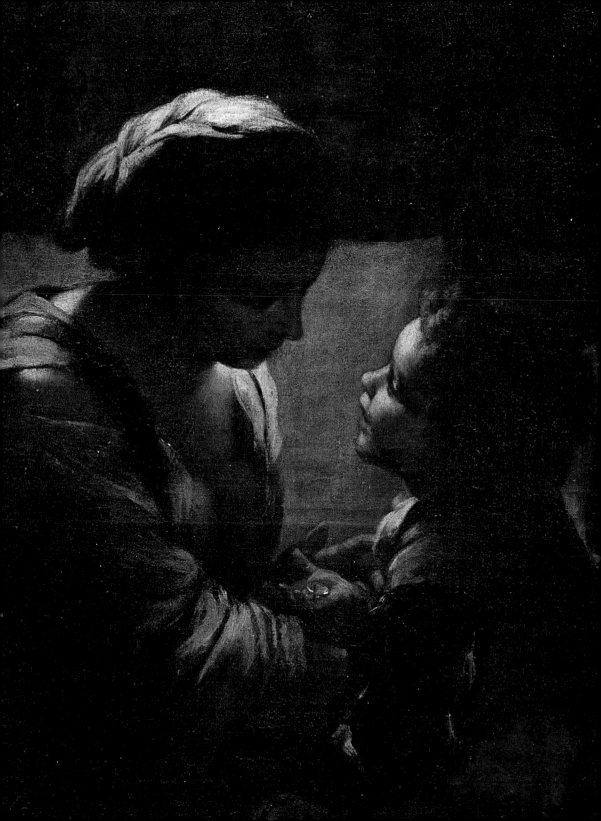

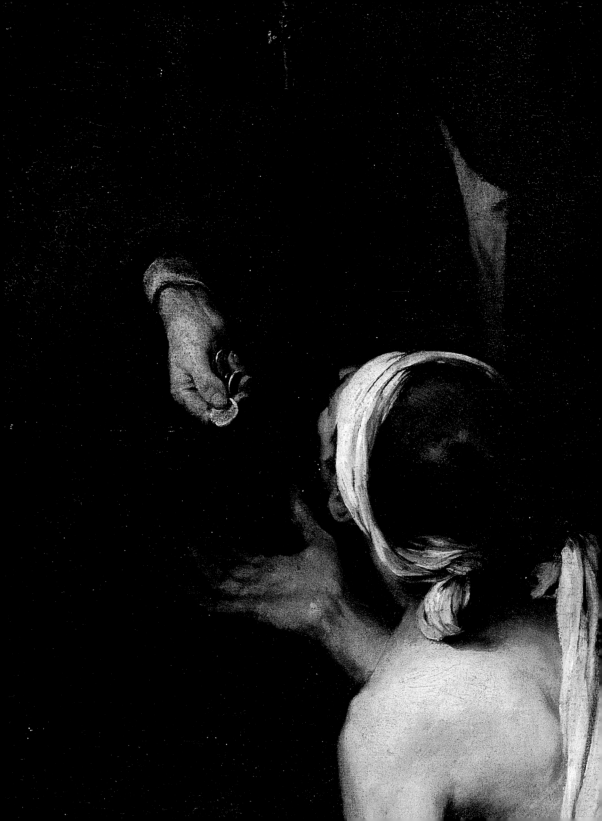

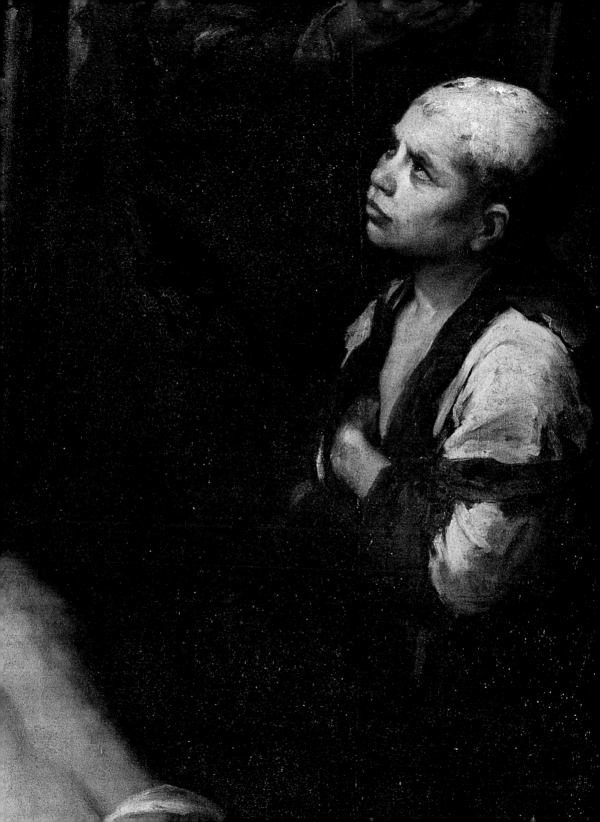

as an incurable disease which we must attempt to deal with. God allots us our places. Those who have nothing offer the rich a chance to save their souls by dint of their acts of charity.

Saint Thomas of Villanueva has abandoned his learned studies in order to draw close to the people. He leaves the world of honour and power and gives away all that he owns. Through him the Counter-Reformation legitimizes all acts of faith. Whereas Lutheranism privileged the grace of God, the Counter-Reformation stressed the importance of the believer's good works. The large book on the left is undoubtedly a sacred text and recalls the saint's intellectual standing, including the knowledge that he had acquired and from which he has turned away, not in a gesture of repudiation but in order to place the Word in the service of the weak. The book, after all, remains open, its text ever present. The light that strikes its pages is the same as that which softens the features of Thomas's emaciated face and is diffused behind him in a kind of cloud.

Murillo's brush unifies all that it touches. It softens the edges of the architectural forms and allows subtle transitions between the colours, masking the contrasts without destroying them and allowing black and white to coexist without clashing. His aim is to harmonize extremes. The mellowness of the image might seem unsuited to the reality that it depicts and too keen to embellish it. But the last thing on Murillo's mind is a saccharine sentimentality. He does not have time for that. The age as a whole is too cruel, and his painting is not meant to decorate someone's salon. The gentleness of the tonalities and gestures has a higher purpose that is also more direct.

In Exodus, the clouds that accompany the people of Israel as they cross the desert remind them that God has remained at their side throughout their ordeal. Murillo's painting is like the Biblical cloud, enveloping its figures and caressing them. By removing all that holds us apart, all that divides and cuts us off from each other, it acts as a balm. In the chapel where they come to pray, the faithful of Seville can believe that a part of heaven has descended to dwell among them. Murillo was there. He had only to add it to his canvas.

Tiny coins glint in the hand of the small boy who marvels at his treasure, his face raised towards his mother. Their tenderness gives a feeling of warmth to the image. In fact, they could form a picture of their own in the corner of the canvas. Theirs is a perfect world. Nothing is lacking. This child with the face of an angel is an emblem of innocence. He is unaware of sadness and famine. Murillo is not writing a realistic chronicle of the life of the beggars of Seville but has composed a poem on the theme of love and providence.

Seville at the time of Murillo
•

In the early years of the seventeenth century, Seville was the most densely populated and cosmopolitan city in Spain and also the wealthiest thanks to its flourishing trade with the East Indies. All the major religious orders had established a base here, and there were at least sixty monasteries and convents. But at the time that Murillo was working here, the local economy was in decline. In 1649, moreover, the city was ravaged by an outbreak of the plague that killed half the population. Poverty and destitution were rife, and the streets were overrun with beggars. The Church opened hospitals and orphanages and devoted considerable sums of money to helping the poor, who were recognized as members of that unique and mystical body evoked by Saint Paul: 'Nay, much more those members of the body, which seem to be more feeble, are necessary: And those members of the body, which we think to be less honourable, upon these we bestow more abundant honour' (I Corinthians 12:22-3). The city's religious orders commissioned numerous paintings in which the weak and the poor played an essential part. The Franciscans in particular often appealed to Murillo to express this special vision of humanity.

Saint Thomas of Villanueva (1488–1555)
•

As court chaplain to Charles V, Thomas was so famous for his acts of charity that he became known as Thomas the Almoner, and it is in this capacity that he appears in Murillo's painting, which was commissioned by the Capuchin Church in Seville, a church that belonged to the Franciscans even though Thomas was an Augustine. Although there were many differences between the various orders, his devoutness and limitless generosity towards the poor meant that he shared an essential point with the founder of the Franciscans, Saint Francis of Assisi. Also, the Capuchins provided shelter for a number of monks who originally came from Valencia, where Saint Thomas was named archbishop in 1544. Saint Thomas was canonized in 1658. He is traditionally depicted in episcopal garments, carrying a crosier (the shepherd's crook) and wearing a mitre (the liturgical headdress), the two points of which symbolize the Old and New Testaments.

The Counter-Reformation
•

Also known as the Catholic Reformation, this vast movement was meant to reassert the Church's authority and began in the fifteenth century, developing momentum in the course of the sixteenth as a reaction to the Lutheran Reformation. New orders were founded, including the Jesuits in 1540, and older ones were reformed – in 1525 the Capuchins asserted their wish to return to the pure spirit of the Franciscans. The aim was to reestablish a sense of discipline, to put an end to numerous abuses and above all to redefine the doctrinal issues challenged by the Lutherans. The Council of Trent (1545-63) was the defining moment. The Counter-Reformation put in place a huge programme of teaching, proselytism and aid, at the same time insisting on the value of charitable acts, which is why seventeenth-century paintings accord a preponderant place to the lives of the saints.

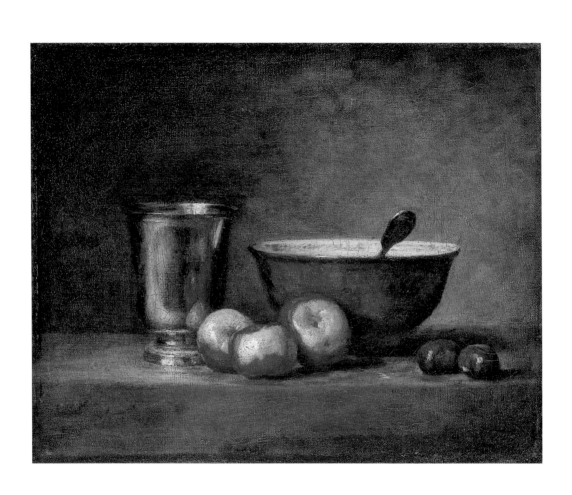

●●●●

Enjoying
a lasting peace

Jean-Baptiste Siméon Chardin (1699-1779)
Three Apples, Two Chestnuts, Bowl and Silver Goblet,
or *The Silver Goblet,* c. 1768
Oil on canvas, 33 x 41 cm (13 x 16¼ in)
Musée du Louvre, Paris

.

.

.

.

.

.

.

.

There is a slight film over the surface of these objects. You want to touch
them. Undoubtedly you could without feeling afraid. They are such simple
things: three apples and two chestnuts, a bowl with a spoon in it and a silver
goblet. There is nothing superfluous here. If necessary, it would be enough
to live on.

A few light shadows hover around these small objects. Their blurry outlines
force us to screw up our eyes a little as if we needed to see them more clearly.
We have to adjust our eyes and take a step closer for the painting is not very
large. In this way, Chardin invites the viewer to slow down. He himself is in
no hurry. He observes things with his habitual patience. They are always the
same, year in and year out. His painting is in a state of rest.

The silver goblet is his. He sees it at home every day and it has become a
companion. Time has no hold on it. The object, which has always been well
cared for, has retained its gleam and serves its purpose as a mirror, quietly
reflecting back the light that flows around its belly, at the same time taking on
the colour of the fruit and even a part of their form. Stripped of its volume,
the image is repeated until it is finally exhausted. We see it disappear round
the edge of the goblet and merge with the darkness beyond it.

The bowl, which is rather more bell-shaped, grows red beside the apples. The two chestnuts stand somewhat apart, touched by the same discreet and transient brightness.

However attentive we may be, it seems impossible to discover in this painting any of those almost imperceptible details that would allow us to identify a hidden subject. Traditions in painting had led the eighteenth-century viewer to seek out a moral lesson beneath the most innocent of objects, to catch the intended allusion and to detect a virtuous warning behind all the images of the pleasures of this world. An apple automatically suggested original sin, and the observer would be implicitly reminded of death and divine judgement. But in this case Chardin allows nature to speak for itself, as if, finally, it had need of nothing else. His little apples certainly lack the emblematic majesty of the fruit of the tree of knowledge that we encounter in so many older still lifes. Their irregular form and tiny defects suggest the gustatory delights of very specific types of fruit, and we may be certain that they have a very particular consistency, freshness and taste. We could describe them as portraits, rather than as abstract models. The softness of the chestnuts and the crispness of the hard apples that have been rubbed against a sleeve until they shine, the different flavours of sugar and the surprisingly acidic tang of the fruit are all part of our everyday repertory of sensations. Anchored in daily life, Chardin's motifs confirm the reality of that world. They contain no metaphysical threat, they imply no ulterior motive.

In the intimacy of the house, nothing moves, which is why there is rarely any sense of scrutiny when we look at things here. Convinced that we will find what we already know to be here, we can afford to be nonchalant, avoiding the rigorous clarity of the contours and taking no interest in definitions. By the same token the painter allows his brushstrokes to show through in the paint, refusing to describe things more coldly than how we usually see them and restoring to the viewer the somewhat unfocused relationship that we have with objects of which we are certain. Chardin also knows that things do not necessarily appear more precise when we linger over them, for unless we study them with scientific rigour, the opposite is almost always the case. By contemplating this or that object, we end up losing sight of the real thing, which dissolves and gradually vanishes without our even noticing. The painting behaves in much the same way. A few moments are enough to turn our detailed examination into a delightful reverie. Time passes. Nothing comes along to undermine the steadfastness of the process by which one day turns into the next.

A painting like this seeks no more to instruct us than it tries to dazzle us. But the constancy with which it attaches itself to objects ensures that those objects become the surest evidence of our relations with the world. There is

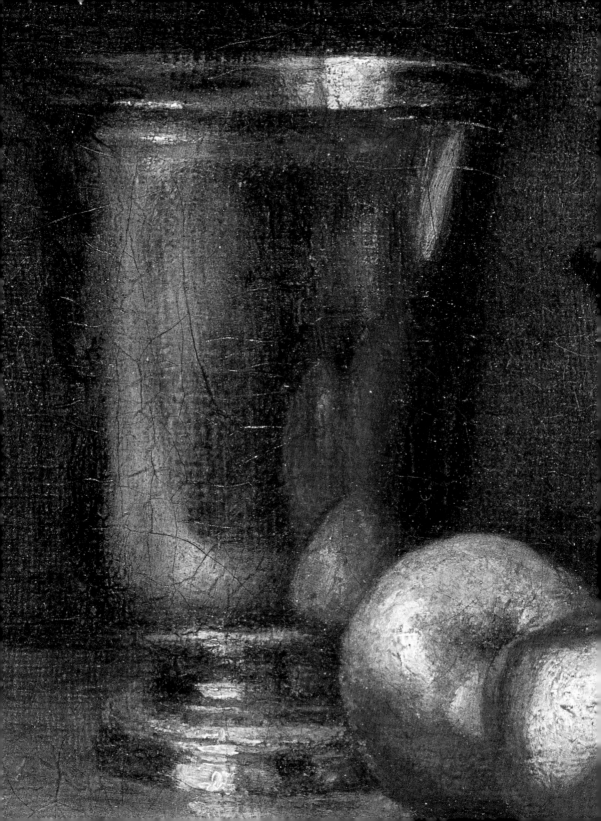

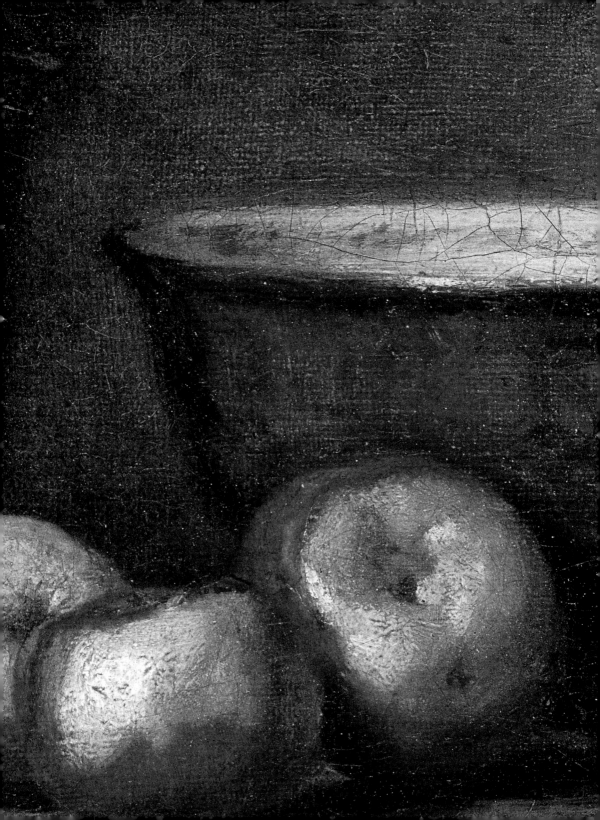

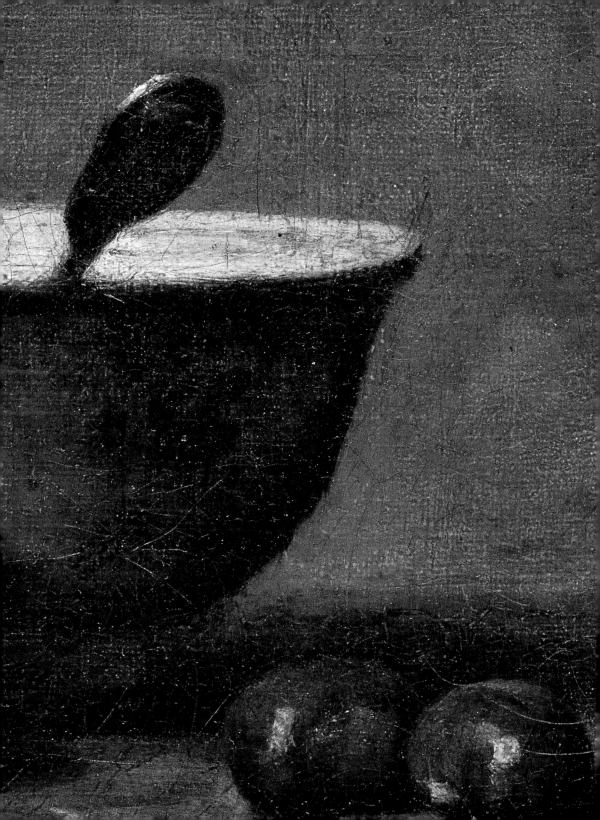

no doubt that they signify only what they show us. Everything is here in this capacity, to fix the obvious. Or what we assume to be the obvious. Without the artist we would have noticed this bowl and goblet and dismissed them as unimportant. But Chardin honours them as guests who were expected and who are always welcome.

By conferring upon them the quality of something exemplary, Chardin comes close to the attitude held by the contemporary philosophers of the Enlightenment. This was the age of the *Encyclopédie*, a great enterprise undertaken by Diderot and d'Alembert that set out to impose order on every aspect of knowledge and technology within the numerous volumes that made up this monumental project. The engraved plates that were published at the same time provided a catalogue of all the various instruments and tools classified according to their function and use. The rationalist spirit that guided this vast intellectual exercise was also the basis of Chardin's view of his art. The objects that he chose illustrate all that was incontrovertibly necessary in our daily lives. Here we see a goblet. Elsewhere he depicted a skimming ladle, a glass of water or a cauldron, all of which take their place in the household version of the great lists that make up the *Encyclopédie*.

Within this entirely personal and novel space, Chardin describes objects that from now on would be judged by the yardstick of our own individual lives. For him, the still life was no longer a symbolic reminder of the concepts of finitude and eternity. The transitory nature of this world and its inherent decay would no longer be waved in our faces like a red rag to a bull. This was how things were. Time calmly wears them away, leaving its patina and allowing them to become cracked. That is all. Stripped of both transcendence and disquieting uncertainty, the image celebrates the continuity of life without creating a fuss in the process.

The apple as a symbol
●

The fruit of the tree of the knowledge of good and evil was generally represented as an apple. The Bible does not in fact say what kind of fruit it was, but the similarity between the Latin words *malus*, meaning 'bad' or 'evil', and *malum*, the noun for an apple, no doubt encouraged this particular iconographical choice. The apple is found, therefore, in representations of original sin that show Eve either about to bite into the apple herself or offering it to Adam. It is also depicted in the hand of the infant Jesus in his role as the 'new Adam'. The link with sin and redemption is also found in seventeenth-century still lifes that stress the vanity and futility of the world. Although the moralizing aspect of these images faded over the centuries, there still remained at least a memory of this portentous symbolic past. While the boundaries between the sacred and the profane were no longer entirely clear, the apple could still point in the direction of knowledge, for all that it was no longer a true symbol.

Between reason and sensation
●

Setting out from the rationalist spirit of the eighteenth-century *philosophes*, the *Encyclopédie* was the first major work to popularize science. Its principal editors were Diderot and d'Alembert, assisted by Montesquieu, Voltaire, Condillac, Buffon, Daubenton and Turgot. It appeared in seventeen volumes between 1751 and 1765 and also included eleven volumes of plates, five supplementary volumes and a two-volume index. Freed from all dogma and all theological preoccupations, this monument to the Age of Reason broke with the Christian tradition and glorified our ability to understand and construct the world in which we live. In parallel with this, the writer Étienne Bonnot de Condillac argued in his *Treatise on the Sensations* that all knowledge derives from our senses and from them alone, attention being a more powerful sensation than all the rest.

'We must learn to look'
●

Diderot, who was one of the first great art critics, recalls the words of Chardin himself when reminding the arbiters of art of the torments suffered by all true artists: 'Messieurs, Messieurs, go easy. Find the worst painting that's here, and bear in mind that two thousand wretches have broken their brushes between their teeth in despair of ever producing anything as good. [...] The eye must be taught to look at nature; and many are those who've never seen it and never will! It's the bane of our existence. After having spent five or six years in front of the model, we turn to the resources of our own genius, if we have any. Talent doesn't reveal itself in a moment; judgments about one's limitations can't be reached on the basis of first efforts. [...] Those who've never felt art's difficulty will never produce anything of value.'

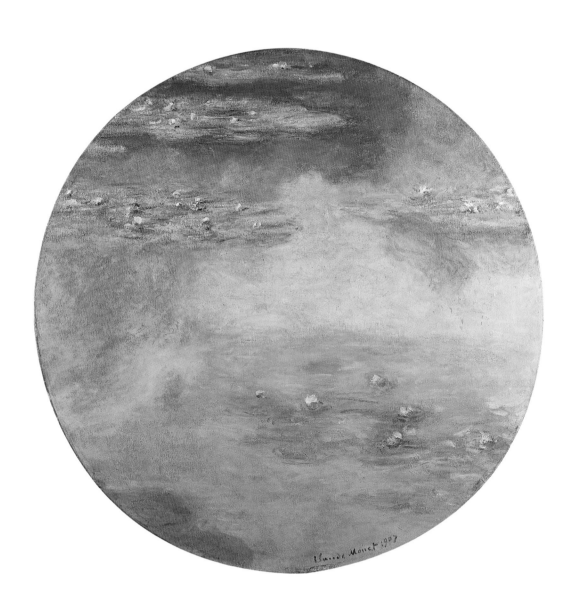

Welcoming
the ephemeral

Claude Monet (1840-1926)
Water Lilies, 1907
Oil on canvas, diameter 80 cm (31½ in)
Musée d'Art et d'Industrie, Saint-Étienne

What has changed? Almost nothing. A slight breeze. The light cannot penetrate the drifting clouds. Looking at the sky in the depths of the water, we no longer know where we are. Everything is silent. We have all the time in the world.

The garden could be on the other side of the world. Lost in the sight of these water lilies, the mind empties. The imperceptible progress of a petal as it opens each morning holds our attention to the exclusion of all else. Each day is a special event. We need to arrive at dawn, a little earlier than necessary. We shudder with the cold, just as the water trembles beneath the breeze. There is no one else around. Who would come to watch something that hardly exists? We suddenly understand why the ancients were so afraid that the sun would set and never return. Most people prefer images that tell a story or help to reconcile them to the disorderly nature of the world. Perhaps paintings from the past have spoilt them in this regard. They do not yet know that painting also likes whatever hesitates and disappears again before we have been able to put a name to it.

When Monet first arrived at Giverny there was nothing else here but a stretch of water beyond the garden that ran down from the house. He first had to deal with the most pressing problems and sort out those parts of the

garden that could be seen from the windows, clearing away the undergrowth, replanting and rearranging the bushes and shrubs according to their colours and never losing sight of all that would happen to them in the course of the changing seasons. The harmony changed each time. At the foot of the trees, the bluish flowers heralded the translucent shadows that his painting would seem to have invented. And then, one day, it was no longer enough: there were still too many lines and masses. Even when lacking in precision, they still retained a vestigial sense of geometric forms. It was like going for broke while always knowing oneself to be covered. Something else was needed.

Crossing the stream marked the start of a further period for Monet, as if the person out walking had all at once found himself carried away with his brushes to a space he had not foreseen. A tiny effort was all that was needed. Divert the watercourse, extend the area of water and make it larger. The drooping branches would mask the edges of the lake, making it impossible to say where the land began beneath the mass of greenery. There were no longer any limits to this water garden, no more pathways, nothing to recall the hurly-burly of life. Canvases piled up in the bottom of the boat. Monet had the impression that he had finally entered the space of one of his paintings. In classical paintings, the foreground turned this space into a substitute for the theatre, the edge of the picture indistinguishable from a box at the opera. Monet cast off his moorings, drifting away until others could no longer see him. In the end he enjoyed imagining it. The bank was not far off. But far enough to stop others from following him. This space was untouched by any paint. It belonged to him alone. And he would wade through the mud if need be.

The colour of the sky evaporated in the water. Monet no longer raised his eyes from the surface of the lake. Sometimes he pushed his canvas away and selected another one. As the mist was lifting, it had settled on the canvas.

He had always wanted to paint all those things that slip through our fingers: the air, a ray of sunlight on a dress, the waves as they strike the cliff, the snow as it starts to melt. But none of this inspired him with any great confidence at the outset. The people who sought in painting the certainties that they lacked in real life could not understand such persistence. All that they could see in it was impertinence coupled with the sort of poor draughtsmanship that produced only wretched sketches that tried to pass themselves off as real landscapes.

What did they want? A profusion of trees and backgrounds, of rocks and winding pathways, of stormy skies and peaceful flocks, of exceptional viewpoints that might even be impossible, of heroic or charming individuals, a touch of pathos and a flood of tears? As if any of this had a single iota of truth to it or any relation to real life. The Academy could teach him to draw antiquities,

but Monet preferred the woods and the beach. It would no doubt have been easier to reproduce the enduring forms of tradition that were all the more immutable in that they had been held up as indispensable models of beauty, balance and moderation. But none of this mattered to Monet when set beside the gust of wind that shook the leaves on the trees and made them rustle. The patience needed to see clearly, a few brushstrokes… He had learnt to spend long hours out of doors, lying in wait like a hunter in all weathers.

A few people would sometimes appear in the painting, but they never insisted and they never added anything. There was always too much chatter – it was better to go without. The painting had long since become the setting for a monologue.

The boat glides along a short distance. The air grows hotter. The reflection of the weeping willows blends with the restful leaves of the water lilies. Higher and deeper the sky turns whiter. Yesterday at this time it was a deeper shade of pink. A canvas back in the studio is drying.

How many paintings would it take to be certain of having painted something, to have captured a reality capable of sustaining you and not leaving you mortified a moment later because everything has changed once again? Monet never wanted to beautify nature or invent an appearance that it had never had and never would have. He painted canvas after canvas on the same subject: he had to adapt, forget, start again. He ran after things for fear that they would vanish before they had allowed themselves to be properly understood. He had to be quick. But then there were other days when he had to wait for ages until reality deigned to be approached. In the end he was bound to ask himself if it was he who was hurrying or time that was pursuing him. He no longer saw the difference. He knew only that by painting changing time he had finally painted the passage of time.

He needed to stop. The paintings that he was producing in dozens, one after the other, formed links in a chain, yet one link was always missing. Painting should never become such a drain on the artist's resources that it finally eats away at him.

The blue invades the boat's surroundings, saturating the flowers that are opening. The water lilies rediscover the daylight.

Monet grew reconciled with time. In the end they became old friends. The hunt was over. It was now a kind of meeting, and it was the artist who arranged to arrive a little ahead of schedule. He painted what never failed to return. The painting grew round in order to greet the cycle of nature. Like him, it had neither a beginning nor an end. The signature follows the curve – it was the least he could do to show his appreciation. He had finally made his peace with eternity.

Giverny
●

It was in 1883 that Monet settled in Giverny, a village in northern France, seventy-five kilometres (forty-five miles) to the north-west of Paris. His wife had died in 1879, leaving him to take care of their two sons and the six children of his companion, Alice Hoschedé. With the help of his dealer, Paul Durand-Ruel, he was able to rent the large house whose garden allowed him to continue the work he had started in Argenteuil and Vétheuil and remain in permanent contact with nature. Giverny was more than a collection of motifs comprising the garden and its colours, together with the lake and its reflections. After Monet had acquired it in 1890, it served as his home for the next thirty-six years, a place where he was able to initiate many of the most innovative ideas of the second half of his life. Each of its three successive elements – the house, the garden and, further away, the Japanese garden and lake – allowed him to explore a new world of expression. With its blue and bright yellow walls, the house was a place of flat colours and geometrical forms; the garden liberated his palette in all its exuberance; and the waters of the Japanese lake destroyed all sense of fixed landmarks. In this way, Giverny came to encapsulate the artist's inner journey.

Water lilies
●

The World Fairs of 1889 and 1900 both included reconstructions of Japanese gardens, and to a certain extent these could well have inspired Monet when he designed his own water garden at Giverny. But Monet's garden is more of a reminiscence than a replica of a formal Japanese garden, being first and foremost a place dedicated to painting and meditation. The narrowness of the path passing through it signals the fact that it expects only a single visitor in the form of the painter himself. The white water lilies that he planted in the lake symbolize the cycle of life and death, light and darkness as part of a process of perpetual rebirth. Fascinated by the beauty of these flowers – and he acquired many of the most recent varieties – Monet spent the next thirty years painting more than two hundred and fifty images of them. 'The landscapes of water have become an obsession,' he told Gustave Geffroy in a letter of 11 August 1908. 'It is beyond my strength as an old man, and yet I want to succeed in rendering what I feel. I have destroyed them. I have started again. And I hope that something will come of so much effort.'

The tondo: a circular painting
●

The circular painting is known as a tondo, a shortened form of the Italian word *rotondo*. The term is derived from the circular painted trays presented to young mothers in fifteenth-century Italy and like them it recalls a domestic interior. Such paintings were used to decorate entrance halls and stressed the tenderness and fecundity of the family by means of a sacred subject such as a *Nativity*, an *Adoration of the Magi* or a *Virgin and Child*. In the course of the following centuries, the idea of timelessness implied by the painting's circular format encouraged artists to explore other imagery. The format of the tondo may also have been an appropriate response to the problem that tormented Monet by suggesting a cyclical conception of time. In any event, this was the theme that emerged in the monumental series of *Water Lilies* that crowns his entire output. In each of two oval rooms at the Orangerie des Tuileries in Paris, the observer is surrounded by the painting on the walls. Instead of approaching successive works in a disjointed manner, we go straight to the heart of a single painting that no longer has any boundaries.

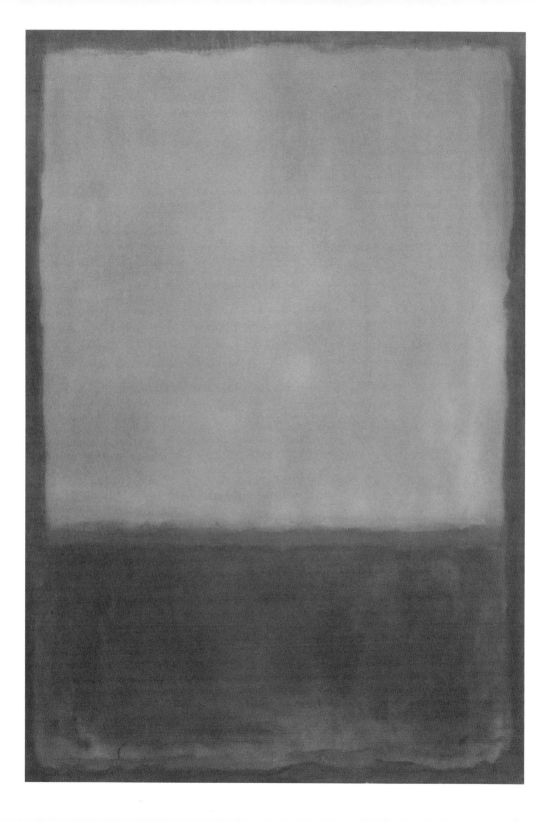

Learning to wait

Mark Rothko (1903–70)
The Ochre (Ochre, Red on Red), 1954
Oil on canvas, 235.3 x 161.9 cm (92¾ x 63¾ in)
The Phillips Collection, Washington DC

.

.

.

.

.

.

.

The painting is on fire, but it does not move. Our eyes lose focus. We sink into the painting without falling, as if with each step that we take, we continue to feel the density of the space surrounding us. There is no image, only air, a breath that is saturated with colour. The orange and ochre are so powerful as to create an impalpable wall. The canvas seems about to become less opaque. Transparency is not far away. We cannot be certain. The painting, too, appears to hesitate. Something trembles imperceptibly. It is impossible to leave.

A work that at first sight is so simple inspires so many contradictory sensations the moment that we draw closer. A Rothko speaks clearly only to the person who faces it directly. One might think that this were true of every painting and that Rothko demands no more than any other artist. Is it not self-evident that we always look at a painting in this way? No, perhaps not. Standing in front of a painting in order to look at it is one thing, but it is a very different matter to stand facing it as one would face another person in a harmonious relationship that ignores the balance of power between them. The apparent emptiness of the painting frees the viewer from earlier commitments: the power of reason is no longer required, we can forget about that. All that is demanded of us is that we should be here. And that we should be genuinely here. The viewer adopts the correct position without thinking,

stepping a little too close, then taking a step back before finally settling somewhere in the middle. We find a physical rapport with the painting, then finally agree to stand still. This is the price we pay for the painting beginning to exist. We gradually become aware of it, as if it were starting to vibrate with life in proportion to our own ability to break free from everything else. Rothko's painting defines its own territory and gently removes the world around it.

The rectangles of colour that are superimposed and that float above one another echo the painting's four edges within the space that it occupies. They gravitate towards the centre, inviting the observer to take the first step and move away from the edge if only a little, leaving the limiting sides of the painting that are still too close to external reality. We have to let go. Then we can linger over these other lines that are not lines at all, these sensitive areas where the red disappears beneath the orange or the orange breaks free from the red without abandoning it completely. We need to learn about the slowness of transitions and forget about the harshness of sudden breaks.

A dull sense of geometry provides some stability for an edifice suspended in space. It conceals the rigour of its outlines – its power must not be exposed – and remains silent and indubitable on the very deepest level. As viewers, we discover the intimacy of a place where we may be alone and where we may collect our scattered thoughts and feelings, noting that they remain confused, while admitting that this is entirely normal: this is a painting on a human scale that none the less gives us the feeling of a limitless space, radiating a colour that is both calm and irregular, no doubt also vulnerable, but capable of absorbing the light and of swallowing it whole in enormous gulps.

The luminous power of the painting would be almost frightening if the blurred outlines did not mitigate its effect on the viewer. It both dazzles and protects us. Only the gold backgrounds of centuries past gave images a comparable intensity: a vague sense of eternity lay behind human history, limiting our movements to those of characters on a stage set. Even when we concentrated on the narratives depicted in these paintings, we could never lose sight of this brilliant, fixed surface that was both a barrier and a promise of something that lay beyond it. Rothko did away with both of these aspects of art. Our gaze no longer collides with any frontier. Eternity yields before the outpouring of colour. But he has also eliminated objects and people and their histories. His paintings tame the observer until we can be in the presence of the void without feeling any fear.

The void. The whole history of painting has been hand in glove with the void. Over the centuries artists had sought to deal with it by concealing it or by

somehow making it bearable. It had to be hidden. Initially artists had produced images to replace what was not visible and what was so cruelly lacking in our lives that we needed a remedy merely to go on: the faces of the absent and the dead. The original legends were all more or less related to this theme: Pliny the Elder reports that when a lover was about to leave her for a long voyage, a potter's daughter used a piece of charcoal to trace the outlines of his shadow on the wall so that after he had gone she would at least have the consolation of his silhouette. According to Pliny, this is how drawing was invented. The legend of Saint Veronica, who helped Christ while He was making His way to Calvary, is based on a similar idea: having wiped away the sweat with the veil that was covering her hair, she discovered that His face had remained imprinted upon it – a miraculous portrait had been entrusted to her, having been offered by Christ to humanity shortly before His death.

Above and beyond all these emblematic examples, the other subjects that painters have used all spring from much the same logic: to reproduce real life or to invent an appearance of it is not a goal in itself but merely the means that is used to ensure that if necessary we have a substitute object. Paintings give back to the world what we have lost or what we are waiting for.

Rothko's painting does neither of these things. It abandons these elements and relinquishes everything that might calm our fears in the face of oblivion. It replaces nothing, offers nothing in return. It does not help to deceive us about an absence but makes absence its subject. The substance of Rothko's art merges quite splendidly with the idea of an endless wait. For there will be no denouement. If there is a final unmasking, we shall not be aware of it. It will exceed our capacity of understanding. It will be outside our time. The painter does not displace the meaning of the painting to a later point in time or to some other place. The problem is not that we have to wait for something but that as human beings we are essentially creatures of waiting. And we wait with a gentleness that renders everything bearable. Rothko encourages the observer to confront this double truth that is buried deep inside the painting: the haunting need for an image and our definitive inability to see it.

The colour seems to fade, allowing us to guess at the splendour of what remains invisible and in that way reducing our desire. But something forces us to remain: the time that we need to watch the ochre disappear and to allow ourselves to be carried away by the heat of the red that does not die away.

A trembling pink horizon crosses the incandescent canvas. Everything could still change.

The painting is a threshold.

.

.

Rothko's technique
●

In describing Rothko's canvases we could have used the term 'dyeing', a word that underscores the tactile quality of the canvas, while also having the merit of suggesting the artist's modus operandi: rather than simply covering the canvas with paint, he tended, rather, to impregnate it. He would begin by placing a monochrome layer on a cotton canvas and then add a glaze, in other words, layers of transparent paint with a heavily diluted oil base. This layer of colour was rubbed with cloth, so that the paint gradually penetrated the very fine mesh of the canvas. The subtle transitions between one colour and another were the result of a complementary process using a brush. In this way the substance of the painting was delicately absorbed by the canvas to the point where it became indistinguishable from it.

The theme of revelation
●

Rothko was born in Russia and spent his childhood there, attending the Talmudic school in Dvinsk. He moved away from all religious practices on his arrival in New York in 1913 and abandoned them for good following his father's death in 1914. Even so, he remained imbued with the spirit of the Hebrew tradition: the space in which the invisible is manifest, the presence of a radiant light, the suggestion of clouds or fire, the evocation of a veil whose substance signals the divine at the same time that it conceals it – all these ideas are not only characteristic of Rothko's art, they also relate to the world of the Bible and in particular to the theme of revelation that recurs again and again in the Old Testament. Rothko had no time for illustrative art or for direct references in his work, which in this way is linked to the very foundations of western culture, expressing what he himself repeatedly termed 'spiritual statues of consciousness'.

Rothko's pictorial conception
●

Rothko was one of the most widely read artists of his generation, as familiar with the Judaeo-Christian tradition as he was with Greek philosophy. For some twenty years, from 1929, he taught drawing and painting at the Brooklyn Jewish Academy. He also wrote prolifically and expressed his thoughts on painting on frequent occasions. 'You have noticed two characteristics exist in my paintings,' Rothko once explained to Alfred Jensen. 'Either their surfaces are expansive and push outward in all directions, or their surfaces contract and rush inward in all directions. Between these two poles you can find everything I want to say.' Rothko was particularly insistent on the role that the viewer must play when confronted by one of his paintings: 'A picture lives by companionship,' he explained in 'The Ides of Art', 'expanding and quickening in the eyes of the sensitive observer. It dies by the same token.'

Select Bibliography and Suggestions for Further Reading

Primary sources
· The Apocrypha
· The Holy Bible (Saint James version)
· Balthazar Castiglione, *The Book of the Courtier*, trans. Leonard Eckstein Opdycke, Charles Scribner's Sons, New York, 1903
· Thomas à Kempis, *The Imitation of Christ*, trans. Leo Sherley-Price, Penguin Classics, London, 2005
· Ovid, *Metamorphoses*, trans. A.D. Melville, Oxford University Press, Oxford, 1986
· Cesare Ripa, *Baroque and Rococo Pictorial Imagery*, trans. Edward A. Maser, Dover Publications, New York, 1991
· Saint Francis of Assisi, *Little Flowers of Francis of Assisi*, trans. Robert H. Hopcke and Paul A. Schwartz, New Seeds, London, 2006
· Torquato Tasso, *The Liberation of Jerusalem*, trans. Max Wickert, Oxford University Press, Oxford, 2009
· Jacobus de Voragine, *The Golden Legend*, trans. Granger Ryan and Helmut Ripperger, Longmans, Green and Co., New York and London, 1948

Reference works
· Herschel B. Chipp, *Theories of Modern Art: A Source Book by Artists and Critics*, University of California Press, Berkeley, 1968
· Pierre Grimal, *The Dictionary of Classical Mythology*, trans. A.R. Maxwell-Hyslop, Blackwell Reference, Oxford, 1987
· Joshua C. Taylor, *Nineteenth-Century Theories of Art*, University of California Press, Berkeley, 1987

Exhibition catalogues
· *Botticelli*, musée du Luxembourg, Paris, 2003.
· *Bruegel, une dynastie de peintres*, palais des Beaux-Arts, Bruxelles, 1980.
· *Cézanne*, Galeries nationales du Grand Palais, 1995.
· *Chardin*, Galeries nationales du Grand Palais, Paris, 1999.
· *La Collection*, musée national d'Art moderne, centre Georges-Pompidou, Paris, 1987.
· *Constable, le choix de Lucian Freud*, Galeries nationales du Grand Palais, 2002-2003.
· *La Couleur seule, l'expérience du monochrome*, musée Saint-Pierre d'art contemporain, Lyon, 1988.
· *Le Douanier Rousseau*, Galeries nationales du Grand Palais, Paris, 1984-1985.
· *Edward Hopper*, Tate Modern, London, 2004.
· *Francis Bacon*, musée national d'Art moderne, centre Georges-Pompidou, Paris, 1996.
· *Gauguin*, Galeries nationales du Grand Palais, 1989.
· *Hommage à Claude Monet*, Galeries nationales du Grand Palais, Paris, 1980.
· *Kandinsky*, musée national d'Art moderne, 1984.
· *Mark Rothko*, musée d'Art moderne de la Ville de Paris, 1999.
· *Munch et la France*, musée d'Orsay, Paris, 1991-1992.
· *Pierre Soulages*, musée d'Art moderne de la Ville de Paris, 1996.
· *Polyptyques, le tableau multiple du Moyen Âge au XXᵉ siècle*, musée du Louvre, Paris, 1990.
· *Les Portraits d'Ingres. Peintures des musées nationaux*, Éditions de la Réunion des musées nationaux, Paris, 1985.

· *Renoir,* Galeries nationales du Grand Palais, Paris, 1985.
· *Watteau,* Galeries nationales du Grand Palais, Paris, 1984-1985.
· Sylvie Béguin, *Les Peintures de Raphaël au Louvre,*
 Éditions de la Réunion des musées nationaux, Paris, 1984.
· Jacques Foucart, *Les Peintures de Rembrandt au Louvre,*
 Éditions de la Réunion des musées nationaux, Paris, 1982.

Secondary literature
· Jonathan Brown, *Velazquez: Painter and Courtier,* Yale University Press, New Haven, 1986
· Mircea Eliade, *Images and Symbols: Studies in Religious Symbolism,* trans. Philip Mairet,
 Princeton University Press, Princeton, 1991
· Edward Fry, *Cubism,* Thames and Hudson, London, 1966
· Ivan Gobry, *Saint Francis of Assisi,* trans. Michael J. Miller, Ignatius Press, San Francisco, 2006
· Andrée Hayum, *The Isenheim Altarpiece: God's Medicine and the Painter's Vision,* Princeton
 University Press, Princeton, 1989
· Robert Hughes, *Barcelona,* Harvill Press, London, 1992
· Sabine Melchior-Bonnet, *The Mirror: A History,* trans. Katharine H. Jewett, Routledge, New York,
 2001
· Steven M. Nadler, *Rembrandt's Jews,* University of Chicago Press, Chicago, 2003
· Roland Penrose, *Tapies,* Rizzoli, New York, 1978

Writings by artists
· Brassai, *Conversations with Picasso,* trans. Jane Marie Todd, University of Chicago Press,
 Chicago, 1999
· Paul Cézanne, *Letters,* trans. Marguerite Kay, Cassirer, Oxford, 1976
· Salvador Dali, *Diary of a Genius,* trans. Richard Howard, Solar Books, n.p., 2007 (incomplete)
· Salvador Dali, *The Secret Life of Salvador Dali,* trans. Haakon M. Chevalier, Vision, London, 1968
· Wassily Kandinsky, *Complete Writings on Art,* ed. Kenneth C. Lindsay and Peter Vergo, Da Capo
 Press, New York, 1994
· Henri Matisse, *Matisse on Art,* trans. Jack D. Flam, Phaidon, Oxford, 1978
· Mark Rothko, *Writings on Art,* ed. Miguel López-Remiro, Yale University Press, New Haven, 2006
· Antoni Tàpies, *A Personal Memoir: Fragments for an Autobiography,* trans. Josep Miguel Sobrer,
 Indiana University Press, Bloomington, 2009
· Leonardo da Vinci, *Notebooks,* trans. Edward McCurdy, 2 vols., Jonathan Cape, London, 1938
· Vincent Van Gogh, *The Letters,* ed. Leo Jansen, 6 vols., Thames and Hudson, London, 2009

Specialist articles
· Yoshiaki Nishino, 'The Boulbon Altarpiece and its Iconographic Programme', *Art History,* x/1
 (1987), 12–22
· Roberta J.M. Olson, 'Lost and Partially Found: The Tondo, a Significant Florentine Art Form, in
 Documents of the Renaissance', *Artibus et Historiae,* xiv (1993), 31–65
· Danièle Gutmann, 'Voile, feu, nuée, les substrats judaïques de la peinture de Mark Rothko
 (1903–1970)', *Revue d'esthétique,* xxxvii (2000), 83–94

Literary works
· Tracy Chevalier, *Girl with a Pearl Earring,* HarperCollins, New York, 1999
· Ernest Hemingway, 'The Killers', *Scribner's Magazine,* lxxxi (March 1927)

Themes

Raphael (Raffaello Sanzio)
Balthazar Castiglione
· Balthazar Castiglione (1478–1529)
· The construction of the portrait
· *The Book of the Courtier (Il libro del cortegiano)*
19

Caravaggio, born Michelangelo Merisi
The Death of the Virgin
· The death of the Virgin
· Catholic doctrine
· The beginnings of opera
27

Bartolomeo Bettera
Still Life with Two Lutes, a Virginal and Books on a Table Covered by a Carpet
· The musical instruments
· The trompe l'œil
· Oriental carpets
· Dust
33

John Constable
Helmingham Dell
· Constable's Suffolk
· A new type of painting
· The meditations of a landscape painter
39

Edward Hopper
Nighthawks
· A short story by Hemingway
· Hopper and the cinema
· Hopper's realism
47

Antoni Tàpies
Seven Chairs
· The wall
· The theme of the chair
· The poverty of materials
53

Rogier van der Weyden
The Descent from the Cross
· The Descent from the Cross
· Golgotha
· A guild commission
· The appeal to sensibility
65

Sandro Botticelli, born Alessandro Filipepi
Primavera
· The world of the gods
· Botticelli's style
· Melancholy
73

Jan Vermeer
The Head of a Young Girl, or *Girl with a Pearl Earring*
· The opposite of a portrait
· The pearl as a symbol
· Blue and yellow
81

Diego Velazquez
The Rokeby Venus
· The motif of the mirror
· Velazquez and his Italian model
· The status of the Spanish artist in Velazquez' day
89

Pierre-Auguste Renoir
The Moulin de la Galette
· The Moulin de la Galette
· Working in the open air
· The Caillebotte Collection
97

Pierre Soulages
Painting
· The link with architecture
· The polyptych
· Monochromaticity
103

Giotto di Bondone
Saint Francis Receiving the Stigmata
· Saint Francis of Assisi (1181–1226)
· The altarpiece on a gold ground
· *The Canticle of the Creatures*
115

Il Parmigianino
The Madonna with the Long Neck
· The attributes of the Madonna
· The sleeping Christ child
· Mannerist elegance
123

Jean-Auguste-Dominique Ingres
Mademoiselle Rivière
· Ingres as a portraitist
· The form of the painting
· Leda and the swan
131

Henri Rousseau ('Le Douanier')
Child with Doll
· The child's dual nature
· Naïveté as a choice
· Rousseau's admirers
137

Pablo Ruiz Picasso
The Aubade
· The connection with history
· The theme of the serenade
· The beautiful and the ugly in painting
143

Salvador Dali
Persistence of Memory
· The terror of softness
· The Catalan countryside of Port Lligat
· Symbolic insects
151

Anonymous Provençal artist
The Boulbon Altarpiece
· The Man of Sorrows
· Debates on the Trinity
· Saint Agricola
· The inscriptions
163

Pieter Bruegel the Elder
The Bearing of the Cross
· The Bearing of the Cross
· The political and religious climate in the Netherlands
· The family of Bruegel (Breughel or Brueghel)
171

Jean-Antoine Watteau
Embarkation for Cythera
· The island of Cythera
· The fêtes galantes
· Watteau and the art of misadventure
179

Paul Cézanne
In the Park at Château Noir
· Château Noir
· The clear-sighted artist
· 'Cézanne, you see, is a sort of god of painting'
187

Vassily Kandinsky
With the Black Arch
· Abstract painting
· The gradual abandonment of the subject
· The black arch
193

Georges Braque
Woman with a Guitar
· Cubism
· Writing in a painting
· The transposition of the real
201

Mathias Grünewald (Mathis Gothart Nithart)
The Crucifixion
· Saint John the Baptist
· Saint Anthony's fire
· The transforming altarpiece
213

Rembrandt (Rembrandt Harmenszoon van Rijn)
The Flayed Ox
· The influence of Judaism
· Scenes in the slaughterhouse
· The tasks associated with the different months
219

Francisco José de Goya y Lucientes
Las Viejas or *Time*
· The allegory of Time
· The Spain of Maria Louisa and Ferdinand VII
· The theme of Vanity
229

Paul Gaugin
Vision of the Sermon (Jacob Wrestling with the Angel)
· Jacob wrestling with the angel
· Pont-Aven
· Japanese art
· The simultaneous contrast of colours
237

Edvard Munch
The Scream
· 'The infinite scream of nature'
· 'They cannot understand'
· The phenomenon of the red sky
245

Francis Bacon
Study of George Dyer in a Mirror
· The model and his suit
· The point of departure for a painting
· Lifting the veil
· Relations with early painting
253

Leonardo da Vinci
The Virgin and Child with Saint Anne
· Saint Anne
· The observation of natural phenomena
· Chiaroscuro
265

Nicolas Poussin
Rinaldo and Armida
· The first meeting between Rinaldo and Armida
· Poussin, a French painter in Rome
· History painting: the 'grand genre'
273

Bartolomé Esteban Murillo
Saint Thomas of Villanueva Distributing Alms
· Seville at the time of Murillo
· Saint Thomas of Villanueva (1488–1555)
· The Counter-Reformation
281

Jean-Baptiste Siméon Chardin
Three Apples, Two Chestnuts, Bowl and Silver Goblet or *The Silver Goblet*
· The apple as a symbol
· Between reason and sensation
· 'We must learn to look'
289

Claude Monet
Water Lilies
· Giverny
· Water lilies
· The tondo: a circular painting
297

Mark Rothko
The Ochre (Ochre, Red on Red)
· Rothko's technique
· The theme of revelation
· Rothko's pictorial conception
303

Françoise Barbe-Gall studied art history at the Sorbonne and at the École du Louvre, where she now teaches. She also runs CORETA (Comment Regarder un Tableau), in which capacity she has lectured extensively. She is regularly invited to take part in management seminars in which she is able to draw on her vast experience not only in analysing images but also in marketing and publicity. A collection of her articles was published in Seville in 2000 under the title *La mirada*. She is also the author of several essays devoted to the work of the sculptor Tom Carr. Her book *How to Talk to Children About Art* was published by Frances Lincoln in 2005.

Acknowledgements

I am particularly grateful to Odile Perrard of Éditions E.P.A. for her intellectual rigour and unwavering good humour, both of which helped me enormously in completing the present book. It is impossible to list all the various individuals who contributed to this volume, but I should none the less like to mention all those friends who accompanied me in thought and deed, sharing with me their enthusiasm and their sensitive responses to the paintings that we looked at together. First and foremost I should like to thank my husband, who generously took upon himself the task of being my first reader.

Françoise Barbe-Gall

Frances Lincoln Limited
4 Torriano Mews
Torriano Avenue
London NW5 2RZ
www.franceslincoln.com

How to Look at a Painting
Copyright © Frances Lincoln Limited 2010

Translation by Stewart Spencer

Original edition published in French
© Éditions EPA - Hachette-Livre, 2006

A catalogue record for this book is available from
the British Library

ISBN: 978-0-7112-3212-9

9 8 7 6 5 4 3 2 1